Drama and Art

AN INTRODUCTION TO THE USE OF EVIDENCE
FROM THE VISUAL ARTS
FOR THE STUDY OF EARLY DRAMA

By Clifford Davidson

Early Drama, Art, and Music
Monograph Series, 1

THE MEDIEVAL INSTITUTE
Western Michigan University
Kalamazoo, Michigan
1977

CONTENTS

ILLUSTRATIONS

Plates I–XIII accompany the sample cards presented in Chapter
V (Examples A–AA).

Plate XIV: Death and a bishop, from Dance of Death (St. An-
drew's, Norwich); emblem from Whitney's *A Choice of Emblemes*.

PREFACE

This book has evolved through a series of circumstances which have placed their imprint on its content and form. Several years ago I conceived the idea of developing an iconographic catalogue which would focus on the extant biblical plays from England—an idea that became modified after Professor Alexandra Johnston asked me to provide a list of York art relevant to early drama for the York volume of *Records of Early English Drama*. The immense problems encountered in developing that list of York art, which eventually included lost art, led to the writing of an extended guide to research in this area of investigation. When the art project and *Records of Early English Drama* were separated last fall, the art project was able to take on a life of its own as *Early Drama, Art, and Music* through the generosity of the Medieval Institute of Western Michigan University. The guide, to which a more elaborate first chapter and an extended Chapter IX as well as an appendix have been added, now includes material which should provide a methodological introduction of somewhat broader usefulness than originally envisioned. It will even be noticed that, though the focus remains of necessity on English drama, constant reference is made to the continent. My own expertise is not, of course, continental, though I recognize the extreme importance of opening our critical windows to the knowledge which can be gleaned from the study of European drama and art. The projected inclusion of continental material in *Early Drama, Art, and Music* actually owes much to the urging of Lynette Muir in her statements at the conference sponsored by the Medieval Institute in 1975. It is in response to her plea for internationalism in early drama criticism and scholarship that *Early Drama, Art, and Music* plans to provide avenues of publication for research and criticism in the area of continental drama as well as of English plays.

The assumptions of this book will perhaps be considered controversial in strictly literary circles, for it asserts the need for applying the techniques of theater research and of art history to dramatic texts. Indeed, I assert that careful and systematic study will lead us rather to intricate knowledge of the production of early drama, which hopefully we might be able to recover on the level of spectacle as well as of sound. Such recovery will be, of course, a matter of degree, and the scholar must be willing to live with some uncertainty. On the whole, however, this kind of task ought to be hailed with excitement when compared with some of the stale literary analyses which have appeared recently on the topic of the late medieval vernacular plays.

No attempt will be made, however, to claim perfection for either the methodology or the insights presented in this book. We will be glad to hear any suggestions or to receive corrections when these might be helpful to scholars at work on projects for *Early Drama, Art, and Music*. It should also be noted that the book was one produced under a deadline, and hence subject to the faults of such publication.

My debts with regard to the preparation of *Drama and Art* extend to an immense number of colleagues, friends, librarians, and even strangers who have volunteered assistance. There is no way that I can name them all. Especially, however, I want to thank Sally-Beth MacLean, who read the manuscript of Chapters II-VII and made valuable suggestions. David O'Connor and Jeremy Haselock provided some absolutely vital information about York glass. The staffs of the libraries of Western Michigan University, the University of Michigan, the University of Minnesota, the University of Chicago, and the Warburg Institute as well as of the British Library, the Bodleian Library, Oxford, and York Minster Library are to be thanked for their patience and kindnesses. With regard to arrangements for the publication of this book, I am grateful in particular to the Board of the Medieval Institute and to the Director, Professor Otto Gründler. Compositors Marc Sheehan and Roberta Depew labored diligently to meet the final deadlines. John Niessink gave essential assistance with the developing of photographs from which the plates were made. Finally, I wish to thank my wife Audrey for her encouragement; in the midst of a busy professional life, she took time to say the right things at the right time, and even in moments of need to assist with the proofreading.

The Appendix was originally published under the title "Death in His Court" in *Studies in Iconography*, and is published here with the permission of the editor, Professor Thomas C. Niemann. Permissions to reproduce the photographs represented in the plates are gratefully acknowledged.

I.
DRAMA AND ART

It is perhaps axiomatic that much of medieval drama cannot
be dissociated from the visual arts, though controversy remains
with regard to the precise nature of the relationship between
the static representations of the artists and the temporal dis-
plays of the early theater. In contrast, Renaissance drama
with its greater theatrical complexity seems less obviously re-
lated to the spatial arrangements and iconography of painting,
sculpture, etc.

In spite of such explicit imagery as Edgar's "O thou side-
piercing sight!" (*King Lear* IV.vi.85) or even the most care-
fully arranged emblematic scenes (e.g., *Richard II* IV.i), it
is of course to the medieval plays that we must turn for dra-
matic expression that finds its exact parallel in the suffer-
ing and death of Christ on the cross as expressed in the
visual arts. Or, if we may assert the principle of "reciprocal
illumination" which is delineated by F. P. Pickering in his
Literature and Art in the Middle Ages,[1] the illustration show-
ing Christ on the cross in the painted glass in the York Minster
Nave (Window 33) hence may provide a highly useful gloss on
Christ's words in the York *Crucifixio Cristi*:

> Al men þat walkis by waye or strete,
> Takes tente ȝe shalle no trauayle tyne,
> By-holdes myn heede, myn handis, and my feete,
> And fully feele now or ȝe fyne,
> Yf any mournyng may be meete
> Or myscheue mesured vnto myne.[2]

In the glass, the severe pain which has been experienced by
Christ is expressed through the stretched sinews in the up-
stretched arms--arms very different in design from the for-
malized position shown in earlier art. Both the glass, painted
in 1338, and the play, presumably from the fifteenth century,
have their origin, to be sure, in the affective piety of the
late Middle Ages and in the iconographic tradition as modified
by that piety.[3] Careful attention to such a play from the
standpoint of what we can learn from the arts will show, how-
ever, that our knowledge of this early vernacular drama re-

mains less developed than we perhaps are willing to admit.
The visual arts thus are to be regarded as a methodological
tool by which we may understand the emotional range and com-
plexity of the drama, which is hardly any longer to be seen
as either simple or primitive.[4]

Systematic study of medieval drama will need, of course,
to be separated from scholarly attention to Elizabethan and
Jacobean drama, which requires different angles of approach
and presents quite different critical problems. Nevertheless,
Renaissance drama was in its time spatial on one essential
level--a level which for the plays unfortunately can only be
recovered in part. In our modern emphasis on *text*, we
have often emphasized the flow of language--i.e., the temporal
movement of the drama along those glorious poetic and linguistic
structures known as verses and sentences--at the expense of the
visual display. The latter requires more rigorous attention
than has in recent years been given to matters of "imagery,"
for, as Glynne Wickham has insisted, the theater of Marlowe,
Shakespeare, and Jonson was essentially emblematic.[5] The task
now will be to scrutinize this later phase of early drama in
terms of its visual effects and its relationship with the
visual arts, while applying the methodology described in this
book to the earlier phase. The focus of this book hence does
not deny in any way that much work remains to be done on the
later forms of early drama (see Appendix).

It is expected that Renaissance drama and art will thus
be treated mainly in the Monograph Series of *Early Drama, Art,
and Music*, which will also collect a wide range of interdisci-
plinary studies on medieval drama, both early and late. The
Reference Series, for which Chapters 2-8 of this book have
been prepared, will for the present almost wholly focus upon
bibliographies and lists of art directly relevant to the drama
from centers of dramatic activity in England and from selected
areas on the continent. These lists will also be made avail-
able on computer tape (see Chapter VI, below) in order that
even more systematic use may be made of the material for the
study of drama.

The subject lists of art relevant to drama combined with
computer programming should provide a more precise means of
charting, for example, the popularity of individual saints
whose lives were potentially the raw material of drama. This
task is ultimately an important one since we only know about
the tremendous popularity of the dramatic genre of the saint
play through reports in records. The earliest in Great Britain
appears to be a St. Catherine play from the twelfth century,
which like almost all the others is lost.[6] The common presence
of such plays in the medieval repertoire is, of course, amply

verified in the dramatic records now known, and the current
work in this area for Records of Early English Drama at the
University of Toronto is expected to add many more to the list
that already contains such figures as St. Nicholas (c.1250),
St. Dionysius (York, 1455), St. Susannah (Lincoln, 1447-48),
St. Mary Magdalene (Oxford, c.1503-04), St. Clothilda (at
court, 1429), and others of equal interest.[7] In Scotland,
a St. Erasmus play was recorded in 1518 at Aberdeen, while
late fifteenth-century records from Edinburgh indicate a pos-
sible St. Nicholas play.[8] Unfortunately, all the British
saint plays are now lost except for the Digby *Mary Magdalene*
and *Conversion of St. Paul* and the Cornish *Life of St. Meri-
asek (Beaunans Meriasek).*[9]

It is possible to see the Digby *Mary Magdalene*, for ex-
ample, as consistent somehow with the traditions of art from
the region of its origin--i.e., from East Anglia or a nearby
region. The complexity of this play may broadly be said to
have much in common with the illuminations of East Anglian
books such as the famous Luttrell Psalter which presents a
wide range of scenes and details.[10] However, such compari-
son, in spite of its attractiveness, is too impressionistic to
be of much value, and in this instance even ignores important
elements of chronology. The Luttrell Psalter was completed c.
1340,[11] and indeed the fourteenth-century heyday of the East
Anglian style is far removed from the early sixteenth century
when the Digby play was apparently written.[12] More to the
point is the iconographic tradition in England that provides
specific attributes for the heroine of the play; as W. L.
Hildburgh notes, Mary Magdalene appears with long hair (only
she and St. Agnes are thus portrayed), and with either the
usual ointment box or a "tress of her hair" as her emblem.[13]
But even such matters as the Magdalen's hair require systema-
tic attention. In the fourteenth-century *Holkham Bible Pic-
ture Book*, which may be from East Anglia, Mary Magdalene at
her conversion possesses long hair, which extends below her
veil as she anoints Christ's feet at Simon's house (fol. 25v);
later, however, she appears with her hair entirely under a
widow's headdress (veil and gorget) (fols. 34v-35). But
whether she should thus be represented in the Digby play will
need to wait until the art of the appropriate period from
East Anglia has been thoroughly examined.

The caution expressed above is not meant to deny the im-
mediate usefulness of evidence from art of a time or place
different from a play, however. Often reference to continental
art which is contemporary with the example of drama under con-
sideration can be very fruitful. As I have shown elsewhere,
such continental woodcuts as Lucas van der Leyden's *Dance of*

Mary Magdalene and Albrecht Dürer's *Mary Magdalene in Ecstasy* provide visual equivalents for action implied in the text of the Digby play.[14] The former shows Mary Magdalene taking part in a dance with a lover, who holds her hand, while two musicians play a side drum and a flute. (Wind music is, of course, traditionally more closely related to the passions than that produced by strings.) The theme of sensuality in the woodcut is reinforced by the more explicitly provocative actions of the other figures in the scene. The Digby play shows the heroine, tempted out of her symbolic castle of virtue, giving herself up to the will of her lover at the conclusion of the dance (ll. 543-46). His name is Curiosity, for he is a species of Pride.

The allegorical expulsion from Mary Magdalene at line 691 of the Seven Deadly Sins--figures which are familiar to us from the visual arts--cleanses her of the guilt which she had taken on herself beginning with her submission to Pride under the guise of Curiosity. Then at the end of the exemplary remainder of her life, she not only becomes the exemplar of contemplation as she eventually retreats to the wilderness (see the famous woodcut *Magdalena Poenitans* by Bruegel, who shows her in a humble dwelling where she is reading and contemplating) and at the last is fed heavenly food by angels. Dürer's *Mary Magdalene in Ecstasy* shows her being lifted up by angels above the wilderness; in tne Digby play, they bring her "an oble" or wafer similar to the Eucharistic bread. As the perfect practitioner of the contemplative life, the Magdalen provides a model for sincere Christians to follow--and in their devotions, late medieval Christians did attempt to follow the pattern which she established. The Digby play of *Mary Magdalene*, like the examples from art, attempts to make visible in an imaginative way the events of her life for all to see.

However, though continental art, particularly from France and the Low Countries, can sometimes illuminate matters of iconography in drama with penetrating clarity, in other instances it is not particularly valuable. Hence the painted glass from Rouen now in York Minster which shows Dolor and Misery within the context of the Expulsion from Eden fails to illuminate to any degree the Norwich Grocers' play, which utilizes the same allegorical figures.[15] The Rouen glass is late, and in actuality only demonstrates the universality of this allegory. If a scene representing these allegorical figures could be found in glass from the Norwich area, we might have an example of greater importance for our study of this play, which actually shows Adam being assaulted by the two allegorical figures.

Local examples of art must, of course, be evaluated

carefully. They do not necessarily have anything to do with
a play on the same subject from the same area. And rarely can
we safely assume that examples in the visual arts might have
been modelled upon actual stage settings. Pageantry is, of
course, another matter, and it is natural that it should not
only have made its influence felt on drama--a point Wickham
has forcefully made in the first volume of his *Early English
Stages*--but also on the visual arts. Hence indirectly we are
able to see certain scenes which pageantry willingly shared in
the Middle Ages with the theater. An example of such a scene
is the pageant castle of the type identified by Merle Fifield
in Vienna Codices 2535-36.[16] These continental miniatures
seem to be also almost perfect illustrations of the allegori-
cal castle of virtue utilized in the Digby *Mary Magdalene* and
the *Castle of Perseverance*. From a staging point of view,
miniatures of this type seem furthermore to set forth some of
the strongest evidence to date against the unlikely plan for
the latter play described by Richard Southern in his *Medieval
Theatre in the Round*.[17] W. L. Hildburgh's arguments in favor
of seeing many details of the English alabasterman's art as
direct reflections of the staging of plays--arguments
which have their basis in the critical opinions of Émile
Mâle--are, unfortunately, not so convincing.[18] The fact that
important parallels exist does not prove the primacy of the
stage.
 Unlike Hildburgh's claims for stage influence on English
alabasters, the theory that Jean Fouquet's miniature of St.
Apollonia in the *Hours of Etienne Chevalier* is a representa-
tion of a production of a continental saint play appears to be
universally accepted as sound. Here an artist who definitely
had connections with the stage depicts a scene from what sure-
ly is an actual production. Within a playing area set up be-
fore scaffolds filled with people, the saint's martyrdom is
being represented. She is shown being fallen upon by God's
enemies, who here, as in the *Golden Legend*, begin "by tearing
out all her teeth." The miniature illustrates her bound to a
plank, with a tormentor tugging at her hair and another extrac-
ting her teeth with a long set of pincers. But the most inter-
esting portion of the miniature nevertheless is the background,
which shows musicians with instruments, ladders, actors dressed
as angels and demons, a hell mouth and other stage parapher-
nalia. Still, one must be careful not to generalize too freely
from this remarkable miniature, for the conditions of produc-
tion were, as we know, quite different from one region to
another.
 Surely in the light of our need for information concern-
ing the production of early drama, we need to be extremely

aware of the value of each piece of evidence available from
the visual arts. Corroborative evidence from the visual arts
can be of great assistance, and happily such evidence is avail-
able for the earliest sacred drama recorded in England. A
dramatized *Quem queritis*, an elaboration of the trope added
to the Easter Introit, is dated c. 970 and is contained in the
Regularis Concordia of St. Ethelwold. Another version, com-
pleted no later than 980, is contained in the compilation
known as the *Winchester Troper*.[20] These may be compared with
the important miniature showing the three holy women at the
tomb in the famous *Benedictional of St. Ethelwold*, one of
the finest examples of Anglo-Saxon art and very likely painted
at Winchester. It is quite clear from the texts of the drama-
tized *Quem queritis* from Winchester that the play was more
ritual than it was dramatization. In the rubrics to the first,
the *fratres* who are to play the role of the three holy women
dress themselves in liturgical garb (copes) and carry thur-
ibles with incense in place of spice jars. The angel is
dressed in an alb and carries a palm. When we turn to the
miniature, we see something which we might be tempted to
label a good deal more advanced. The Marys in their costumes
are stylized but nevertheless recognizable as women at the
tomb, while the winged angel seated there makes a colorful
contrast with the simple person in an alb who played the
role of the angel in the play. There is hence no reason
to believe that the miniature reflects directly the staging
of the early *Quem queritis*, yet the very suggestion that it
offers with regard to the positioning of the characters in
relation to the tomb will need to be taken into consideration.
Furthermore, the design of the tomb should be regarded as
vital evidence for the design which may have been followed
in the case of the Easter Sepulchre at Winchester. If so,
the Sepulchre, which may have been made of wood to make it
portable, would have been very much like the mansion that
later would be so familiar in medieval staging. Hence it would
have been a prominent temporary architectural feature in the
choir of the Old Minster from Good Friday through Easter Sunday.
By further good fortune, recent archaeological study of the
building where the play was performed in St. Ethelwold's day
has even enabled Dunbar H. Ogden to trace the probable path
of the play's characters in the choir.[21]

Easter Sepulchres, whether temporary or permanent, are,
of course, very much worth our attention, and should be list-
ed in the subject lists for the various regions to be covered
by the Reference Series of *Early Drama, Art and Music*. The
presence of even a permanent stone Sepulchre as at Lincoln
does not, however, argue for the presence of the liturgical

Easter play or *Visitatio Sepulchri*. Indeed, the dramatic records from Lincoln, edited by Stanley J. Kahrl for the Malone Society, are ambiguous up to 1390-91, after which the ambiguity ends, for there are no more references to any play at Easter time.[22] The records for the cathedral between 1321-22 and 1390-91 refer to a play of St. Thomas, which apparently was performed in the nave at Eastertide, and the later records specify further that it is a play of the Resurrection. Whether the drama included the three Marys at the tomb we cannot tell, and curiously its staging in the nave removes it from the permanent Easter Sepulchre, which was located in the choir. The Sepulchre at Lincoln was hence probably only used for the Holy Week ceremonies of the *Depositio Crucis* and *Elevatio Crucis*.[23] At York, at least ten parish churches are recorded to have had Easter Sepulchres which, though there is no evidence of dramatic activity as such in any of them, were clearly the center of important ceremony during Holy Week. We know from the wills of York citizens that a "Sepulchre candle" was burned before each Sepulchre at Easter time "secundum usum et laudabilem consuetudinem civitatis Ebor."[24] At St. Michael, Spurriergate, York, the church accounts in 1547 indicate that the Easter Sepulchre was discarded along with the figures of saints, etc., all of which were called "muck."[25] We can be assured that by this time, the climate had become hostile toward liturgical plays through much of England. In Protestant countries, only in conservative Sweden were such medieval remnants as the *Quem queritis* trope in Latin allowed to survive into the seventeenth century.[26]

Unlike the Latin liturgical drama, which is akin to the more formal and abstract art of the earlier Middle Ages, the vernacular plays, particularly as they are associated with the urban culture, demonstrate a different aesthetic which suggests quite different origins. Formerly the vernacular plays were held to have grown out of the liturgical plays by an evolutionary process, but recent scholarship instead sees the two forms of drama as independent developments.[27] The one is earlier, though the high point of its history was the twelfth century—a period which also marks some activity in vernacular drama—while the other tends to be later. No longer can anyone defend any theory of natural selection at work here which might have impelled the alleged movement from the "simple" liturgical drama toward more complex forms and toward secular content. Liturgical drama indeed is artistically in many ways more sophisticated than the vernacular plays; they show liturgy spilling over into action in a manner that literally presents images in movement. C. Clifford Flanigan has suggested convincingly that this drama has its roots in the imposition of the Roman

rite in the course of the Carolingian reforms, which thus creat-
ed a need for religious expression in addition to the simple
and abstract liturgy of the new rite.[28] In particular, the
plays signified a way in which the past could be re-actualized
in the liturgical experience.[29] From our standpoint, we need
to understand this development also in terms of the tendency
in the West to desire to visualize the crucial scenes from
biblical history, albeit in abstract ways designed to be truth-
ful through their avoidance of strict verisimilitude. The early
liturgical plays, like devotional objects in art, hence attempt-
ed to mediate between the viewer and the person or scene repre-
sented. These plays can only be described as embodying the
"iconic quality" which Mary Marshall observed as their distin-
guishing characteristic.[30]

The argument for illustrating the scenes from sacred story
most commonly encountered is that the illiterate require in-
struction, which cannot be better presented than through pic-
tures. According to Durandus, who speaks for a long-standing
tradition, "pictures and ornaments in churches are the lessons
and the scriptures of the laity."[31] These same images, accord-
ing to Durandus, may properly be adored (but not worshipped)
on account of "the memory and remembrance of things done long
ago."[32] In this, he is following St. John of Damascus, who was
the first to insist that the adoration offered to an image
involves the transference of that adoration to the person shown
in the image--an opinion asserted as the doctrine of the Church
by the Seventh Ecumenical Council in 787.[33] The intense desire
to see with the eyes of faith beyond the veil of earthly
appearances thus not only makes its effect known in the sym-
bolism of architecture and liturgical actions, but also in the
scenes painted or otherwise represented in the visual arts.
Like the images in art, the liturgical drama attempted in what
was felt to be a very real way to reactualize moments in sacred
history.

With regard to the rise of vernacular drama in the twelfth
century in such plays as the Anglo-Norman *Adam* and *La Seinte
Resurreccion,* the impetus toward penetrating the veil of
appearances takes a different turning, while the Provençal
and Latin of the *Sponsus* functions in a more conservative
manner to bring a vernacular language into an eschatological
play set to music and otherwise designed according to the
principles of liturgical drama.[34] For the vernacular drama,
however, the pattern established by the former plays is by far
the most important. As early as c.1220 in Beverley, a play on
the topic of the Resurrection was performed in the churchyard
of St. John's Church by masked actors, who were viewed by an
audience motivated by delight, curiosity, and devotion.[35]

The combination of folk traditions and imaginative handling probably was of the type which offended Robert Grosseteste, the Bishop of Lincoln. In a directive of c.1244, Grosseteste specifically condemned miracle plays ("ludos quos vocant miracula") which apparently had been written and produced under the auspices of the clergy.[36] The later civic drama, though influenced by such popular expression, nevertheless requires that it should be examined as a separate phenomenon since its rise was not part of the folk expression which found its release at Beverley and elsewhere at an early date.

The civic cycle plays are, of course, very much the product of a middle class located in urban areas--a class which thought of itself as distinct from the folk and from the aristocracy and higher clergy. Of the utmost significance are such statements as the following dated 1417 from the *York Memorandum Book A/Y:* "For the profit of the citizens of the city of York and of all foreigners coming there in the afore-mentioned Feast [of Corpus Christi], all of the pageants of the play [omnes pagine ludi] called the 'Corpus Christi play' should be maintained and brought forward in order by the crafts of the said city for the honor and reverence especially of our Lord Jesus Christ and for the profit of the aforemention-ed citizens."[37] In the context of this document, "profit," it should be pointed out, is a term which does not distinguish between secular profit and spiritual gain. Nevertheless, we can safely say that without the religious motivation, the cycle plays at York would not have been conceived or mounted. The quality of Northern spirituality informs these plays, which thus are indeed designed with a devotional purpose that links them with the scenes of devotional art.[38] Because the drama did not exist as an art form in total isolation from cultural patterns and cultic experience, we cannot ever expect to arrive at any scientific "laws" by which the particular forms of drama of the fourteenth and fifteenth centuries were "evolved."

Perhaps it might be instructive to recall the over-whelming confidence with which Chambers set forth the theory of progressive "secularization"[39]--a process which, as we know, led allegedly from the early liturgical play to the later civic cycle plays and then on to the glories of the Eliza-bethan theater. The widespread acceptance of such thinking was established as the normal framework for criticism for well over fifty years. Of course, as noted above, the whole understanding of evolutionary development in drama has recently been successfully challenged, and with it the concept of "secularization" has likewise fallen from fashion. Such thinking can no longer be accepted.

While the birth of a play cycle such as the one at York is yet a controversial question, there is currently agreement that progress toward settling this question cannot be achieved by theory divorced from (1) careful attention to the dramatic records, (2) close analysis of the plays themselves, and (3) systematic observation of evidence from the visual arts. Criticism cannot any longer be taken seriously if it merely provides interpretations which do not extend our knowledge beyond what can be established through a careful reading of the texts. "Close reading" is not able by itself to solve problems which in the case of early drama necessarily include matters more broad in scope than values that are narrowly poetic. Hence even analysis of the play texts as demanded above requires something more than the usual dull exercise of literary criticism, and it must always be joined with attention to the dramatic records and evidence from art.

Perhaps one day the origin of the York plays will be spelled out in detail, though the prospects for exact knowledge in this area are not as good as we would like. Did it have its beginning in the Corpus Christi procession as introduced from the continent? If so, we would have a very clear explanation of the source of the pageant stages utilized in that city. A new source would also argue for a new form: instead of a single miracle play on some subject, there would be a patterned series of playlets with an origin in the processional presentation of scenes from sacred history. As a new beginning, this drama eventually gave illustration to the whole history of the world, though primarily it focused on the Incarnation and Crucifixion of Christ at the center of this history.

Naturally, the York plays, in spite of the thesis that they appear to represent a new start and hence are not the result of any straight line of development out of liturgical drama or earlier popular plays, show evidence of acting as a magnet for ideas regarding the visualization of the biblical story and perhaps even for portions of earlier plays which may have attached themselves to the cycle. It has been argued, for example, that the York cycle has dramatic antecedents in the oddly macaronic *Shrewsbury Fragments*, which seem to be linked both to the sung plays and to the plays in Middle English.[40] Further, even the earlier liturgical plays must have helped in general to suggest ways in which the story of the life of Christ might be given visual representation in lively dramatic form. Yet, contrary to the expectation of Chambers and his followers, there is no evidence of the pressure of a "mimetic principle" surfacing in the history of medieval drama, nor is there any proof of an urge to

"secularize" the Latin drama, which retained its place in
Cathedral worship at specified festivals until fairly late.
It is thus necessary to look very critically at the whole
context of the drama during the fourteenth century in order
to test the theory that the vernacular plays indeed grew out
of the Corpus Christi procession as introduced from the
continent.

It is common knowledge that the Corpus Christi pageants
at York are mentioned in the *York Memorandum Book A/Y* in 1378,
and that this date does not represent the institution of a new
practice by any means.[41] This entry, which reports a fine
against the bakers, is indicative of an established custom.
We know on the basis of stylistic and iconographic study that
many of the plays currently entered in the Register which con-
tains the York cycle (British Library MS. Add. 35,290) must
have been written considerably later. It is tempting to believe
that the pageants, following continental practice, were in the
late fourteenth century no more (or little more) than *tableaux
vivants* displayed as part of the Corpus Christi procession.
Thus Martin Stevens has conjectured that such *tableaux* "grad-
ually" came to include "a few spoken lines," though until
relatively late they "bore only a skeletal resemblance to the
collected pageants of the York register."[42] Stevens' scenario,
however, would need to be corroborated by the dramatic records,
and currently evidence seems to be solidifying to indicate that
the development of the York plays was more rapid and complete
than Stevens' theory would allow. Nevertheless, his insis-
tence that we should see the drama of the civic cycle as closely
allied with the *tableaux vivants* of continental practice
provides an extremely useful direction for our thinking.

The above provides at least a rough suggestion that we
ought to view the vernacular cycle plays as an extension
of the visual arts. Like painting and sculpture in the late
Middle Ages, drama attempted no longer to pierce the veil of
appearances through presentation of abstract and idealized
forms, but rather it turned its efforts toward stimulating
the *imaginations* of the beholders. Thus drama, like the visual
arts, had been molded into a channel for the affective piety
demanded by the spirituality of the North during the late
Middle Ages. The cycle plays at such centers as York and
Coventry therefore involved the new aesthetic which encouraged
audiences to return *on an imaginative level* to the sight of the
scenes from sacred history.

Earlier art and drama had participated in the reality of
the persons and events represented; fifteenth and early six-
teenth-century art and drama re-create their appearance and
actions in a manner which only suggest how they *might* have

appeared. St. Bernard in the twelfth century had been extremely suspicious even of mental images arising during the exercise of meditation. According to him, "You have not gone a long way unless you are able by purity of mind to fly over (transvolare) the phantasmata of corporal images that rush in from all sides."[43] Nevertheless, by the fifteenth century such doubts made little impact on the popular practice of piety; mental images, images in art, and scenes in drama all were regarded as important aids to the intensely emotional devotion favored within the region affected by the Northern spirituality. That remarkable woman Margery Kempe may have been exaggerated in the *degree* to which she reacted upon seeing an image of Our Lady of Pity in Norwich, but her response ("thorw þe beholdyng of þat pete hir mende was al holy ocupyed in þe Passyon of owr Lord Ihesu Crist & in þe compassyon of owr Lady, Seynt Mary"[44]) is not different *in kind* from what during the period was considered by many to be the norm. The liveliness of the vernacular drama, therefore, was particularly suited to the stimulating of the imagination in the service of the spiritual life of the public.

I have elsewhere discussed the role of late medieval nominalism in the change in the aesthetics of drama noted above,[45] but perhaps it should be again noted here that the movement away from the philosophical realism so influential in the earlier medieval period made possible the new artistic "realism" present in both the civic theater and the work of the visual artists of the later Middle Ages. The feeling that externals or signs may be arbitrary rather than direct expressions of the reality behind the veil of appearances, gave impetus toward seeing *what might have been* imaginatively. Iconographic details are not, of course, rejected, but the new fascination with specifics brings a revival of interest in what Professor Kahrl insists upon labelling "verisimilitude."[46] The mimetic practice which is thus implied hence is an extension of the tentativeness introduced through philosophical nominalism, which was clearly spread far and wide from Oxford during the late fourteenth and fifteenth centuries.

At York as elsewhere where plays were regarded as major civic projects, the members of the city council and/or the appropriate guild were engaged in a venture[47] which would make visible the events that previously had been presented normally in religious art. These events then were made to become alive upon the pageant wagons, which were utilized for more than merely *tableaux vivants* reproducing the silent scenes of the painting or sculpture of the time.

A particularly convincing statement which gives evidence in favor of the view that the drama's roots were in the

[margin note: Cf. Doubting Thomas]

representations of the visual artists, may be found in an
attack on the medieval stage by the Wycliffite writer who
was responsible for *A tretise of miraclis pleyinge*. In spite
of this writer's extreme hatred of plays, he nevertheless
understood intellectually the major arguments which were then
used to defend religious drama. Most significant is the
following statement:

> sithen it is leveful to han the myraclis of God
> peyntid, why is not as wel leveful to han the
> myraclis of God pleyed, sythen men mowen bettere
> reden the wille of God and his mervelous werkis
> in the pleying of hem than in the peyntynge, and
> betere thei ben holden in mennus mynde and oftere
> rehersid by the pleyinge of hem than by the
> peyntynge, for this [painting] is a deed bok, the
> tother [i.e., playing] a quick.[48]

The religious plays hence were regarded by their orthodox
supporters and heretical enemies alike to be closely allied
with religious pictures, which in the drama are made to come
to life in a manner which could move men's hearts.

Drama and art are also in point of fact brought into union
in a practical way, since the artists were indeed asked to lend
their skill to the preparations for playing in various locales.
Though the influence of drama upon art can only rarely be
proved to our satisfaction, the facts indicate that painters
and carvers were actually employed about the pageants, sets,
and costumes for the plays. The conservative nature of drama
is proof of its derivative character; it is rarely innovative
with regard to either iconography or ways of visualizing
scenes.[49] The art hence provided, as we have seen, models
for the crucial moments within the cycle plays, which only
require the "fleshing out" of scenes by means of action and
dialogue. But further the dramatic records show that the
artists were intimately involved in providing and painting
scenery, wagons, garments, and stage properties for the plays.

To be sure, in many instances the dramatic records do not
indicate to whom payments were made for the repair of a wagon,
the preparation of a painted cloth, etc. We can, however,
assume that the strictly decorative arts such as painting were
done by those with the appropriate specialized skill--i.e., by
artists. Such assumptions are corroborated by cases in which
the records do say to whom money was paid for specific jobs.

At Coventry in 1498, 8 pence were "paid to the peynter
ffor peyntyng" faces (masks?), and the same year an amount was
"paid for peynttyng of the demones hede."[50] In 1554 John
Hewet is named as the "payntter" responsible "for dressyng of
Erod hed and the faychon ij s."[51] Division of labor is implied

in a 1551 entry which provides separate entries for making the "demons garment" (including the cloth) and "for collyryng of þe same garment."[52] It is hard to believe that the repair of an angel's wing, as recorded at Lincoln in the cordwainers' accounts in 1526-27,[53] would have been done by anyone but a skilled artist. Particularly useful here are the York Mercers's records, since they list many items which could only have been provided by artists. For example, the "ix smaler Aungels payntid rede" in the unique indenture of 1433 could only have been made by carvers or sculptors and finished by painters.[54] The mercers' records are additionally helpful, since they also provide some vital information about assistance given by artists to the upkeep and refurbishing of the Doomsday pageant at York. In 1449-50, a man named Thomas Steynour was paid 13s. 4d "for steynyng of þe clothes of oure pageand," while Robert Michell received 23s. 4d "for payntyng of þe said pagient newe" in 1451-52.[55] In 1461, the mercers' pageant was repainted at a cost of 20d, an amount that suggests touch-up work made necessary by extensive repairs at that time.[56] In 1463, the master painter was employed for 12d "for pantyng of þe dellwys gere."[57]

Most interesting of all in the York Mercer's records is the entry from 1501-02 which reveals that Thomas Drawswerd, a prominent citizen and a a "carver," should "mak the pagiant of the dome belonging to the merchauntes newe substancialie in euery thing þervnto belonging."[58] Apparently this new pageant was painted by Henry Marshall in 1504, when he received the large amount of 22s. 6d for the job, and in 1507 Drawswerd was commissioned to make the pageant even more elaborate than it had been before.[59] An inventory of 1526 reveals the complexity of the pageant and the play; the stage properties include even a Trinity, presumably an alabaster representation, which could easily have been supplied from Drawswerd's shop.[60] As dramatic records are studied and scrutinized, surely the pattern of deep involvement of the artists in drama will become even more apparent.

If we in the twentieth century are to visualize the theatrical performances of the Middle Ages, either early or late, the work of the visual artists must for us be a topic of genuine interest. Though we currently lack careful descriptions or anything approaching photographic evidence, through systematic study of the art of the time we are potentially able to learn much that is new about the plays as they were produced. A systematic approach to collecting and classifying information about relevant art from centers of dramatic activity in England-- and additionally from important locations on the continent-- is the subject of the following discussion.

II.
Preparatory

The amount of extant art from the late Anglo-Saxon period through the Reformation is massive, and hence any attempt to come to terms with it must, if it is to throw light on the English drama of these centuries, be broken down into segments that can·be handled. The subject lists of art for the Reference Series of *Early Drama, Art, and Music* will provide just such a convenient way of dividing the task, since investigation by city and region will give careful attention to the iconographic and stylistic differences that will be encountered in each part of England. More particular distinctions on the basis of date may in many cases need to be held over until the series is nearing completion in the future, at which time the accumulated regional lists can be examined with the help of the computer.

Quite clearly the value of the subject lists in the volumes of *Early Drama, Art, and Music* will depend upon the care with which they are prepared and on the methodology which is employed. It is hence important that the investigators devoting themselves to the task of studying regional art should adopt uniform procedures and that they individually have in hand the appropriate evidence which can provide the basis for the brief but careful description of each of the works of art to be noted in the subject lists for the various volumes.

Ideally, each person preparing a subject list would already be familiar with the art of the region, and would be knowledgeable with regard to early dramatic activity both in the area and in the country as a whole. He would also be deeply steeped in the study of iconography, and would possess the skills required to take down those details which he would need to draw upon when preparing the subject lists--i.e., he would need to be able to sketch details with pen or pencil, and he would be able to handle a camera of some sophistication. The reality is, however, that he may find himself at first weak in one or more of these spheres, particularly, since he will normally be primarily a literary scholar, in the advance knowledge of the art and in photographic skills.

The starting point must be the acquisition of detailed maps of the city and/or region under study, and in his work the investigator requires something which gives not only extant buildings but also those no longer in existence. He needs to begin locating objects of art and architecture in space as soon

as possible. Such maps as those produced in the early seventeenth century by John Speed are invaluable, but need to be supplemented by modern cartography, which can, especially because of knowledge gained through archaeological excavations, often be quite precise in locating the outlines of the sites of destroyed buildings. Speed's map of York (1611) hence shows, for example, the pageant route and the churches and other buildings along its way very much as they had been less than half a century before when the plays had been staged in the streets. We get some sense of how the churchyard of St. Michael, Spurriergate, and the very church itself were reduced in later times when Low Ousegate was widened, and we see what the Cathedral Close was originally like in the days when the pageants paused before the Minster Gates. But when we turn to a map such as the one conveniently included in Angelo Raine's *Mediaeval York* (1955), we see much more that must be essential knowledge for anyone attempting to orient himself in this city. Dotted lines on this map show the site of the Dominican Friary adjacent to Toft Green, where the pageant wagons were stored, and a considerable number of locations which were altered beyond recognition in the course of the sixteenth century. Such locations need to be known by the investigator who approaches the early art of this city.

Assuming that the researcher is already familiar with M.D. Anderson's *Drama and Imagery in English Medieval Churches* (1963), he needs to return to that book and to the same author's *Imagery of British Churches* (1955) as well as her *History and Imagery in British Churches* (1971) for whatever information they may provide concerning the region which is being studied. The indices in these books will in many cases prove helpful, and the bibliography provided will lead one to other works which can be of assistance at the outset of the investigation. To one who is beginning examination of Chester, for example, these books will draw attention to some interesting stall-ends and misericords in the Cathedral. One in particular, a nineteenth-century copy of presumably a lost fourteenth-century misericord, illustrates the Resurrection in a unique way by showing two angelic figures raising the lid of the tomb in which Christ is still lying.[1] This scene may throw light on the Chester Skinner's play of the Resurrection, though it is surely not the business of the compiler of the Chester Subject List to follow Miss Anderson's suggestion that "we *may* have here a unique illustration of a medieval stage effect."[2] The belief that the carvers might have been illustrating what they saw performed in the streets is, as I have indicated above, a very shaky conjecture, and should not find its way into the presuppositions of the

investigator. On the other hand, he is well warned by Miss
Anderson that the present misericord might well have failed to
reproduce for one reason or another the design of the original
from the medieval period. Thus here, as in other instances in
which medieval objects of art have been tampered with by
modern restorers of the past 150 years, healthy scepticism
must take the place of blind faith with regard to icono-
graphic and stylistic features.

The next stage of preparation will be to branch out to
those works which have systematic, though not complete lists
of works of art in various media. The most important is
perhaps Philip Nelson's *Ancient Painted Glass in England,
1170-1500* (1913), which contains a listing of early glass for
each county. Nelson's lists, though incomplete and often very
out-of-date, remain extremely useful, particularly since English
glass, in spite of its fragility and the careless treatment it
has received, still preserves the bulk of medieval art in many
areas. Much of the rest, including carved images, wall
paintings, painted cloths, and embroidery on vestments, was
swept away by the Reformation by the end of the sixteenth
century. Everyone who has visited Ely Cathedral knows what
the wrath of the early Protestant iconoclasts did after the
dissolution of the monastery in 1539 to the delicate and lovely
stone carvings showing the life of the Virgin in the Lady
Chapel. Generally, the damage to parish churches and regular
cathedrals was most serious during the late 1540's upon the
accession of Edward VI to the throne; at this time, as noted
above, such churches as St. Michael, Spurriergate, York, were
stripped of their images, lights, and even Easter Sepulchres.
Following a reprieve during the reign of Queen Mary, the program
of destruction carried out against religious art was again con-
tinued. In a letter to the editor of the *Gentleman's Magazine*
in 1830, R. Almack reports the evidence from the churchwardens'
accounts at Long Melford, Suffolk. During the reign of Edward VI
images are recorded as sold, while in 1562 a man was paid
10s. 6d "for the scraping owt of the pay'tinges all ye
lengthe of the Quire" and in 1576 two shillings were paid "to
Flyemyn the Glasyer of Sudburye for defacynge of the sentence
and Imagerye in the glasse Wyndowes."[3] The extent of the des-
truction and loss at Long Melford is reported by Roger Martin,
whose account of an English parish church before the Reform-
ation is of extreme value.

In 1576, visitation articles in the diocese of York show
that under Elizabeth the destruction of art continued, for they
are explicit about the illegality of many objects which we
would regard as having artistic value:

Item whether is there any person or persons in your

parishe that hath in his kepinge any masse bookes
or forbidden Latyne service bookes, or any vestements
albes tunicles stoles phanons pixes handebells
sacring bells sencers crismatories crosses candle-
sticks holie water stocks or fatts, Images or any
other reliques or monuments of superstition or
idolatrie, or whether any such be reserved or
secretlie kept in any place in the said parishe.[4]

Only glass was to receive a reprieve from the general destruc-
tion, and this only in the time of Queen Elizabeth, in whose
time the windows were decreed to be "monumentes of antiquitie"
and hence exempt from iconoclastic fury. The Royal Injunc-
tions of 1560 hence threaten with prison anyone who would
break down or deface any image in glass windows in any church
without consent of the ordinary."[5] Yet probably of greater
importance in the final analysis was the simple fact that the
cost of replacing so much glass with plain white glass was
prohibitive within the limited budgets allowed to the churches
during this period. Such petty matters as expense did not, of
course, deter the Puritans in the 1640's, when a man like
William Dowsing could not be prevented from going through the
countryside with the purpose of smashing all images, including
the ones in glass, and when rebel soldiers might denude entire
cathedrals of their glass. Nevertheless, the damage done before
the Restoration did not match the loss of glass thereafter.
The very basic principles of iconography were forgotten, and
even when glass was releaded (as it must be approximately
every 125 years) terrible mistakes were made, sometimes scram-
bling windows beyond recognition. An anonymous letter writer
in *The Ecclesiologist* (August 1842) noted the "miserably
neglected and precarious state" of the parish church glass in
York (pp. 191-92). The letter writer commented: "In many cases
the pieces are actually ready to drop out of the decayed leaden
frames into the street; in others, the windows are coated ex-
ternally with dust and filth; in all there are the marks of
wanton breakage and mean repairs in paltry white glass--a fit
substitute, truly, for the glories which once blazed from these
storied chronicles of saintly achievement, in scarlet and gold
and blue of almost unearthly brilliancy....The value of this
glass is probably beyond estimate, yet it is suffered to go to
decay as if [it were] a mere valueless relic of bygone 'super-
stition.'" The remarkable thing is that so much painted glass
has indeed survived, much of it now in even fairly good con-
dition.

Wall paintings have often survived through a quite
different set of circumstances. Generally they were ordered
to be whitewashed over, and in this process their tempera

cf
Hegge's
grandfather

colors were sometimes preserved until the time in the nine-
teenth or twentieth century when the covering might be re-
moved, revealing the original designs on the wall. Such
was the case with the remarkable wall painting of Doomsday in
the Church of St. Thomas of Canterbury, Salisbury, which was
whitewashed in 1593, uncovered first in 1819, whitewashed
again, and then finally uncovered in 1881. Unfortunately,
the rediscovered wall painting was given a Victorian restor-
ation, which corrected a number of details in the design and
furthermore repainted the whole in oil paint, which currently
is deteriorating because the pigments are unsuited for the
surface to which they were applied.[6] Listings of extant wall
paintings in A. Caiger-Smith, *English Medieval Mural Paintings*
(1963), should be consulted as a preliminary guide to major
examples, which are noted according to location.

Roof bosses, which often are the best preserved of
medieval art objects because of their inaccessibility to the
iconoclast and because of their durability, receive attention
in C.J.P. Cave's <u>Roof Bosses in Medieval Churches</u> (1948).
Usually the brilliant paint and gilt which covered the bosses
in medieval times have worn away, but the carved stone or
wood itself sometimes presents an essential scene in consider-
able detail, as in the case of the illustration of scenes from
the life and death of Herod in the roof bosses of Norwich
Cathedral. In the cathedral transept, Herod reads the prophe-
cies, becomes indecorously angry and crosses his left leg with
his right as a symbol of his emotion, sends his soldiers out
to perform the slaughter of the innocents, appears with a
doctor who is taking his pulse, and dies in the presence of
demons who snatch up his soul.

In spite of the rarity of relevant figure sculpture, in-
cluding alabaster carvings, in the country, these items are
nowhere listed in a manner designed to be particularly useful
to scholars systematically interested in regional examples of
art. But a good introduction is nevertheless provided by
Edward S. Prior and Arthur Gardner in *An Account of Medieval
Figure-Sculpture in England* (1912), while the important
*Illustrated Catalogue of the Exhibition of English Medieval
Alabaster Work, 1910* (1913) should also be consulted. For
misericords, the excellent listing in G. L. Remnant (*A Cata-
logue of Misericords in Great Britain*, 1969) will be found
essential.

At this point, the researcher should be prepared to
tackle the more specialized books and articles which treat
individual arts either generally (e.g., E.W. Tristram's
books on wall paintings in England from the twelfth through
the fourteenth centuries, and the articles on alabasters by

Philip Nelson and W.L. Hildburgh in the *Archaeological Journal, Archaeologia, Folk-Lore, Antiquaries Journal,* and the *Burlington Magazine*) or specifically for a region (e.g., Christopher Wood-forde's book on glass painting in Norwich). Among the latter also may be mentioned as examples the important work by G. McN. Rushforth, *Medieval Christian Imagery* (1936), which focuses on Great Malvern but ranges broadly over many aspects of late med-ieval iconography and design, Bernard Rackham's book on Canter-bury glass, the volume on the glass of King's College Chapel, Cambridge, in the series *Corpus vitrearum medii aevi* (1972), and a number of books and articles on York glass by various scholars and writers.

Nor should the researcher neglect local books, guides, and pamphlets, though these will vary especially widely in quality and accuracy. A few would insult the intelligence of even the most ordinary tourist, but many others provide a surprising range of information, much of it sometimes sur-prisingly well researched. Such a book as O.F. Farmer's little monograph on the glass at Fairford, Gloucestershire, for example, is extremely useful, while L.A. Hamand"s *Ancient Windows of Gt. Malvern Priory Church* provides not only some helpful descriptions but also some crucial information about some rearrangement of Great Malvern glass since the publication of Rushforth's book. M.D. Anderson's pamphlet on the Lincoln choir stalls and George Zarnecki's *Romanesque Sculpture at Lincoln Cathedral* are exemplary. It is advisable to search local libraries, both public and ecclesiastical, for publi-cations of this sort which are no longer in print. Invaluable descriptions of works of art and architecture are sometimes to be found in these items, though it is unwise to accept statements from many of them without corroboration. Still, even at their worst, they can provide leads which can culminate in important discoveries.

Some of the basic bibliography for the art of each region in England will be contained in periodicals which focus on matters archaeological and antiquarian. The general ones include, of course, the *Archaeological Journal, Antiquaries Journal,* and *Journal of the British Archaeological Association.* Though these have been indexed in research tools such as Edward Mullins' *A Guide to the Historical and Archaeological Publica-tions of Societies in England and Wales,* which covers the period from 1902-33, the most effective way of searching for items dealing with the region under consideration remains the direct examination of the table of contents and the index for each volume on the shelf. Needless to say, an open-shelf library, where one can have convenient access to all the published volumes of these journals, is almost a necessity.

Unfortunately, the regional and specialized journals really must be searched in the same way. To be sure, the bibliographic aids such as Mullins' *Guide, Poole's Index to Periodical Literature* (for 1802-1906), the *Subject Index to Periodicals* (1934-61), and the *British Humanities Index* (1962-) should not be neglected; however, it is only by patient searching that the researcher will be able to complete his bibliography of items pertaining to the art of a city or county. Thus, for example, the researcher at work on the art of Chester and Cheshire will turn to such periodicals as the *Transactions of the Lancashire and Cheshire Antiquarian Society* directly; this periodical will be found to contain, among other items of interest, the article by Maurice H. Ridgway entitled "Coloured Window Glass in Cheshire" (vols. 59 [1948], 41-84, and 60 [1949], 56-85). To an American or Canadian literary scholar the very existence of the English county antiquarian or archaeological journals may come as a surprise, but it has often been in these publications that some of the most remarkable discoveries of medieval art have been announced, not seldomly with analyses and information which have never been duplicated elsewhere. Hence, for example, the person interested in the wall painting showing the Doom at St. Thomas, Salisbury, will not fail to consult the article by Albert Hollaender (cited in footnote 6, above) in the *Wiltshire Archaeological and Natural History Magazine*. And one who wishes to know about the extensive wall paintings at Pickering in Yorkshire must go to the paper by G.H. Lightfoot in the *Yorkshire Archaeological Journal,* 13 (1895), 353-70. The important painted glass windows of St. Neot, Cornwall, are described by G. McN. Rushforth in the *Transactions of the Exeter Diocesan Architectural and Archaeological Society,* 15 (1937), 150-89. Ten years previously the same author had published in the same journal an article on "The Kirkham Monument in Paignton Church," which provides the most important discussion of the iconogrpahy of the Mass of St. Gregory as it appears in English art (1927, pp. 11-13, 21-28).

Some attention may even be desirable in some regions to funeral monuments both in stone and in brasses. Though these are often standardized shop work, at times they are capable of yielding significant information about costume for various levels of society from the highest down to the tradesmen of more modest means. Herbert Druitt's *Costume on Brasses* (1906) is a good introduction to the brasses, and may be supplemented by various other books, including specialized studies of lay and ecclesiastical garb during the late medieval and renaissance periods. Chapter VIII, below, will also provide some introductory information about costume. Because of the popularity

of brass rubbings, guides to English brasses are easily obtained and should be consulted. Stone monuments of significance may, however, need to be sought out on location. Some of these, particularly floor slabs, have been done away with, as in the case of the ones on the floor of the York Minster which were removed in the eighteenth century. Fortunately, the York monuments were described in the late seventeenth century by James Torre, whose manuscript entitled *The Antiquities of York Minster* may be consulted in the York Minster Library. It is through Torre and references in the wills of John de Gisburgh in 1479 and Robert Este in 1493 that we are able, for example, to locate rather exactly the image of the Blessed Virgin which the *Fabric Rolls* tell us was placed within a tabernacle on "the parclose before the Altar of St. Stephen" in York Minster. The tombs in the North Aisle of the Choir are carefully marked and described in Torre's manuscript.

The lost image of the Virgin associated with the Altar of St. Stephen in York Minster brings to mind the question of the usefulness of listing all such items in subject lists. Images of the Virgin are ubiquitous, though of course extant examples are of considerable importance in many ways and *must* be listed. However, in the case of lost examples, only the most important clearly deserve to be included in the subject lists. No purpose will normally be served by noting the presence of an image that is already known to be everywhere present. The same may be said about images of the Madonna and Child and about the figures shown in the carved roods of churches during the period before the Reformation.

Manuscript illuminations often tended, of course, to be part of a more aristocratic tradition than many of the arts noted above, and in some instances may seem at first to be less valuable for purposes of throwing light on early drama. The work of such a master as the Flemish Herman Scheerre, from whose workshop came some of the finest book illumination of the early fifteenth century, included examples produced for patrons in various parts of the country. The taste for the work of this painter may be traced, for example, in the region of York, where affluent patrons must have admired his style enough to order books produced in his shop. In any case, books of devotion stylistically associated with Herman Scheerre have survived with uniquely Northern saints illustrated or noted in the Calendar.[7] The emotionalism implied by Scheerre's handling of the religious image therefore is an important indicator of religious feeling at the top of the social scale, and we will recall that emotionalism was indeed characteristic of civic piety as well during the late medieval period. The merchants of York and London had particularly close ties with

the Low Countries, especially with Antwerp which was a con-
venient center of trade during the fifteenth and early six-
teenth centuries. Flemish modes of spirituality and art hence
were singularly influential, and illuminations by Flemish
artists both abroad and in England must have commonly shaped
regional designs by local artists. Certainly the individuality
which Flemish art taught is reflected in the faces of the
figures in the Great East Window of York Minster which John
Thornton of Coventry created in 1405-08.

Locally produced manuscripts, of course, must have been
less expensive, and we know that they often were a good deal
less stylish. However, these too could be extremely beautiful
books. The York Minster Library possesses two fine books of
hours which were illuminated in or near York about 1420, and
these contain within them a remarkable number of figures and
scenes that serve to chart the episodes in the religious story
most emotionally resonant to the residents of that region at
that time. The researcher will do well to check out local
cathedral libraries and other regional holdings that might
yield such important examples of early art which would be
appropriately utilized for examples to be included in his
subject list.

Systematic location of manuscripts according to region can
be extremely difficult, in part because the origin and early
ownership of many items have not been sufficiently analyzed
and listed. Often there is a degree of mystery about a manu-
script, as in the case of the famous *Holkham Bible Picture Book*
which, though it likely is East Anglian, has been also claimed
for London.[8] Nevertheless, if all the major British libraries
had catalogues of the kind prepared by Pächt and Alexander for
the Bodleian Library at Oxford, the researcher's work would be
comparatively easy. Volume III of this catalogue provides a
listing and description of all the English illuminated manu-
scripts in the library, with plates showing some of the more
important illuminations. Some of the older catalogues, such
as the ones prepared by M.R. James for the Fitzwilliam Museum
(1895) and the Lambeth Palace Library (1932), also provide the
kind of careful description that is needed. But the task of
handling the catalogues of the manuscript holdings of the
British Library alone is formidable, while the sheer number of
smaller libraries is intimidating, to say nothing of the
possibility that some important regional manuscripts might have
strayed from the country. The listing that appears in
Medieval Libraries of Great Britain, ed. N. R. Ker (2nd ed.,
1964) is useful, along with the same scholar's *Medieval Manu-
scripts in British Libraries*, Vol. I, which currently only
covers London. Fortunately, Vols. II and III, covering Aber-

deen-Liverpool and Maidstone-York, are forthcoming. Nevertheless, the researcher must always be alert to potential sources of further information; he must be willing to spend considerable time examining individual library catalogues and periodical articles which might possibly be relevant to his work.

Printed books of devotions and liturgical books from the period before the Reformation are somewhat more easily handled, since these can be often conveniently located in the *Short-Title Catalogue of English Books 1475-1640* compiled by Pollard and Redgrave. Books illustrated by woodcuts can be located and studied either in appropriate libraries or by means of microfilm. The woodcuts are, of course, often crude, and in many cases were supplied by foreign printers contracted to print liturgical or devotional books in Latin for use in England. A Sarum Breviary with extensive woodcuts, sometimes showing very interesting features of iconography (STC 15830), was, for example produced at Paris in 1531. Since the Use of Sarum was very widely followed in England, such a book would likely have received broad circulation in a number of dioceses. But other examples of these foreign service books would have been much more restricted in their circulation, as would have been the case with the 1533 York Missal (STC 16224), also printed at Paris by one of the two printers who had recently been involved with the production of the Sarum Breviary noted above. This York Missal will be found to contain an extensive series of Minstry woodcuts, showing illustrations of such scenes as the Marriage at Cana, Jesus and the Samaritan woman at the well, Our Lord driving moneychangers from the Temple, Mary Magdalene anointing the feet of Jesus in the house of Simon, etc. These woodcuts, in spite of their foreign source, must not be neglected, for they may be important with regard to visualizing some of the scenes from the York cycle plays, though of course they must be used with caution by the critic.

At the preparatory stage, the main office of *Early Drama, Art, and Music* will attempt to provide some further assistance to individual scholars. Several projects are in progress, including the development of a general holdings list for the smaller museums in England and a bibliography of their catalogues as well as other publications in the areas of interest to researchers working on subject lists.

III.
BEGINNING

The procedures described in the previous chapter are ones
that are naturally centered around libraries and ones that
utilize reference tools essential to the proper beginning of a
project focusing on a region. As soon as the groundwork has
been laid, however, the researcher must move to examination
of the works of art both as described in articles and books
or on location. The latter must, of course, be part of the
research since there is no substitute for physical examination
of the works of art being listed and described. If a less
complicated city or a smaller region is to be covered, there
will normally be no particular problem with finding all relevant
examples, but for a larger area such as a whole county other
methods of pinpointing subjects may be needed. Letters to
rectors and vicars of parishes can sometimes be quite effective
in helping to make arrangements for a visit or to inquire
about potential examples for the Subject List. Sometimes a
priest has been known generously to lend slides or photographs
by mail when such evidence is sorely needed by a scholar on
this side of the Atlantic.

The search for items must be carried on concurrently with
the examination and recording of examples as they are located.
Hence a visit to a church such as All Saints, Pavement, York,
in order to look over and photograph the painted glass formerly
in St. Saviour's in that city also brought to my attention a
thirteenth-century brass knocker with a hell mouth swallowing
a woman. The brass knocker is the kind of item that often fails
to turn up in lists or articles, and hence it is necessary to
be alert for such specimens of art everywhere. Church guides
should, when available, be consulted, since they will normally
mention items of this sort, though they are notoriously un-
reliable with regard to matters of dating, etc. Used criti-
cally, church guides, like museum guides, can be immensely
helpful.

The necessity of photographing as many examples of art
from a region cannot be too strongly urged. Even an item
improperly photographed (i.e., blurred through incorrect focusing
or dim because of inadequate light) can yield vital information
at the time of the preparation of a subject list. But a slide
or print of a work at its best will reveal details that were
not noticed on location, and hence photography is able to

increase immensely the efficiency of the researcher. The camera has become an essential tool, more valuable than pad and pencil even in the hands of the most skilled draughtsman. Of course, sketches, even by those of utterly no skill, are required for protection against the hazards of photography, and it is wise to copy by hand if possible the relevant passages of text in such examples as painted glass. Nevertheless, the camera's unfailing eye for detail cannot be matched, and preserves the work of art with precision not only for the immediate project but also for potential research in the future.[1]

In order to use photography effectively, the researcher needs to have mastered some rudimentary photographic skills and to have acquired a camera which will do what is needed. My preference is for a camera with a built-in spot meter as well as an averaging meter, since the former can be essential to gauging the brightness of a panel of painted glass. Glass, because light penetrates various parts of a window with different levels of intensity, can be extremely difficult to capture on film, as examination of the plates in almost any book on painted or "stained" glass will illustrate. Furthermore, some windows possess outer coverings of glass (or even sometimes plastic!) which cast shadows upon the design which the photographer wishes to capture. The steel rods which hold the panels of glass in place occasionally obscure portions of a window. Certain windows are capable of being photographed only at certain times of the day when the glare of the sun is subdued or when in other cases there is sufficient light to penetrate almost opaque glass. Faced with these difficulties, it is not possible to proceed with any confidence unless the photographer is able to gauge with exactness the light coming through each portion of a window, and this is most easily achieved with a spot meter.

Even with optimum equipment, the problems of obtaining a thoroughly satisfactory slide or print of a panel of painted glass may be insurmountable. Glass in a small church such as the parish church at Fairford may be fairly easy to photograph on the whole, but cathedral windows can prove extremely frustrating. The height of the windows and the conditions of light obtained in them may defeat several attempts to gain a satisfactory photograph. The Great East Window of York Minster, for example, presents serious difficulties, even with a telescopic lens. The panels, approximately two and one-half feet square, are very difficult to capture at the higher rows or the tracery. One row in this window is also obscured partly by stonework, which complicates the work of the viewer who would like to see the scenes illustrating the story of Moses, the death of Samson, David and Goliath, and the death of Absalom.

Wall paintings likewise present serious problems for the photographer, and again a spot meter will be found to be a necessity. Furthermore, glare, which occasionally will be found in glass, particularly when the sun is shining directly through the window, must also be scrupulously dealt with in the case of wall paintings. Restored wall paintings, such as the examples at St. Thomas, Salisbury, and Pickering, Yorkshire, can give the most trouble in this regard. A camera with a view-finder that gives the photographer a view through the lens is hence utterly essential if glare in such instances is to be dealt with successfully. A flash is absolutely never satisfactory with glass, and also should be used for wall paintings only in the event that no other options are available. A faint wall painting will not create a bright picture through the glare of a flash. Indeed, even in natural light the best procedure is to work carefully over the area to be photographed, taking the details of all the most significant features from the most advantageous positions. Naturally, wisdom dictates taking two or three shots at least of such details, and in each instance making adjustments in position and camera setting. The use of a stable camera stand will also greatly improve the quality of the pictures, and at times with both glass and wall paintings stability is of utmost importance. Satisfactory photos with a telephoto lens will never result without the use of such a stand.
Recommended camera equipment will include the following:

 Camera with spot and averaging meters, 35mm
 e.g., Mamiya/Sekor DTL 1000)
 1:2 Lens, 50mm
 1:2.8 Telephoto Lens, 135mm
 2x Tele-Converter
 1:6.3 Telephoto Lens, 400mm
 Wide Angle Lens
 Cable Release
 Electronic Flash Attachment
 Camera Stand

Two camera bodies are preferred so that two rolls of film of different kinds can be used simultaneously. The large tele-photo lens need not be of the expensive variety; a manually operated lens such as can be supplied by some mail order photographic equipment firms for under $100 will serve just as well as a higher priced lens if cost is a problem. Electronic flash is necessary since in precisely those cases when a flash is required the regulations are likely to prohibit flash bulbs. Such instances will include occasions in museums where photo-graphy is permitted, though stands and flash bulbs are prohib-

ited; as everyone who has visited such museums as the Victoria and Albert Museum will know, many exhibits do not have sufficient light even for the fastest film without the assistance of a stand. The best that sometimes can be done is to brace the camera as much as possible.

The use of a wide-angle lens will be found advisable in taking photographs where adequate distance from the object cannot be achieved. Details of panels in windows, for example, can usually be kept in reasonable order through careful notation at the time when the photo is taken. However, even combinations of sketches and carefully numbered lists of the items on each roll of film sometimes fail to prevent occasional confusion; hence a photo of the entire window, using the wide angle lens if necessary, will show the precise location of each panel within the whole. The same may be said, of course, of any larger work of art from which the photographer has taken a number of details. A tapestry hanging in a narrow hallway can demand a wide angle lens, as can a wall painting in an area which is narrow, such as a small chapel.

The kind of film which is used is, of course, vitally important. The most satisfactory all-around color film for slides is high-speed ektachrome, which provides sufficiently faithful color reproduction along with higher speed (ASA 160) needed in many cases. For work in a dimly-lit museum or church, however, high-speed ektachrome may be shot at ASA 400 if special processing is requested. GAF 500 (ASA 500) should also be considered.[2] Such film would produce slides of such items as roof bosses or other objects hidden away in darker areas, and in these cases color slides might be a distinct advantage, especially if the item involves remnants of the original paint and gilt. With regard to high-speed films, a warning is in order: any exposure to x-rays such as are used to examine personal belongings at airports should be avoided since they will cause clouding of the film. Hence exposure of this kind must be avoided, and manual inspection of containers containing such film should be requested.

With regard to black and white film, the most useful for the purposes of the kind of research with which we are concerned is perhaps Kodak Tri-X since it also is a fast film (ASA 400). This is, unless special care is taken in the processing of photographs, quite a coarse film, and when possible the photographer may wish to switch to a slower film such as Plus-X (ASA 125). When using black and white film, it is advisable to take four or even five exposures of each item. The negatives alone can be developed cheaply, and then the best examples may be chosen for printing.

The careful filing of all slides, photographs, and even

xerox prints should be an ongoing process as research proceeds. Slides can be conveniently arranged, normally by location, in trays which will hold up to 300 items and which are provided with index sheets that fit neatly inside the tray covers. It will not be necessary to work out anything but the most rudimentary arrangement schemes, since each slide will have a number which will be noted on the appropriate index cards. Needless to say, the trays will need to be numbered consecutively, beginning with *I* and continuing through any number of projects in which the investigator is involved.

Negatives may be filed either in special loose-leaf holders or in envelopes within regular filing folders in a file cabinet, as may large glossies if they are placed against stiff cardboard so that they will not be damaged. However, it may also be found convenient to make a small file of 4x5 inch photographs which can be keyed to the negatives so that further copies can be made if they are needed. Such a small file can easily be kept in small plastic or metal file boxes, appropriately labelled.

In the instances when photographs and slides have not been taken because permission to photograph is denied, black and white prints and slides can sometimes be obtained from other sources. For important examples in England, the National Monuments Record (Fortress House, 23 Saville Row, London) can sometimes provide assistance. At other times copies of photographs are available locally. Museums and libraries will normally arrange to supply the needed prints or slides, though the service is sometimes maddeningly slow--and expensive.

The researcher is advised that it is often wise to write in advance to locations which are to be visited so that permission to photograph may be obtained without delay. Furthermore, for buildings that are sometimes closed advance arrangements can be crucial.

Possession of a photograph does not, of course, imply the right to publish. Prints that might be used later as illustrations for a subject list or article will require permission of the appropriate person--the museum director, the rector or vicar, the dean of a cathedral, the librarian--before publication.

The listing of lost examples of art will necessitate an additional set of procedures above and beyond those described above. It is true that sometimes lost examples are described or illustrated in articles or books. For example, the oak roof bosses in York Minster were carefully drawn by John Browne before the fire of 1840 destroyed them, and these illustrations appear reproduced in the engravings in his book

The History of the Metropolitan Church of St. Peter, York (2 vols., 1847). E. W. Tristram in his *English Wall Paintings of the Fourteenth Century* describes what is known of the important wall paintings in St. Stephen's Chapel, Westminster, which were destroyed in the late eighteenth century. The periodical *Archaeologia* in 1892 carried Christopher Wordsworth's "Inventories of Plate, Vestments, &c., belonging to the Cathedral Church of the Blessed Mary at Lincoln." Such publications should be sought out at the start, and thereafter when published sources are not available the researcher may need to turn to archival material.

York fortunately has been the subject of considerable activity by scholars and antiquarians for more than a century, and hence such records as the Minster Fabric Rolls, various inventories, and many wills have been published. The Fabric Rolls are often disappointing, for from them we learn, for example, that the glass painter John de Burgh, who appears to have been made free of the city in 1376-77, and his helpers had been paid various amounts between 1399 and 1404, while the information presented fails to indicate whether or not he indeed was responsible for painting some of windows along the North Aisle of the Choir that were clearly completed about this time. At other times the Fabric Rolls indicate when repairs were made, but do not give any hint concerning new projects.

In many ways the wills for an area may be a richer source of information since they tend often, especially during the fifteenth and early sixteenth centuries, to take note of the images, usually sculpture of painted stone or wood. Margery Salvayn, for example, in 1496 requested that her body be laid to rest "in the north side of the church of the Gray Freres in the cite of York, affore the ymage of our Blissed Lady."[3] Upon other occasions, wills included bequests to cover the cost of one or more wax candles to burn before a particular image, the existence of which would not otherwise be known to us. Hence in 1390 John de Whettlay, a "wolman" of York, left money for a candle to burn for one year before the image of John the Baptist in the Church of St. Martin, Micklegate. In 1465, William Riche, a pewterer of York, left the sum of twenty shillings for the painting of the image of the blessed Virgin in the Choir of St. John, presumably in his parish church of St. Helen's. The will of Richard Russell, a merchant, in 1435 notes the location of several images in the Church of St. John the Baptist, Hungate, and an inventory in the will of John Clerke in 1449 provides a long list of examples of religious art. Angelo Raine's lists of images for York churches in his *Mediaeval York* are mainly taken from wills,

and, while not always complete, provide useful information
since his sources extend beyond published documents to unpub-
lished wills in the York Registry.

To the above may be added the church accounts and inven-
tories, particularly of the sixteenth century, which often
give fairly complete listings of religious objects and vest-
ments. The cathedral inventories, especially for York and
Lincoln, are, of course, the most complete, and provide evi-
dence of a remarkable range of religious art, all of it lost
during the century of the Reformation. Of the chalices listed
in connection with the cathedral in the York inventories, no
design seems more common than that which featured a crucifix
with Mary and John on the foot of the cup. Not one of these
is extant, though the Minster possesses earlier examples re-
covered from tombs of archbishops which illustrate the design
which must have been so popular.

Seventeenth and eighteenth century descriptions must also
not be neglected, and in the case of York two of the most im-
portant are the manuscripts of James Torre and Thomas Gent's
The Antient and Modern History of the Famous City of York
(1730). Torre's descriptions of the Minster glass, for exam-
ple, are annoying in the extreme, since he has an appalling
lack of understanding of iconography, yet they are unquestion-
ably important because he was describing the glass before the
centuries of decay that followed until more careful attention
would be paid to strict matters of design. Gent, a York
printer, was also not entirely reliable, but his lists of sub-
jects in such buildings as the Bedern Chapel and Christ Church,
King's Square, are nevertheless invaluable. These buildings
are now destroyed, and the glass itself has been lost for-
ever.

Work on the art of other cities and regions will not al-
ways be able to benefit from extensive published wills and
other documents such as are available at York. Unfortunately,
in some areas the records which the researcher will need to see
will themselves not even be as accessible as they ought to be.
Of course, the effort to locate and record lost items in the
subject lists must for each city or region be limited by what
can be found during the time at the researcher's disposal. No
absolutely complete list of lost items will be ever possible,
and the goal must be to provide information which is as com-
plete as possible within the restrictions of what is avail-
able. Some subjects, such as the Blessed Virgin or the Cru-
cifix, are ubiquitous and hence, as noted above, mere listings
of these are not of much value. But the investigation will
turn up many, many subjects that are of the highest importance.
When the work for the subject lists progresses sufficiently,

the mere possibility of obtaining statistics on the frequency
of the occurrence of particular images in various regions may
suggest crucial methods of approaching problems surrounding
the plays.

IV.
SUBJECT HEADINGS AND ABBREVIATIONS

At the very beginning of the project, the investigator
ought to begin making listings on subject cards which will
need to be organized according to the standard subject head-
ings that will be used throughout all of the subject lists for
Early Drama, Art, and Music. The necessity of using the stan-
dard headings will become obvious when plans for computer pro-
gramming are taken into account. The purpose of the standard
subject headings is to provide a measure of standardization
compatible with the topics dealt with in the plays and the
figures and episodes illustrated in existing and lost exam-
ples of medieval art.

Essentially the arrangement is more or less chronologi-
cal, beginning as the plays did with God the Creator of all
things and proceeding through the Fall and presentation of
other Old Testament examples. To be sure, a neatly schema-
tized reason for the selection of Old Testament topics in
drama has never been successfully argued. It is hence likely,
as Patrick J. Collins has suggested, that the plays merely
were placing on stage those scenes which previously had be-
come favorites in the programs of the visual arts.[1] Further-
more, these Old Testament topics also clearly focus upon the
condition of man in precise terms, and emphasize his separa-
tion from his source which is God. Without recourse to the
heavy typology which sometimes appears in art in such works as
the *Biblia Pauperum* or the *Speculum humanae salvationis*,[2] the
dramas thus open by setting forth the background of the work
of salvation which will be wrought by the Savior, who will be
the Second Adam appointed to repair the ruins of the Fall.
Thereafter, the emphasis will be upon the Infancy of the
Savior, including in many cases a considerable amount of mate-
rial from the story of his parents and even grandparents, and
upon the Passion, death, and Resurrection. The culmination of
the history which is thus the focus of the plays and of the
art will be, of course, Judgment Day, when Christ returns as
Judge to examine the souls of men against the test set forth
in *Matthew* 25--i.e., against the demands placed upon Chris-
tians by their understanding of the Corporal Acts of Mercy.
Those who have done the requisite charitable deeds will be ad-
mitted to the golden gate guarded by St. Peter, while those
who have been weighed (by St. Michael) and found wanting will
be taken off unwillingly to hell mouth.

The history of the human race between Pentecost and the Last Judgment is seen rather strictly in terms of the persons and acts of the saints, beginning with the apostles whose lives extend into the mission activities and the martyrdoms which terminate their witnessing in various parts of the world. Thus St. Thomas appears in sixteenth-century glass in St. Michael-le-Belfrey, York, with a spear and carpenter's square. The latter is a symbol of his later employment as carpenter for King Gundaphorus of India, while the spear is the sign of his martyrdom in that country. Sometimes the apostles are arranged in a program which is aligned with the various sections of the Apostles' Creed (see Chapter IX, below), and the researcher needs to be on the lookout for this important subject heading which will require separate listing.

Saints are often illustrated in art as separate figures with their symbols--rather undramatic representations. Yet even when their stories are not given the treatment of pictorial narrative in art, their costume, appearance, and iconography indeed, as noted above in Chapter I, can be very important for the potential light these may throw on the saints' plays of the period.

More elaborate representations of the individual saints are, as might be expected, extremely common, and hence we should look for series which illustrate the lives of a particularly popular figure. St. Thomas of Canterbury, as England's most popular saint, receives extended illustration in a series of painted glass panels which probably were originally designed for the windows of St. Wilfrid's Church in York. St. Wilfrid's was closed in the sixteenth century, and some of the panels thereafter appeared in a window in St. Michael-le-Belfrey, the parish which was united with St. Wilfrid's in 1585, while others were inserted in the windows of the Chapter House of the Minster. The extant glass includes matter from the *Golden Legend* which tells the story of the parents of the saint. Their fond farewell and subsequent reunion and marriage in the glass of St. Michael-le-Belfrey was only identified correctly with regard to its subject matter in 1963. Other popular saints who receive very full treatment in painted glass and other arts are St. Cuthbert, St. William of York, St. Edmund, St. Catherine of Alexandria, and St. Martin of Tours, but many further examples of such thorough illustration of a saint's exploits also remain.

It is expected that the following list of subject headings will be carefully adhered to. The number before each heading is its computer code.

(001000) CREATOR
(002000) ANGELS
(003000) FALL OF LUCIFER
(004000) DEMONS
(005000) CREATION
(006000) FALL
(007000) EXPULSION
(008000) CAIN & ABEL
(009000) ENOCH
(010000) DEATH OF LAMECH
(011000) NOAH
(012000) TOWER OF BABEL
(013000) ABRAHAM
(014000) JACOB
(015000) MOSES & EXODUS FROM EGYPT
(016000) PATRIARCHS
(017000) PROPHETS
(018000) BALAAM
(019000) JOB
(020000) SAMSON
(021000) JUDITH & HOLOFERNES
(022000) KING DAVID
(023000) SOLOMON
(024000) OTHER OLD TESTAMENT SUBJECTS
(025000) JESSE TREE
(026000) PARENTS OF BVM
(027000) ST ANNE & BVM
(028000) OTHER MEMBERS OF HOLY FAMILY
(029000) BVM
(030000) MARRIAGE OF JOSEPH & BVM
(031000) PARLIAMENT OF HEAVEN
(032000) ANNUNCIATION
(033000) VISITATION
(034000) ST ELIZABETH
(035000) JOSEPH'S VISION
(036000) TRIAL OF JOSEPH & MARY
(037000) NATIVITY
(038000) BVM & CHILD
(039000) BVM, YOUNG JESUS, & HER PARENTS
(040000) ANGEL APPEARING TO SHEPHERDS
(041000) ADORATION OF SHEPHERDS
(042000) JOURNEY OF MAGI & THEIR ARRIVAL AT HEROD'S
 COURT
(043000) ADORATION OF MAGI
(044000) PURIFICATION OF BVM
(045000) FLIGHT TO EGYPT
(046000) MASSACRE OF INNOCENTS

```
(047000)   DEATH OF HEROD
(048000)   CHRIST IN TEMPLE
(049000)   JOHN THE BAPTIST
(050000)   AGNUS DEI
(051000)   BAPTISM OF CHRIST
(052000)   TEMPTATION OF CHRIST
(053000)   TRANSFIGURATION
(054000)   MINISTRY
(055000)   ENTRY INTO JERUSALEM
(056000)   CONSPIRACY
(057000)   JESUS WASHING FEET OF DISCIPLES
(058000)   AGONY IN GARDEN
(059000)   BETRAYAL
(060000)   CHRIST BEFORE HIGH PRIESTS
(061000)   BUFFETING
(062000)   CHRIST BEFORE HEROD
(063000)   CHRIST BEFORE PILATE
(064000)   PROCULA'S DREAM
(065000)   SCOURGING
(066000)   MOCKING
(067000)   ECCE HOMO
(068000)   PETER'S DENIAL
(069000)   DEATH OF JUDAS
(070000)   CHRIST CARRYING CROSS
(071000)   VERNICLE
(072000)   PLACING CHRIST ON CROSS
(073000)   PASSION
(074000)   SIGNS OF PASSION & 5 WOUNDS
(075000)   JESUS
(076000)   CRUCIFIXION
(077000)   CASTING OF LOTS
(078000)   DEPOSITION
(079000)   OUR LADY OF PITY
(080000)   IMAGE OF PITY
(081000)   CORPUS CHRISTI
(082000)   BURIAL
(083000)   HARROWING OF HELL
(084000)   EASTER SEPULCHRE
(085000)   RESURRECTION
(086000)   ANGEL & 3 WOMEN AT TOMB
(087000)   APPEARANCE TO BVM
(088000)   APPEARANCE TO MARY MAGDALENE (HORTULANUS)
(089000)   APPEARANCE TO ST PETER
(090000)   ROAD TO EMMAUS & SUPPER AT EMMAUS
(091000)   APPEARANCE TO 11 APOSTLES
(092000)   INCREDULITY OF ST THOMAS
(093000)   ASCENSION
```

(094000) PENTECOST
(095000) DEATH OF BVM
(096000) FUNERAL PROCESSION & BURIAL OF BVM
(097000) ASSUMPTION OF BVM
(098000) CORONATION OF BVM
(099000) SOULS OF DEPARTED
(100000) GOOD SHEPHERD
(101000) CHRIST IN MAJESTY
(102000) ANTI-CHRIST
(103000) 15 SIGNS OF DOOMSDAY
(104000) JUDGMENT DAY
(105000) CORPORAL ACTS OF MERCY
(106000) ST MICHAEL
(107000) TE DEUM
(108000) TRINITY (WITH CHRIST ON CROSS, ETC.)
(109000) OTHER NEW TESTAMENT
(110000) CREED
(111000) APOSTLES (As a group, & individual listings)
(112000) SAINTS (Individual listings)
(113000) 7 SACRAMENTS
(114000) ALLEGORICAL SUBJECTS
(115000) MISCELLANEOUS

The above list of subject headings will provide the categories for filing the subject cards (see Chapter V, below), while the numbers in parentheses before each heading (the computer code) will be for office use only and will not appear in the published lists. Needless to say, each city or region will be expected to lack examples of subjects in some categories.

The abbreviations and computer codes for the medium are presented below, and these too will remain standard for all the subject lists:

(01) al alabaster carving
(02) ESp Easter Sepulchre
(03) em embroidery
(04) im image
(05) iv ivory carving
(06) j jewelry
(07) msi manuscript illumination
(08) pc painted cloth
(09) pg painted glass
(10) rb roof boss
(11) sc sculpture
(12) tp tapestry
(13) wdcarv woodcarving
(14) wdcut woodcut

(15)	wp	wall painting
(16)	v	vestments

An asterisk following the identification of medium will denote a lost or destroyed work. Hence the window formerly illustrating the Last Judgment in Christ Church, King's Square, York, will be designated as *pg**.

Some symbols for locations which are being used in the York volume of the Reference Series of *Early Drama, Art, and Music* will need to be continued in subsequent volumes; these and others are included in the following list, which also provides the computer code for major areas:

(100100)	B	Bath
(100200)	Bd	Bedfordshire
(100300)	Bk	Berkshire
(100400)	Bv	Beverley
(100500)	Bl	Bristol
(100600)	Bu	Buckinghamshire
(100700)	C	Cambridge
(100800)	Cs	Cambridgeshire
(100900)	Ct	Canterbury
(101000)	Cs	Cheshire
(101100)	Ch	Chester
(101200)	Co	Cornwall
(101300)	Cv	Coventry
(101400)	Cu	Cumberland
(101500)	Db	Derbyshire
(101600)	Dv	Devonshire
(101700)	Do	Dorset
(101800)	D	Durham (city)
(101900)	Du	Durham (county)
(102000)	Es	Exeter
(102100)	E	Fairford
(102200)	F	Gloucester
(102300)	G	Gloucester
(102400)	Gs	Gloucestershire
(102500)	GM	Great Malvern
(102600)	Ha	Hampshire
(102700)	H	Hereford
(102800)	He	Herefordshire
(102900)	Ht	Hertfordshire
(103000)	Hl	Hull
(103100)	Hu	Huntingtonshire
(103200)	K	Kent
(103300)	La	Lancashire
(103400)	Le	Leicester

(103500)	Lr	Leicestershire
(103600)	Lc	Lichfield
(103700)	Li	Lincoln
(103800)	Ls	Lincolnshire
(103900)	Lo	London
(104000)	NT	Newcastle-upon-Tyne
(104100)	No	Norfolk
(104200)	Nt	Northumberland
(104300)	N	Norwich
(104400)	Ng	Nottingham
(104500)	Ns	Nottinghamshire
(104600)	O	Oxford
(104700)	Os	Oxfordshire
(104800)	P	Peterborough
(104900)	R	Rutland
(105000)	SA	St. Albans
(105100)	S	Salisbury
(105200)	Sh	Shropshire
(105300)	So	Somerset
(105400)	St	Staffordshire
(105500)	Sf	Suffolk
(105600)	Sr	Surrey
(105700)	Sx	Sussex
(105800)	Wk	Wakefield
(105900)	W	Warwick
(106000)	Ws	Warwickshire
(106100)	We	Wells
(106200)	Wt	Westmoreland
(106300)	Wl	Wiltshire
(106400)	Wn	Winchester
(106500)	Wo	Worcester
(106600)	Wr	Worcestershire
(106700)	Y	York
(106800)	Ys	Yorkshire
(107000)	STL	Scotland
(107500)	WLS	Wales
(200000)	BL	Belgium
(300000)	FR	France
(400000)	GR	Germany
(500000)	HO	Holland
(600000)	IT	Italy
(700000)	SC	Scandinavia
(800000)	USC	U.S. and Canada
(900000)	OR	Other

Locations within the areas listed above (e.g., towns or cities

within counties; churches, guildhalls, cathedrals within cities, etc.) will need to be assigned code abbreviations consistent with the abbreviations utilized in the York volume. Hence, for example, a church dedicated to St. Nicholas, wherever it might occur, will always carry the abbreviation *StNic*. The Computer code for such locations will be assigned in the EDAM office and will utilize the last two digits of the number. For convenience, investigators should adopt two further kinds of abbreviations, one which allows them to use shortened forms for the dozen most common given names (Chas, Edw, Eliz, Geo, Jn, Jos, Js, Nich, Rich, Robt, Tho, and Wm) and the other which provides code symbols for items in the bibliography to which reference will be made within the subject list. When the subject lists are published, they will appear in a form as condensed as possible, eliminating the articles *a, an, the.*

The bibliography itself will contain standard abbreviations for various journals, including the following:

Ant	*The Antiquary*
AntJ	*Antiquaries Journal*
Arch	*Archaeologia*
ArchA	*Archaeologia Aeliana*
ArchCt	*Archaeologia Cantiana*
ArchJ	*Archaeological Journal*
AB	*Art Bulletin*
BlGsArch	*Bristol and Gloucestershire Archaeological Society*
BSMG-PJ	*British Society of Master Glass-Painters Journal*
BurlM	*Burlington Magazine*
ChmS	*Chetham Society*
CompD	*Comparative Drama*
EsR	*Essex Review*
GdesB-A	*Gazette des Beaux-Arts*
JBAA	*Journal of the British Archaeological Association*
JRIBA	*Journal of the Royal Institute of British Architects*
LaCsAnt	*Lancashire and Cheshire Antiquarian Society*
MP	*Modern Philology*
NoArch	*Norfolk Archaeology*
PTS	*Publications of the Thoroton Society*
N&Q	*Notes and Queries*
SxArch	*Sussex Archaeological Collection*
TrBAS	*Transactions of the Birmingham Archaeological Society*
TrHSLaCs	*Transactions of the Historic Society of Lancashire and Cheshire*
WlArch	*Wiltshire Archaeology and Natural History*

	Magazine
YsAJ	*Yorkshire Archaeological Journal*

The above examples are not, of course, a complete listing.

V.
THE CARD FILES

The main card file will of necessity be the subject listing on 4x5 inch cards which are arranged according to subject. On these cards the following information should be given for each subject:

1. The Subject (in upper left-hand corner).
2. A notation of location of slides in slide trays and of black and white prints on file (in upper right-hand corner).
3. Medium (i.e., painted glass, woodcarving, etc.).
4. Location of work.
5. Previous location of the work, if it has been moved; or origin, if different from present location.
6. Name of artist, if known; otherwise, when a local school is not the source, indicate stylistic characteristics.
7. Date.
8. Brief description of the item, including comment whenever relevant and available on its condition.
9. Bibliography.

It will be from these cards that the subject lists will be set up; hence it is important to provide meticulously accurate information at this point.

On smaller note cards (3x5), a location index (cross indexed, of course, to the subject cards) will insure that all important items in each window or church or museum have been properly listed. These cards should contain merely the following information:

1. Location and medium.
2. Cross index information in case another location is to be indicated (e.g., when an item has been moved from one building to another).
3. Subject.
4. Reference number. (Once assigned, this

Plate I

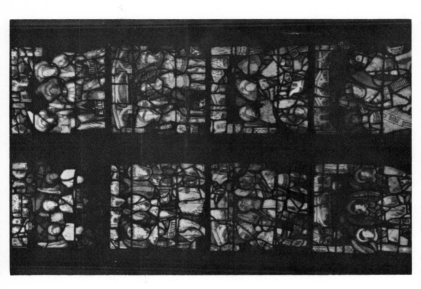

Ex. B. Eight of Nine Orders of Angels, painted glass in St. Michael, Spurriergate, York. Code: Y-StMi-S-1.

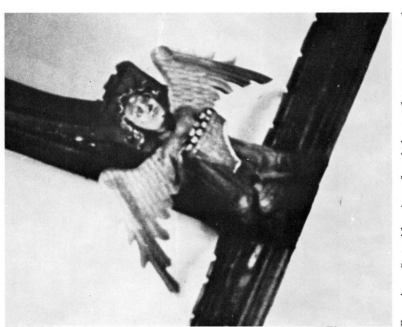

Ex. A. Detail: Angel with psaltery, carved hammer beams in All Saints, North Street, York. Code: Y-ASts-No-r.

Plate II

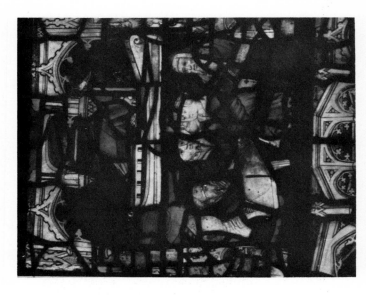

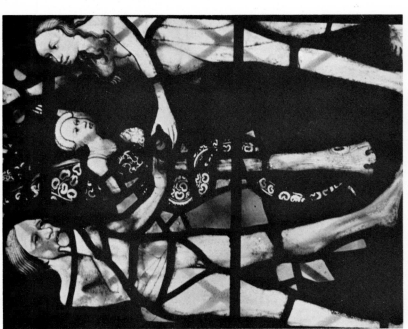

Ex. C. Fall of Man, York Minster Choir, Great East Window. Code: Y-YMC-84I8.

Ex. D. The ark in background, with Noah and his family at work. Painted glass; St. Michael, Spurriergate, York. Code: Y-StMi-S-3.

Plate III

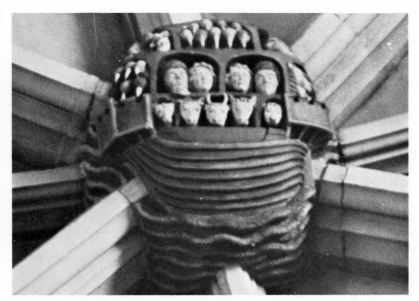

Ex. E. The Ark. Roof boss in the nave of Norwich Cathedral.
Code: N-NCN-rb-2.

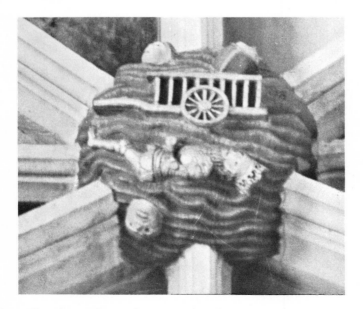

Ex. F. The drowning of the Egyptian army in the Red Sea.
Roof boss in the nave of Norwich Cathedral. Code:
N-NCN-rb-6.

Plate IV

Ex. H. Annunciation. Painted glass in the nave of York Minster. Code: Y-YMN-32.

Ex. G. David harping. Detail from painted glass in St. Michael, Spurriergate, York. Code: Y-StMi-S-2

Plate V

Ex. I. Detail of Annunciation with Crucifix on Lily. York
Minster Choir, Bowet Window. Code: Y-YMC-8.

Ex. J. Nativity. Painted glass in Great Malvern Priory
Church. Code: Wr-GM-10.

Plate VI

Ex. L. Christ before Pilate. Roof boss in the Nave of Norwich Cathedral. Code: N-NCN-rb-11.

Ex. K. The Last Supper. Painted glass in the choir of York Minster. Code: Y-YMC-3.

Plate VII

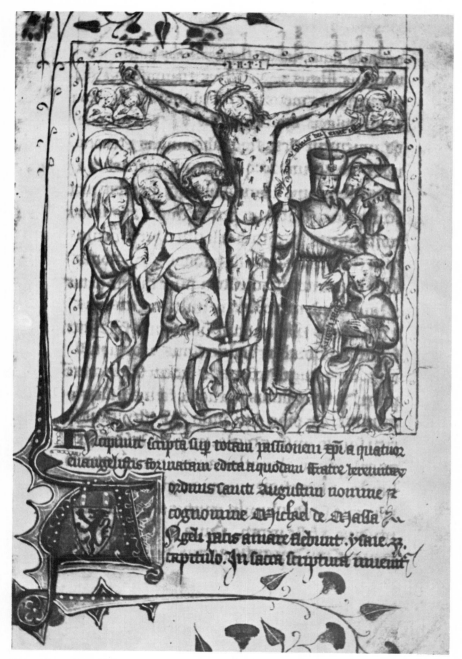

Ex. M. Crucifixion. Manuscript illumination in Bodley MS. 758. Code: O-BodL-MS-Bod758.

Plate VIII

Ex. O. The Harrowing of Hell. Wall Painting at Pickering, Yorkshire. Code: Ys-Pic-wp.

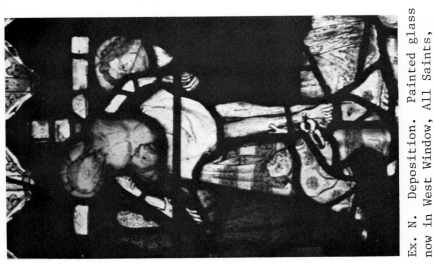

Ex. N. Deposition. Painted glass now in West Window, All Saints, Pavement, York. Code: Y-ASts-P-W.

Plate IX

Ex. Q. The Supper at Emmaus. Painted glass at Fairford, Gloucestershire. Code: Gs-F-8.

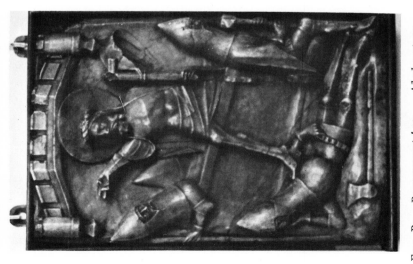

Ex. P. Resurrection. Alabaster probably from Nottingham, now at Bruges. Code: Bel-Bruges-G-al.

Plate X

Ex. S. Pentecost. Engraving from the drawing by John Browne of oak roof boss in York Minster. The original was destroyed by fire in 1840. Code:Y-YMN-rb6*.

Ex. R. Ascension. Painted glass in the West Window of All Saints, Pavement, York. Code: Y-ASts-P-W.

Plate XI

Ex. T. Details from Corporal Acts of Mercy: Visiting Prisoners
and Caring for the Sick. Painted glass in All Saints, North
Street, York (Corporal Acts of Mercy Window). Code:
Y-ASts-No-4.

Plate XII

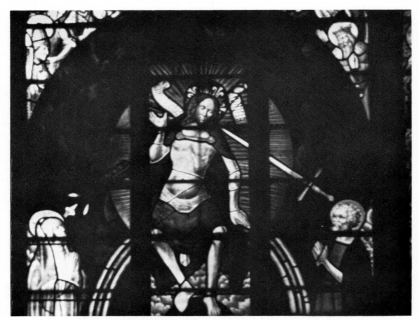

Ex. U. Last Judgment (detail). Painted glass in the West Window of the church at Fairford, Gloucestershire. Code: Gs-F-W.

Ex. V. St. Peter. Painted glass in Pilgrimage Window in York Minster. Code: Y-YMN-40.

Ex. W. St. Peter. Flemish style painted glass in the south transept of York Minster. Code: Y-YMT-S-71.

Plate XIII

Ex. Y. St. Edmund's Martyrdom. Wall painting at Pickering, Yorkshire. Code: Ys-Pic-wp.

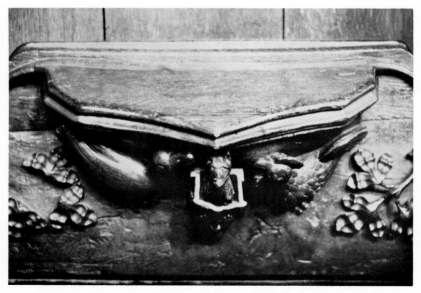

Ex. AA. The fox preaches to farm fowls. Misericord at Ripon Cathedral. Code: Ys-RiC-m.

Plate XIV

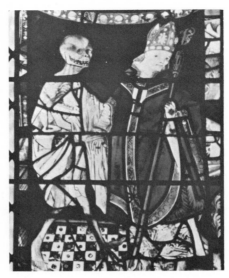

Death comes for the Bishop. Panel from Dance of Death Series.
Painted glass in St. Andrew's, Norwich. See p. 101.

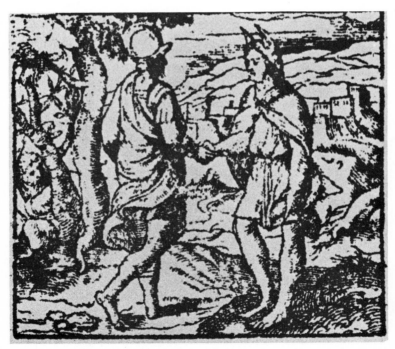

The danger from one whose malice is "secret" is worse than from
an "open" enemy. Emblem from Whitney, *A Choice of Emblemes*.
See pp. 126-27.

> number should also be written across the
> top of the subject card.)

The remainder of this chapter will be given over to
specimens of both subject cards and location index cards for
the examples illustrated. It will be noted that abbreviations
are here avoided to a large extent, though in the practical
task of preparing the cards some abbreviation will be helpful.
Nevertheless, the researcher should be advised that abbrevia-
tions often can tend to increase the potential for error.
For principles of condensation and form for the final subject
lists, the investigator is advised to compare the entries for
York art below with the published entries for the same items
in the York volume. Of course, York is not the only location
represented among the specimens below, which covers a number
of areas in England. Notations indicating location of slides
and photographs are strictly to the author's own private
collection. References to bibliography items are abbreviated
and refer to the complete listings in the bibliography at the
end of this book.

EXAMPLE A

```
All Saints, North Street, York:
hammer beams, wdcarv.

Angels

Ref: Y-ASts-No-r
```

→ Location Card ←

↓ Subject Card

Angels Y-ASts-No-r B&W File: 10-1975

Woodcarvings on hammer beams, All Saints, North Street,
York. Roof was probably designed by John Foulford.

c.1470

 Angel musicians and angels holding emblems. Not in
very good condition; very dark, having apparently been
scraped to the wood and stained in 19th century.

Bibliography:
Harvey, *English Medieval Architects*, p. 108.
Morrell, *Woodwork in York*, pp. 92, 94, fig. 92.
Shaw, *An Old York Church*, pp. 18-20.
York Historical Monuments, III, 96-97, Pl. 43.
Note: Identifications of some of the musical
instruments in Shaw are incorrect.

Comment: Although angels are ubiquitous and cannot be listed in
all instances, these angel musicians are very much worth noting,
for they provide unique examples of the carver's art in York in
the later 15th century. Since we know that small puppet angels
were utilized at least in the Doomsday pageant of 1433 (see
Johnston and Dorrell, "The Doomsday Pageant of the York Mercers,
1433," pp. 29-34), these examples are of particular importance.
Unfortunately, they are difficult to see and, particularly
because of their condition, will require careful study in
order to assess their full significance. Angels in English
art are discussed by Woodforde, *English Stained and Painted
Glass*, pp. 128-48. On angel musicians, see Prideaux, "The
Carvings of Mediaeval Musical Instruments in Exeter Cathedral
Church." A convenient rudimentary guide to musical instruments
appears in Brown and Lascelle, *Musical Iconography*, pp. 63-84.

EXAMPLE B

St. Michael, Spurriergate, York:
1st Win from East, South Aisle, pg.

Angels

Ref: Y-StMi-S-1

| Angels: | Y-StMi-S-1 | Slides: III.5A, V.E.8-11, V.E.17A |

Nine Orders of Angels

Painted glass, St. Michael, Spurriergate, York,
1st Win from East, South Aisle.

15th century

Eight of nine orders of angels. The various orders
have been identified, and standard symbols appear:
Cherubin carry book, Thrones possess pair of balances,
etc. Armor is worn by Principalities and Dominations.
Wings are white or gold, feathered coats are white.
Compare Nine Orders at New College, Oxford, and
Beauchamp Chapel, Warwick.

Bibliography:
Harrison, *Painted Glass of York*, pp. 168-70.
Gibson, *Stained and Painted Glass of York*, p. 201.
Anderson, *Imagery of British Churches*, p. 138.

Comment: The nine orders of angels, to which reference is
made in the opening play of the York cycle, are variously
depicted; the freedom which the artists enjoyed in depicting
the orders hence often creates some problems with regard to
identification, as in the case of the examples in the tracery
of the St. Martin Window at St. Martin, Coney Street, York.
Nevertheless, the provison of standard symbols in the St.
Michael, Spurriergate glass is indicative of a long tradition
which clearly must have affected dramatic representations.
Still useful for its discussion of the angelic orders is
Mrs. Jameson's *Sacred and Legendary Art*, I, 41-94.

46

EXAMPLE C

York Minster Choir: Great East
Win (Win 84), Row I, No 8, pg.

The Fall

Ref: Y-YMC-84I8

Fall Y-YMC-84I8 Slides: I.91, VI.B.5

Painted glass, York Minster Choir, Great East Win
(Win 84), Row I, No. 8.

By John Thornton

1405-08

The serpent's head and the heads of Adam and Eve are
in good condition, but serpent's wings and body are
lost (reconstructed from pieces of black and white
damask). Serpent's face appears to be that of a
woman. See Torre's description (p. 71): "a serpent
twisted about a great Tree like a fair Woman wth his
face toward Eve who is wth one hand reaching to take
an Apple from the Tree. . . ." Adam and Eve are nude.

Bibliography:
Friends of York Minster: Annual Report, 19 (1947), 28-29.
Gibson, *Stained and Painted Glass of York*, pp. 115-19.

Comment: The condition of this panel is reported in the annual
report of the Minster by Dean Eric Milner-White, who provided
some information about the state of the York glass during
the post-war restoration until his death in 1963. On the
iconography of this subject, see especially Bonnell, "The
Serpent with a Human Head in Art and in Mystery Play."

EXAMPLE D

St. Michael, Spurriergate, York:
3rd Win from East, South Aisle, pg.

Noah (building ark)

Ref: Y-StMi-S-3

| Noah: | Y-StMi-S-3 | Slide: V.E.14A |
| Building the Ark | | B&W File: 16-1974 |

Painted glass, St. Michael, Spurriergate, York, 3rd
Win from East, South Aisle.

15th century

Panel shows Noah and his family, with ark under
construction in background. Hull of ark is of
contemporary 15th-century style.

Bibliography:
Gibson, *Stained and Painted Glass of York*, pp. 201-02

Comment: Since the hull of the ark in the panel in the Great
East Window by John Thornton in the Minster is lost (the hull
is replaced with 14th-century scraps), the ark in this window
is particularly useful as a late medieval visualization of
the vessel. The glass in the St. Michael, Spurriergate window
appears to contain a large ship such as must have sailed be-
tween York or other Northern ports and the continent. The
construction of such ships was, of course, intimately known
to the Mariners, Fishers, and Shipwrights who produced the
plays concerning Noah in the York cycle.

48

EXAMPLE E

Norwich Cathedral Nave, rb.

Noah (in ark)

Ref: N-NCN-rb-2

Noah: N-NCN-rb-2 B&W File: 1A-1974
Noah, his family, and animals in ark

Roof boss, Norwich Cathedral Nave.

c.1470

Stylized hull in stylized water, with three-level super-
structure open to show passengers in ark. Noah and his
family are on the second level.

Bibliography:
Cave, *Roof Bosses in Medieval Churches*, fig. 150.

Comment: The traditional three-level ark is here adapted in
the Norwich boss, though there is no attempt to apply rigorously
the symbolism set forth by Gregory the Great. Cf. Rushforth,
Medieval Christian Imagery, p. 161. The Norwich boss never-
theless makes clear the fact that late medieval art had not
rejected entirely the earlier iconography, which continued to
inform religious art until the Reformation. See also Davidson,
"After the Fall: Design in the Old Testament Plays in the York
Cycle," pp. 10-12.

EXAMPLE F

Norwich Cathedral Nave, rb.

Moses and Exodus from Egypt
(drowning of Egyptian army in
Red Sea)

Ref: N-NCN-rb-6

Moses and Exodus from Egypt: N-NCN-rb-6 B&W File:
Drowning of Egyptian Army in Red Sea 1A-1974

Roof boss, Norwich Cathedral Nave.

c.1470

Stylized waves with Pharaoh's chariot represented as a
cart on its side in the sea. Pharaoh appears below the
cart as crowned figure in plate armor. Heads of other
drowning soldiers are visible.

Bibliography:
Cave, *Roof Bosses in Medieval Churches*, Fig. 152.

Comment: The depiction of Pharaoh as a crowned king and of
his chariot as a cart of contemporary design is typical.
Pharaoh, who was regarded, of course, as an unsympathetic
tyrant, is depicted in art as akin to Herod.

50

EXAMPLE G

```
St. Michael, Spurriergate, York:
2nd Win from East, South Aisle, pg.

Jesse Tree (figure of David with harp)

Ref: Y-StMi-S-2
```

```
Jesse Tree:      Y-StMi-S-2      Slide: III.5
David harping                    B&W File: 16-1974

Painted glass, St. Michael, Spurriergate, York,
2nd Win from East, South Aisle.

15th century

King David, crowned and holding scepter in right hand.
The harp, held with left hand, is placed across his
breast.  He appears bearded and wearing the cloak of
royalty.

Bibliography:
Gibson, Stained and Painted Glass of York, p. 201.
Benson, Ancient Painted Glass Windows in the Minster
     and Churches of the City of York, p. 17.
Knowles, "John Thornton of Coventry and the East Win-
     dow of Gt. Malvern Priory," pp. 279-81, Pl. XLII.
```

Comment: The harp held by King David here in this position
is clearly a symbolic rather than realistic detail, and
without doubt was designed as a foreshadowing of the Cruci-
fixion when Christ would be stretched out on the cross in
the same manner that the strings of the instrument are
stretched in order to create harmony--a harmony which, in
the case of Christ, overcomes the dissonance created by
the Fall. See especially Pickering, *Literature and Art in
the Middle Ages*, pp. 223-307.

EXAMPLE H

York Minster Nave: Win 32, pg.

Annunciation

Ref: Y-YMN-32

Annunciation Y-YMN-32 Slides: VI.B.24A,
 VII.A.12

Painted Glass, York Minster Nave, Win 32.

By "Artist B"

Mid-14th century

Excellent condition; taken from Chapter House in post-
war restoration and returned to its pre-1657 position
in Win 32. The work of this glass painter is marked
by heavy use of yellow stain. Angel at left, kneeling
before seated BVM, who is placed beneath a rounded arch.
Dove appears at upper right under arch.

Bibliography:
Friends of York Minster: Annual Report, 24 (1952), 21-24.
Milner-White, "The Resurrection of a Fourteenth-Century
 Window."

Comment: Technologically the use of silver stain to produce
yellow was an innovation of considerable importance in painted
glass. This panel illustrates the use of this new technique
and also provides a suggestion in glass of the brilliant effects
normally achieved in other media by the use of paint and gilt.
On the iconography of the Annunciation, see the article by Robb,
"The Iconography of the Annunciation in the Fourteenth and
Fifteenth Centuries."

52

EXAMPLE I

York Minster Choir: Win 8
(Bowet Win), pg.

Annunciation (with Crucifix
on Lily)

Ref: Y-YMC-8

| Annunciation Y-YMC-8 | Slides: VI.A.14A, VII.A. 10 |
| with Crucifix on Lily | B&W File: 14-1974 |

Painted glass, York Minster Choir, Win 8 (Bowet Win).

1423-32

Lily between Gabriel and BVM contains Crucifix. Gabriel
has rich, elaborate mantle and wings of peacock's
feathers. See Gibson, *Stained and Painted Glass of
York,* p. 132.

Bibliography:
Hildburgh, "An Alabaster Table of the Annunciation with
 the Crucifix: A Study in English Iconography."
Hildburgh, "Some Further Notes on the Crucifix on the
 Lily."

Comment: This panel shows a lily in the design between the
angel of the Annunciation and the Blessed Virgin, and on this
fairly common feature appears the symbolic Crucifix which
suggests a central point for Christ's earthly journey. Cf.
York Plays 12.84: "þe floure is Jesus." The centrality of the
passion and Crucifixion in the York cycle is also indicated
by the presence of the masterful revisions, designed to improve
this section of the cycle, by the York Realist. For late
medieval theology, the Crucifixion was already implicit in
the Annunciation.

EXAMPLE J

Great Malvern Priory: North Win
in North Transept
(Magnificat Win), pg.

Nativity

Ref: Wr-GM-10

Nativity Wr-GM-10 Slide: V.D.14

Painted glass, Great Malvern Priory Church, North Win
in North Transept (Magnificat Win; No. X)

1501-02

Very good condition. Mary, in mantle over blue kirtle,
kneels and adores Child in aureole on ground. Ox and
ass are behind; Joseph with his crutch is at right.
The scene is set in a ruined stable with walls of
wattles and with a ruinous thatched roof.

Bibliography:
Rushforth, *Medieval Christian Imagery*, p. 379, fig. 173.
Hamand, *Ancient Windows of Gt. Malvern Priory Church*, ·
 p. 72.

Comment: The iconography in this example is that established
by the *Meditations on the Life of Christ* and the *Revelations*
of St. Bridget of Sweden. See Henrik Cornell, *The Iconography
of the Nativity of Christ*. These are the versions that inform
the York plays, as J. W. Robinson explains in his article,
"A Commentary on the York Play of the Birth of Jesus." An
earlier play, if we are to judge by Burton's *Ordo* of 1415,
followed earlier iconography. See Chapter IX, below.

EXAMPLE K

York Minster Choir: Win 3, pg.

Last Supper

Ref: Y-YMC-3

Last Supper Y-YMC-3 Slide: VII.B.25

Painted glass, York Minster Choir, Win 3.

1330-39

Glass is not in its original position in the Minster
and is older than this portion of the building; formerly
in South Choir Aisle.

Christ is in center giving blessing with right hand,
while with left he seems to exclude Judas, who is alone
in front of table. The other apostles are arranged on
each side of Jesus behind the table, which is covered
by a cloth. A ciborium filled with wafers and a chalice
are on the table.

Bibliography:
Gibson, *Stained and Painted Glass of York*, pp. 104-05.

Comment: Judas here is separated from the other apostles, as
is conventional. He is often represented as a thief (e.g.,
a panel at Great Malvern where he is represented hiding a fish
under the tablecloth). See Rushforth, *Medieval Christian
Imagery*, Pl. 13, pp. 61-63. In Byzantine tradition, Judas
must not look at the audience. See Anderson, *Imagery of
British Churches*, p. 116. The ciborium and chalice are
reminders that the Last Supper was the point at which the
Mass was instituted--a fact that obviously was very im-
portant for the plays.

EXAMPLE L

Norwich Cathedral Nave, rb.

Christ before Pilate
Ref
Ref: N-NCN-rb-11

Christ before Pilate N-NCN-rb-11 B&W File: 1A-1974

Roof Boss, Norwich Cathedral Nave.

c.1470

Christ, in gown of humility, appears at left, before
Pilate on right. Pilate is seated on throne with
canopy. Interrogation scene during trial. Repainted.

Bibliography:
Cave, *Roof Bosses in Medieval Churches*, p. 32.

Comment: The throne with canopy could easily be adapted for
use as a portable stage property, but this fact is no indica-
tion that the carver was modelling his work on what he had
seen in a play. The placement of figures around Christ in
this scene on the boss emphasizes the manner in which circum-
stances are closing in on him, and this may well have been
reflected in stage productions which show the humble Savior
confronted with the symbol of Roman authority in the region.

EXAMPLE M

Bodleian Library, Oxford,
MS. Bodley 758, fol. 1, msi.

Cross index: *from* Norfolk

Crucifixion

Ref: O-Bodl-MS-Bod758

Crucifixion O-BodL-MS-Bod758

Manuscript illumination, in Michael de Massa,
On the Passion of Our Lord, MS. Bodley 758, fol. 1.

1405

Christ on the cross, with holy women below at left.
BVM is weeping and swooning, and is being comforted
by St. John. Christ's wounds are very red and are
still bleeding; these wounds include not only the usual
five wounds but also lesions on all parts of his body
from the treatment he has received during his trial
and afterward.

Bibliography:
Pächt and Alexander, *Illuminated Manuscripts in the
 Bodleian Library, Oxford*, Vol. III, No. 794.
Saunders, *English Illumination*, I, 119.

Comment: Saunders (p. 119) suggests some Flemish influence,
and on the whole this miniature shares the emotional piety of
the Low Countries. It should be noted, however, that the
emotionalism, especially surrounding the Passion and Cruci-
fixion, was also a mark of English civic piety, of which
Margery Kempe represented an extreme form. See Davidson,
"Civic Concern and Iconography in the York Passion," and
Davidson, "Northern Spirituality and Late Medieval Drama."
The tendency in the late Middle Ages was to increase the
portrayal of pain and sorrow in the representations of the
Crucifixion.

EXAMPLE N

All Saints, Pavement, York:
West Win, pg.

Cross index: *formerly in*
St. Saviour's, York

Deposition

Ref: Y-ASts-P-W

Deposition Y-ASts-P-W Slide: VI.E.3A
 B&W File: 2A-1974

Painted glass, All Saints, Pavement, York, West Win;
formerly in St. Saviour's, York.

c.1370

The Blessed Virgin, in blue, holds Christ's right arm,
and St. John, on other side of the body, grasps his
left hand. Joseph of Arimathea holds the body itself,
while Nicodemus, below, pulls the nail out of the
feet with pincers.

Bibliography:
Gibson, *Stained and Painted Glass of York*, p. 172.
F. J. M., *All Saints, Pavement, York* (leaflet).
Harrison, *Painted Glass of York*, p. 157.

Comment: In the series of painted glass panels formerly in
St. Saviour's and now in All Saints, Pavement, York, the
placing of Christ on the cross is depicted *jacente cruce*
without ladders. Nor are ladders used for the illustration
of taking down the body from the cross. The Deposition as
shown here and in other late medieval examples was designed
to achieve a strong emotional response on the part of the
viewer. On the iconography, cf. Ratkowska, "The Iconography
of the Deposition without St. John."

EXAMPLE O

Pickering, Yorkshire: Nave, wp.

Harrowing of Hell

Ref: Ys-Pic-wp

Harrowing Ys-Pic-wp Slides: V.A.7-7A
 B&W File: 9-1974

Wall painting, Pickering, Yorkshire, South Wall of Nave.

Late 15th century; restored in 19th century

Jesus with his right hand grasps Adam, who holds out
apple to him. Behind are Eve and Patriarchs, all of
them emerging from great open hellmouth. In his left
hand Christ holds a cross-staff. A demon with a bird-
like head stands behind, helpless to prevent the nude
souls from leaving his kingdom of darkness. Streams
of light shine into the area of hell.

Bibliography:
Lightfoot, "Mural Paintings in St. Peter's Church,
 Pickering."

Comment: The apple, which is unchewed, is an emblem of the
cause of Adam's 4000 years of suffering, from which he is now
being rescued. The detail seems to be unique in iconography.
The manner in which Christ, holding a staff, grasps Adam's
forearm is, however, conventional, as is the remainder of
the illustration in the wall painting. In other examples,
such as the painted glass now in All Saints, Pavement, York,
the alabaster at Carcassone, and the glass at Great Malvern,
Christ has actually broken the *gates* of hell, which at
Malvern are shown having pinned a demon underneath.

EXAMPLE P

Bruges, Gruuthuse Museum, al.

Cross index: *possibly from* Nottingham

Resurrection

Ref: Bel-Bruges-G-al

Resurrection Bel-Bruges-G-al B&W File: 5-1975

Alabaster, Bruges, Gruuthuse Museum; possibly from Nottingham.

c.1400

Embattled canopy of late 14th-century style. Armor is also very late 14th century. The grave cloth is over Christ's right arm; he is dressed only in a loincloth and wears the crown of thorns. Holding the vexillum, he steps out of coffer tomb onto sleeping soldier. One of the four soldiers (the one at the left end of the tomb) looks up at Christ with amazement.

Bibliography:
Guide Gruuthuse, No. 307.
See *Illustrated Catalogue of the Exhibition of English Medieval Alabaster Work.*

Comment: The motif of Christ stepping onto a sleeping soldier is discussed by Hildburgh, "Note on Medieval Representations of the Resurrection of Our Lord." The Resurrection subject at Bruges is one of many extant continental examples of English alabasters, which are quite rare in England itself. See, however, similar alabasters showing this scene in the Victoria and Albert Museum (A.110-1946) and the British Museum.

EXAMPLE Q

Fairford Church, Corpus Christi
Chapel, 1st Win from East, pg.

Supper at Emmaus.

Ref: Gs-F-8

Emmaus: Gs-F-8 B&W File: 4A-1974
Supper at Emmaus

Painted glass, Fairford Church, 1st win from East in
Corpus Christi Chapel. (Window No. VIII.)

Flemish style.

c.1495-1500

Jesus, dressed as a pilgrim and seated at center behind
round table, blesses the bread; one apostle appears at
each side. On table is a dish with a bird and other
food and drink. Apostles are showing signs of surprise
at recognition that the stranger is indeed Christ. Head
of Christ is modern. Window above at right [not visible
in illustration accompanying this example] opens to
show the road over which the disciples and the Lord had
come to this chamber in Emmaus.

Bibliography:
Farmer, *Fairford Church and Its Windows*, p. 19.

Comment: Jesus originally may have worn a pilgrim's hat since,
as Farmer notes (p.19), he holds the traditional Pilgrim's
staff and is otherwise dressed as a pilgrim. The Flemish
style of the Fairford windows, which were probably completed
about 1500, represents the stylistic innovation introduced
by the foreign glass painters brought to England under Henry
VII.

EXAMPLE R

All Saints, Pavement, York:
West Win, pg.

Cross index: *formerly in* St.
Saviour's, York

Ascension

Ref: Y-ASts-P-W

Ascension Y-ASts-P-W Slide: III.3
 B&W File: 2A-1974
Painted glass, All Saints, Pavement, York, West Win;
formerly in St. Saviour's, York.

c.1370

Blessed Virgin at lower left, crowned, and apostles
watch the Savior disappearing into a cloud at top of
scene (under canopy). Only Christ's feet and bottom
of his robe are visible. Below his feet is the rock
from which he ascended, and upon it are the marks of
his feet.

Bibliography:
Gibson, *Stained and Painted Glass of York,* p. 172.
F. J. M., *All Saints, Pavement, York* (leaflet).
Harrison, *Painted Glass of York,* p. 158.

Comment: On the iconography of this scene, see especially
Meyer Schapiro, "The Image of the Disappearing Christ: The
Ascension in English Art around the Year 1000" and Hildburgh,
"English Alabaster Carvings as Records of Medieval English
Drama," pp. 63-65. The footprints on the rock also appear
in the *Speculum humanae salvationis;* see Wall, *Mediaeval
Wall Paintings,* p. 156.

62

EXAMPLE S

York Minster Nave: rb (destroyed 1840).

Pentecost

Ref: Y-YMN-rb6*

Pentecost Y-YMN-rb6* Destroyed

Roof Boss* (oak), York Minster Nave, destroyed by
fire in 1840; present boss is copy made from drawing
of original drawn by John Browne.

14th century

See John Browne, *History of the Metropolitan Church of
St. Peter, York*, I, 144, and Pl. CXVIII. Dove appeared
in center, with scroll-lines (no lettering) from its
mouth to mouth of each of a double circle of apostles
with Blessed Virgin.

Bibliography:
Cave, *Roof Bosses in Medieval Churches*, pp. 39, 222.

Comment: The plate illustrates Browne's careful drawing,
taken from scaffolding while York Minster was being repaired
following the fire of 1829. Cave (p. 39) notes the oddity
of the iconography of this boss, which presents an upside-down
dove, etc. On the iconography of Pentecost, see Fabre,
"L'Iconographie de la Pentecôte."

EXAMPLE T

All Saints, North Street, York:
2nd Win from East in North Aisle, pg.

Corporal Acts of Mercy

Ref: Y-ASts-No-4

Corporal Acts of Mercy Y-ASts-No-4 Slides: VI.E.15-17,
III.30-31A
B&W File: 2A-1974

Painted glass, All Saints, North Street, York, 2nd Win
from East in North Aisle. (Win IV.)

Almost certainly by John Thornton

1410-35

Excellent glass. Burial of Dead is missing, but this
is not mentioned in *Matthew* 25, which is the source for
the Corporal Acts of Mercy. The six illustrated are:
visiting the sick, visiting prisoners [both of which
are shown in the plates accompanying this example],
giving drink to the thirsty, giving food to the hungry,
giving clothing to the naked, providing shelter for the
homeless.
Bibliography:
York Historical Monuments, III, Pls. 109, 111-13.
Gee, "Painted Glass of All Saints' Church, North Street,
 York," pp. 162-64.
Gibson, *Stained and Painted Glass of York*, p. 168.

Comment: In *Matthew* 25, the Corporal Acts are associated with
the Last Judgment, and indeed the York plays themselves
illustrate Doomsday according to this account of the end of
the world rather than according to the narrative in the
Apocalypse. See Davidson, "The End of the World in Medieval
Art and Drama," pp. 261-63.

64

EXAMPLE U

```
┌─────────────────────────────┐
│ Fairford Church:            │
│ West W, pg.                 │
│                             │
│ Last Judgment               │
│                             │
│ Ref: Gs-F-W                 │
│                             ├──────────────────────────┐
│ Last Judgment        Gs-F-W                Slides: V.C.2-8│
│                                                          │
│ Painted glass, Fairford Church, Gloucestershire, West Win.│
│ (Win XV.)                                                │
│                                                          │
│ Flemish style                                            │
│                                                          │
│ c.1495-1500                                              │
│                                                          │
│ Christ appears sitting on a rainbow and with his feet on the│
│ globe of the world, which is flaming.  BVM and St. John the│
│ Baptist appear on each side of him, and he is encircled by│
│ red angels (Seraphin), outside of which appear saints and│
│ apostles.  Below [not shown in plate accompanying this ex-│
│ ample] is St. Michael with the scales; hell is on Christ's│
│ left and heaven on his right.  Evidence of considerable  │
│ restoration.                                             │
│                                                          │
│ Bibliography:                                            │
│ Farmer, Fairford Church and Its Windows, pp. 27-31.      │
└──────────────────────────────────────────────────────────┘
```

Comment: This window, though in Gloucestershire and of Flem-
ish design or influence, nevertheless provides the clearest
explanation for the possible arrangement and movement of the
puppet angels in the York Doomsday play. Cf. Johnston and
Dorrell, "The Doomsday Pageant of the York Mercers, 1433,"
pp. 29-34.

EXAMPLE V

York Minster Nave:
Win 40, pg.

Apostles: St. Peter

Ref: Y-YMN-40

Apostles: St. Peter Y-YMN-40 Slides: III.40A,
 VII.A.22
 B&W File: 4A-1974
Painted glass, York Minster Nave, Win 40 (Pilgrimage
Win).

14th century

St. Peter appears in panel showing model of Minster as
it appeared in 1312 in his right hand and his keys in
the left hand. He wears pallium over green outer
vestment. Panel utilizes yellow stain.

Comment: The apostle is here wearing 14th-century vestments,
including the pallium. The location of the panel in this
window points to special veneration of St. Peter in this
ecclesiastical center.

EXAMPLE W

York Minster Transept (South):
Win 71, pg.

Apostles: St. Peter

Ref: Y-YMT-S-71

Apostles: St. Peter Y-YMT-S-71 B&W File: 14-1974

Painted glass, York Minster Transept (South), Win 71;
lancet in south wall.

Flemish style

1490-1510

St. Peter holds keys with right hand and a book in the
left. Painted in style which became popular after
Flemish glass painters were imported under Henry VII.
Note borders, which are distinctly different from
earlier York work.

Bibliography:
Friends of York Minster: Annual Reports, 20 (1948),
 8-9, 29-30.
Gibson, *Stained and Painted Glass of York,* p. 141.

Comment: This representation of the apostle Peter should be
compared with the 14th-century portrait in the Pilgrimage
Window (Example V, above). Flemish art had influenced
artists at York as early as the beginning of the 15th-cen-
tury, and Flemish book illumination was known in York at
that time. William Revetour, the priest who apparently
was responsible for the York Creed Play, indicated in
his will, dated 1446, that a Primer "cum ymaginibus intus
scriptus ad modum Flandr'" was to be given to Isabella
Bolton (*Testamenta Eboracensia,* II, 117). The Flemish
style must have influenced the sets for the plays by the
sixteenth century, if not before.

EXAMPLE X

St. Martin, Coney Street, York:
2nd Win from East in North Side
of Clerestory, pg (destroyed 1942).

Saints: St. Denys

Ref: Y-StMart-Co-NC12*

Saints: St. Denys Y-StMart-Co-NC12* Destroyed 1942

Painted glass*, St. Martin, Coney Street, 2nd Win from
East in North Side of Clerestory.

c.1450

Destroyed by German bomb, 1942. Described as follows by
Harrison: "St. Denys, holding his head, as he was mar-
tyred by being beheaded" (*Painted Glass of York*, p. 136).
The subject had been identified by Browne in 1846.

Bibliography:
Parker and Browne, "Architectural Notes of the Churches
 . . . with Notices of the Painted Glass," p. 16.

Comment: Loss of an item in recent times has often meant that
it is described (and, in some cases, fortunately, even illus-
trated in a printed source). In spite of the sketchy de-
scriptions, Harrison's book on York nevertheless provides in-
formation about the glass which remained in St. Martin, Coney
Street, when it was hit by a bomb in 1942, and such records
as Browne's survey of the glass from the 1840's also give oc-
casional evidence of significance from a time before exten-
sive restorations of glass were undertaken.

EXAMPLE Y

```
Pickering, Yorkshire:
Nave, wp.

Saints: St. Edmund (martyrdom)

Ref: Ys-Pic-wp
```

```
Saints: St. Edmund       Ys-Pic-wp        Slide: V.A.3
                                          B&W File: 9-1974

Wall painting, Pickering, Yorkshire, North Wall of Nave.

Late 15th century; restored in 19th century

Center presents St. Edmund, wearing only his crown, tied
to a tree.  Scandinavian archers are shooting arrows into
his body from each side.

Bibliography:
Lightfoot, "Mural Paintings in St. Peter's Church, Picker-
    ing."
Rouse, Discovering Wall Paintings, p. 32.
```

Comment: St. Edmund, King of East Anglia in the 9th century,
is a popular English saint who according to tradition was
martyred in Suffolk at the hands of the Vikings, who first
shot him with arrows and then decapitated him. A number
of guides are available which assist in the identification
of saints as they appear in English art, including Milburn,
Saints and their Emblems in English Churches, Drake and
Drake, *Saints and Their Emblems*, and Bond, *Dedications of
English Churches: Ecclesiastical Symbolism, Saints, and Em-
blems*. The book by Bond is indispensable. Representations
of saints are especially important to tabulate because of the
known existence of the saint play in England.

EXAMPLE Z

St. John the Baptist Church, Hungate,
York: im (lost).

Saints: St. Mary Magdalene

Ref: Y-StJnB-H-im*

Saints: St. Mary Magdalene Y-StJnB-H-im* Lost

Image*, St. John the Baptist Church, Hungate, York,
on South Side of the Church.

Extant in 1435

Noted in will of Richard Russell, merchant, whose wish
in 1435 was that an altar be set up on the south side
of the church in front of the images of St. Mary Magdalene
and St. Catherine ("coram ymaginibus Sanctarum Katerinae
et Marie Magdalenae").

Bibliography:
Testamenta Eboracensia, II, 53.
Raine, *Mediaeval York*, p. 83.

Comment: The evidence from wills is exemplified here in a
reference to images by a merchant, Richard Russell, in
1435. His will is in the York Registry (Vol. III, fol.
439).

70

EXAMPLE AA

```
Ripon Cathedral:
misericord, wdcarv.

Miscellaneous:
Fox preaching to duck and cock

Ref: Ys-RiC-m
```

Miscellaneous: Ys-Ri-C-m B&W File: 3A-1974
Fox preaching to farm fowls

Misericord (woodcarving), Ripon Cathedral.

c.1490

Fox is in pulpit, center, with duck on one side, and cock
on the other. Formalized design.

Bibliography:
Remnant, *Catalogue of Misericords in Great Britain*, p. 182.
Varty, *Reynard the Fox*, p. 55, fig. 70.
Purvis, "The Use of Continental Woodcuts and Prints by the
 'Ripon School' of Woodcarvers," pp. 117-19.

Comment: Misericords are normally rather fanciful in design and
generally show a wide display of fabulous animals such as
griffins and dragons as well as of knights and ladies. Some-
times the subjects are relevant to the plays, however, as in
the instance of this playful example or of another misericord
at Ripon which shows Samson carrying off the gates of Gaza.
See Remnant, *Catalogue*, Pl. 4c.

VI.
THE COMPUTER

Since the subject lists eventually will for some pur-
poses be quite cumbersome to use, plans are underway for com-
puter programming which will assist scholars in the retrieval
and analysis of material of potential aid for the study of
drama. Computer codes, which will not appear in the pub-
lished lists, are indicated for medium and location as noted
in the chapter dealing with abbreviations, above. The loca-
tion codes, of course, are designed to be expanded to include
specific buildings within cities or towns within counties.
Thus, for example, the code number for the location which is
the city of York is 106700, wihle 106701 will be the Church of
All Saints, North Street in that city, and 106702 will be All
Saints, Pavement. Additional information concerning location
(e.g., the location of a subject in a building or the identi-
fication of an illumination in a specific manuscript) will be
contained in the text which the computer will print out.

Essentially, the computer programming will be keyed to
subject, location, and date. Unfortunately, it will not be
possible to break down the subject listings by individual
iconographic details, since to do so would involve prohibi-
tive expense. However, when utilized with the other materi-
als available and with slides and/or photographs, the in-
formation which will be made available will be formidable.

Computer programming, designed by Gerald Landry, is keyed
to the DEC-10 computer at Western Michigan University, with
the testing of the program scheduled for August 1977 when the
York subject list has been completed and checked. The flow
charts included here are intended as preliminary, with the
final program to be completed and in operation by Fall 1977.
Persons seeking information about any revisions of the flow
charts and about the final program therefore should contact
the office of *Early Drama, Art, and Music* after 1 January
1978.

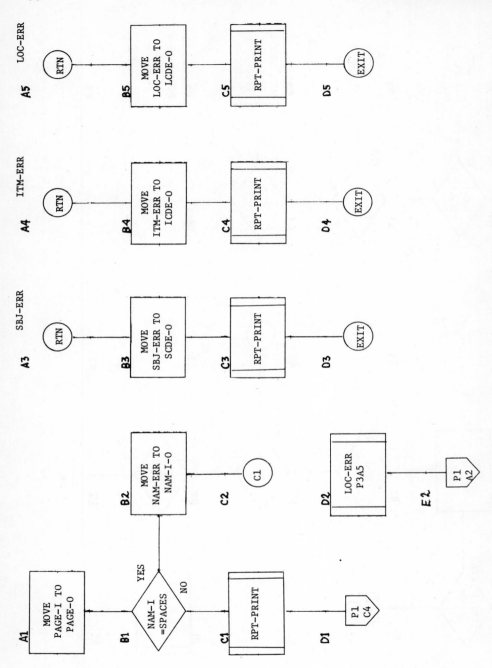

RPT-PRINT

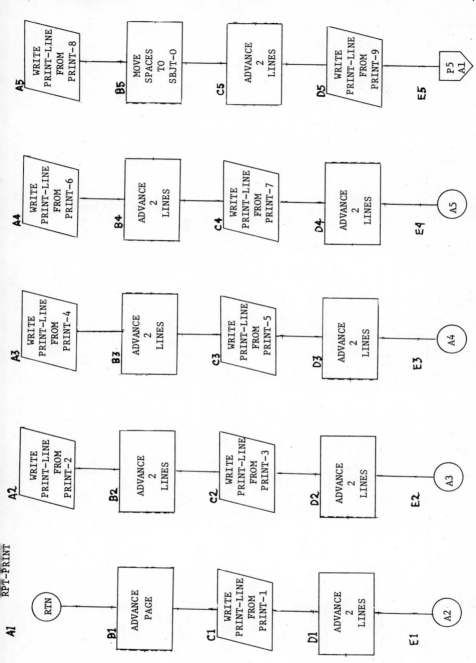

A1

A2 WRITE PRINT-LINE FROM PRINT-2

B2 ADVANCE 2 LINES

C2 WRITE PRINT-LINE FROM PRINT-3

D2 ADVANCE 2 LINES

E2 A3

A3 WRITE PRINT-LINE FROM PRINT-4

B3 ADVANCE 2 LINES

C3 WRITE PRINT-LINE FROM PRINT-5

D3 ADVANCE 2 LINES

E3 A4

A4 WRITE PRINT-LINE FROM PRINT-6

B4 ADVANCE 2 LINES

C4 WRITE PRINT-LINE FROM PRINT-7

D4 ADVANCE 2 LINES

E4 A5

A5 WRITE PRINT-LINE FROM PRINT-8

B5 MOVE SPACES TO SBJT-O

C5 ADVANCE 2 LINES

D5 WRITE PRINT-LINE FROM PRINT-9

E5 P5 A1

B1 ADVANCE PAGE

RTN

C1 WRITE PRINT-LINE FROM PRINT-1

D1 ADVANCE 2 LINES

E1 A2

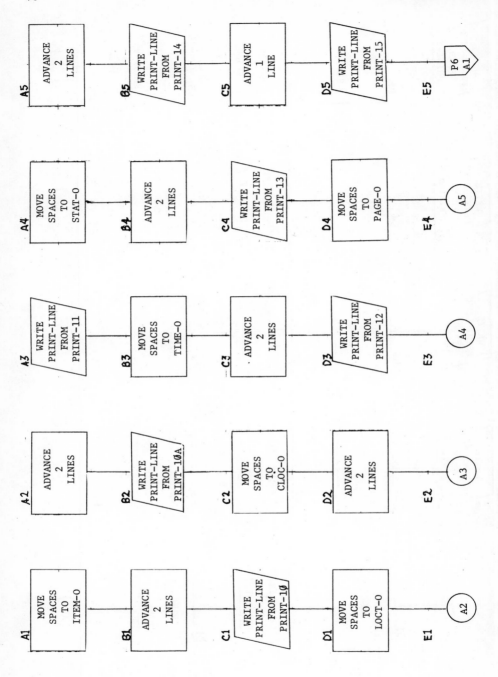

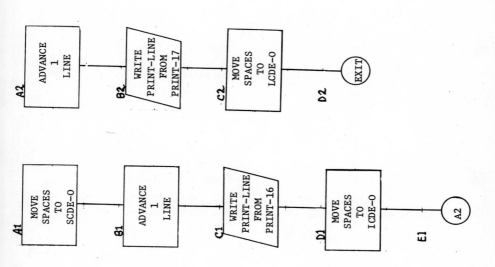

INPUTS

Card-File

Positions	Entry	Code	
1-20	20 ALPHA	NAM-I	Name of person making inquiry
21-26	6 NUMERIC	SBJ-I	Subject of interest (coded)
27-28	2 NUMERIC	ITM-I	Medium of interest (coded)
29-34	6 NUMERIC	LOC-I	Location of interest (coded)

Disk File

Positions	Entry	Code	
1-6	6 NUMERIC	SBJ-D-I	Subject (coded)
7-8	2 NUMERIC	ITM-D-I	Medium (coded)
9-14	6 NUMERIC	LOC-D-I	Location of item (coded)
15-64	50 ALPHA	SBJT-I	Subject
65-87	23 ALPHA	ITEM-I	Medium
88-143	56 ALPHA	LOCT-I	Original location of item
144-199	56 ALPHA	CLOC-I	Current location (if different)
211-207	8 NUMERIC	TIME-I	Date
208-216	9 ALPHA	STAT-I	Status of item
217-231	15 ALPHA/ NUMERIC	PAGE-I	Page in Subject List

OUTPUTS--PRINT FILE

Code	Print-Line
NAM-I-O	PRINT-1
SBJ-I-O	PRINT-4
ITM-I-O	PRINT-5
LOC-I-O	PRINT-6
SBJT-O	PRINT-8
ITEM-O	PRINT-9
LOCT-O	PRINT-10
CLOC-O	PRINT-10A
TIME-O	PRINT-11
STAT-O	PRINT-12
PAGE-O	PRINT-13
SCDE-O	PRINT-15
ICDE-O	PRINT-16
LCDE-O	PRINT-17

VII.
DATING, AUTHENTICITY, PROVENANCE

If the work of the scholar concerned with the information art can throw on drama is to have value, he necessarily needs to have some knowledge in that area of expertise known as connoisseurship. Questions of provenance, authenticity, and dating are, to be sure, normally answered more satisfactorily by art historians than they can be by students of drama, Nevertheless, in many, many instances careful evaluation of previous judgments must be made, and at other times the researcher must simply make judgments of his own. Hence there is no alternative to knowing a good deal about the practices of the artists and about their products during the periods under consideration.

Since painted glass is in many areas of England the only medium of medieval religious art that has survived with any completeness, the investigator who approaches a city or region with any amount of this art will need to know something of the techniques used in successive stages by the glass painters from the earliest extant work to the middle of the sixteenth century and beyond.

The earliest glass in England is reputed, probably incorrectly, to be a panel from a Jesse Tree in the nave of York Minster. This panel is particularly useful in demonstrating the closeness in technique and design between early English glass painting and the painting in the same medium on the continent. Stylistically it is very similar to work done for the windows of St. Denis and Chartres. Twelfth-century and thirteenth-century examples of glass both in France and England relied heavily on deep reds and blues, as the specimens at York, Canterbury, and French buildings show. The glass itself was not normally manufactured in England, but was purchased from Normandy, Lorraine, and Hesse in sheets which were both plain and colored. Essentially the technique of the glazier in this early work involved mosaic construction, and as has been noted Noah and his ark in the North Choir Aisle at Canterbury are made up of more than fifty pieces.[1] The glass was cut into shapes by means of touching with a hot iron and, when necessary, applying water or even saliva; the pieces were then carefully fitted together by trimming with the grozing iron. The leaded panels when completed were inserted into an iron framework. Such

construction particularly encouraged the use of medallions
with separate scenes, as in the case of the example of Noah's
ark at Canterbury which was cited above. Early work was not,
of course, limited to medallions, as any cursory examination
of the glass of Canterbury or Chartres will prove.

In early painted glass, the color was laid on with a
brush in brilliant designs which are reminiscent of manuscript
illumination. Figures themselves were set against colorful
backgrounds without any serious attempt to depict scenery.
When the painting was completed, the colors were fixed in a
kiln where the pigments were fired at high temperatures. Then
all the pieces of a window were assembled, fitted together in
lead cames which had been cast for the purpose, and soldered.
Instructions for the creation of such glass are contained in
the treatise *On Diverse Arts* by Theophilus, who is probably
to be identified with Roger of Helmarshausen who lived in the
early twelfth century.[2]

The great discovery of the Middle Ages in glass painting
was silver stain, which was introduced to the West in the
fourteenth century. Its use in glass still extant was appar-
ently first at York Minster, where windows in the nave illus-
trate the bright yellow that could be produced by this tech-
nological innovation (see especially Example H in Chapter V,
above). As Noël Heaton has demonstrated, silver stain and
its use were probably borrowed from an Arabic treatise.[3] Like
other importations from the East (e.g., the pointed or "goth-
ic" arch), silver stain was put to unique uses with spectacu-
lar results. From the standpoint of connoisseurship, the
distinctive yellow of silver stain clearly distinguishes the
later work from the earlier. But other innovations also ap-
pear in the course of the fourteenth century, and the glass
of this period is marked by such features as the widespread
elaboration of the borders and canopies of the windows.
These are normally subject to important local differences,
and involve the handling of detail that can distinguish in
many cases the provenance of the glass.

By the fifteenth century, the techniques of glass
painting had been very thoroughly transformed, and in place
of the earlier mosaic glass technique of the twelfth and
thirteenth centuries, the workmen now produced an art marked
by far more realism and by more freedom from the limitations
of the medium in which they worked. At York and Great Mal-
vern, for example, the new styles and techniques are well re-
presented by more careful and individualized figure drawing as
well as scenes that are less conventional in scope. Por-
traits of donors in the fifteenth century were at times ob-
viously genuine portraits, as in the case of Nicholas Black-

burn, Sr., his wife, and his son, Nicholas, Jr., also pictured
with his wife, in the East Window of All Saints, North Street,
York. The culmination of the new kind of work may be said to
be the Great East Window of York Minster for which John Thorn-
ton of Coventry was placed under contract in 1405 (see Example
C in Chapter V, above). The Minster authorities apparently
decided that the glaziers currently working at the cathedral
(apparently John de Burgh and his associates) were not suf-
ficiently expert in the new style of painting, and hence
Thornton was brought in to do the job. From this time on-
ward, glass in York may often (though not always) be fairly
closely dated by means of careful attention to style and by ex-
amination of documents which shed light on probable completion
dates. It is, of course, from records that we are able to
date, for example, the St. Martin Window in St. Martin, Coney
Street, York (1437) and the East Window in Holy Trinity,
Goodramgate, in the same city (1470-80), but considerations of
detail cannot be ignored in arriving at such dating.

At York and elsewhere, as at Great Malvern, fifteenth-
century work is set within borders and canopies that are
distinctly different from those of the previous century.
These now are of extremely elaborate workmanship in yellow
stain on white glass, with backgrounds of colored glass; the
designs are of shafts and pinnacles--i.e., of architectural
details--often uniquely displayed. Hence in the borders of
the Fifteen Signs of Doomsday Window in All Saints, North
Street, York, figures of men peer forth in horror at the signs
of doom displayed in the panels. Visually, the frames for
the scenes in these windows are now no longer the metalwork
supporting the glass, but the borders and canopies. And
within the panels themselves, the lead lines no longer needed
to be obtrusive, but rather could be worked into the design
itself.

The realism of the fifteenth-century panels provides, of
course, some extremely useful suggestions about a great many
matters of costume and other elements of visualizing religious
scenes--all of which are of immense importance to the student
of drama. This is not to denigrate the earlier art of the
glazier and its usefulness for the student of drama, but the
delight in detail evidenced in the fifteenth century must also
be a particular joy to the scholar attempting to isolate and
examine the visual effects of an early performance of a mystery
play. With the work that is being done through the subject
lists for the Reference Series of *Early Drama, Art, and Music,*
we will be able to arrive at some more precise conclusions
with regard to the stability of certain details as they ap-
pear in the art of regions and periods of time during this ex-

tremely important century.

Developments in the latter part of the fifteenth century and the early sixteenth century should not, however, be neglected, since under the influence of the Flemish glass painters favored by Henry VII some radically different effects again appeared. The glass of King's College Chapel, Cambridge, described in great detail in the volume devoted to this glass in the series *Corpus vitrearum medii aevi*, demonstrates the latest style of glass painting that requires full attention. At York, this style makes its appearance in the south transept of the Minster in the rose window with its Tudor roses as well as in the lancets beneath (see the figure of St. Peter illustrated in Example W in Chapter V, above). It also is very evident in the windows of St. Michael-le-Belfrey, York, which have been judged inferior by a number of writers on the glass. These examples of painted glass are characterized by very different brush work and by a concern for immediate visual effect that had not been present in local work previously. For the scholar in the area of drama who is interested in the glass, simplistic value judgments about the quality of this work are not very useful. Rather, the researcher will see that here is a potential source of information about changing taste that must have been reflected sooner or later in the design of the costumes and the settings for the civic plays produced at York and elsewhere. Perhaps it is no accident that in 1507 the affluent Mercers, who must have been aware of questions of style in art, were willing to spend forty shillings to obtain a new pageant for their Doomsday play. Commissioned to produce this new pageant was the carver Thomas Drawswerd, the prominent local craftsman.[4] While Drawswerd would not have reflected the latest London fashion (he was invited to submit drawings for the tomb of Henry VII, but the contract was given to the Italian Torrigiani), we can assume that, like the new style of painted glass windows in York, his work for the Mercers would have been substantially different in design from the earlier wagon.

A footnote should perhaps be added about two further techniques of glass painting, one early and the other late. Grisaille, which was used in Salisbury Cathedral and which is perhaps best exemplified in the famous Five Sisters Window in York Minster, involved a reaction against the figure painting of earlier ecclesiastical art, particularly under the influence of the Cistercian order. Utilizing the paint which had normally been utilized for making designs on glass, the monochrome grisaille windows were essentially part of an iconoclastic style that, outside of Cistercian houses, died out

before the fourteenth century, though grisaille was still used
for background much later. The other technique involved enamel
painting, developed in the late Middle Ages but not used exten-
sively until the supply of good foreign glass tended to dry up
in the sixteenth and seventeenth centuries. In the production
of enamel glass, such as the examples of the Betrayal and of
David and Goliath inserted in one of the windows of St. Michael-
cum-Gregory, York, the enamel was painted on and then the glass
was fired. Unfortunately, this product is less permanent
than the work of the older glass painters, since the enamel
tends to come loose from the glass. Though it was heavily used
for domestic glass, much of it containing heraldic designs and
secular scenes, it is also a good deal less satisfactory from
an aesthetic standpoint.

Actually much more difficult than the problem of dating
or of establishing possible provenance for painted glass is
the matter of authenticity. The earlier mosaic glass because
of its intricate nature was particularly susceptible to loss
of pieces and scrambling by ignorant or careless workmen, but
even very clear and simple designs in later windows have been
jumbled beyond recognition. A well known example of a disas-
trous releading is the Nine Orders of Angels Window in All
Saints, North Street, York, which was not even identifiable
until the discovery in the Bodleian Library of a drawing of
the window in its original state from the seventeenth cen-
tury.[5] At Malvern, where neglect of the glass had been ex-
tremely serious, modern and accurate restoration also could
only be achieved by the assistance of earlier descriptions,
especially Thomas Habington's seventeenth-century *Survey of
Worcestershire* and Dr. William Thomas' *Antiquitates Prioratus
Majoris Malverniae* (1725).[6] It is, we must recognize, quite
precarious to depend upon the accuracy of the arrangement of
the pieces of glass in a window that has not had the benefit
of expert attention.

In many cases, however, the attention given to the glass
by way of restoration has itself become a prime hazard for the
student, since very often the modern craftsman has been care-
less,unscrupulous, or ignorant in his work. Occasionally
whole panels or entire windows of new work have been inserted,
and it is sometimes difficult to detect the difference between
these fakes and the original work from the medieval period.
Yet it is when smaller pieces and segments have been replaced
by modern work that the most difficulty is caused, since the
alteration in the original might effectively be so great as to
change the very subject of the panel or window. Much of this
kind of work was carried out in the later nineteenth century
and in the early part of the twentieth century. Under the

guise of "restoration," these projects caused much irreparable
harm to the original art of all kinds during the period of the
Gothic Revival enthusiasm. Even the post-war restoration of
York Minster glass has produced confusion in some cases, par-
ticularly because the nature of the alterations has not always
been adequately recorded. It is wise, therefore, not to trust
superficial examination of the glass; rather, the investigator
needs to look into the matter of the history of the window or
other art object to discover what can be known about its back-
ground. The volumes of *Corpus vitrearum medii aevi* will con-
tain very careful illustrations showing the dating and condi-
tion of every piece of glass in each window. The precision of
the ongoing work in this series may be gauged by the volume al-
ready issued on the glass of King's College, Cambridge. The
scholar in the area of drama who is approaching painted glass
may well feel humble in the presence of the expertise shown
in such volumes as these, but he must content himself only
when he has obtained all that he can discover about the con-
dition of those subjects to be located and included in the
subject lists.

As a popular art, glass painting always, of course, re-
tained a level of draughtsmanship and design that links it
more closely with manuscript illumination than with wall
painting, which could be surprisingly crude in some of its
manifestations, as we see from extant examples in English
churches. For example, in spite of its obvious interest, the
"Christ of the Trades" at Breage, Cornwall, evidences charac-
teristics which we would all agree to label "primitivism."
Yet wall painting, normally done with simple colors painted
directly on specially prepared plaster, could at the same
time be extremely effective and sophisticated. The re-
searcher needs to know something of the limitations of the
process, especially with regard to the use of pigments, since
in general the more expensive ones were considered too dear
to be used in wall painting. E. Clive Rouse notes in his ex-
cellent little guide entitled *Discovering Wall Paintings* (re-
vised ed., 1971):

> The pigments were of the simplest. Oxides of
> iron are the commonest--red and yellow ochre, which
> even in themselves had a wide range, the red ochres
> going almost from purple to pale red. Lime white
> and lamp or charcoal black gave an added variety.
> Vermillion is found, but this was a difficult and
> expensive colour to make and is unstable in lime
> painting, tending to blacken in certain conditions.
> Greens were generally a copper salt. Blue is rare
> and is usually an azurite. The skilful mixing of

> only two colours, blue black and white at Coombes
> shows what a rich range and effect can be produced--
> deep red, down to the palest pink: deep yellow, al-
> most brown, through to the palest cream: grey, and
> a colour you would almost swear to be blue, but is
> in fact black and white with a touch of red. (p.
> 10)

The fixative was apparently usually casein, with lime water
used as the vehicle for the paint.

From the standpoint of iconography, extant wall paintings
can give us some extremely important evidence for our study of
drama. This point has been well proven by Patrick Collins'
article, "Narrative Bible Cycles in Medieval Art and Drama,"
which points out that wall paintings such as those at Crough-
ton, Northamptonshire, from the early fourteenth century in-
deed throw light on such basic questions as the selection of
topics to be dramatized in the great English cycles which would
come later. The Croughton paintings had previously been de-
scribed in 1927 in an article in *Archaeologia* by E. W. Tris-
tram and M. R. James, but the full significance of such exam-
ples for drama has been recognized only following Collins' ar-
ticle. Many of the more important wall paintings in the
country have thus been studied and described with regard to
date and design, but much needs to be done even here by way of
interpreting this information so that it can be brought to
bear on another popular art--the art of drama. When the re-
searcher is not able to be guided by previous publications on
a wall painting, the most serious hazards for him are that he
will accept as authentic elements of design that are the work
of modern restorers or that he will fail to recognize details
that are very faint. His problems will be greater in the in-
stances in which he encounters lesser-known and more frag-
mentary paintings, and in these cases he will need to search
church records for information, if this is possible, and to
study the designs for evidence of dating and so forth.

It should be noted that references to painting in re-
cords are often ambiguous, but there are times when, super-
ficially at least, wall paintings seem to be indicated. We
cannot be sure in the case of, for example, two references to
painting in the Church Accounts of St. Michael, Spurriergate,
York (cited by Angelo Raine, *Mediaeval York*, p. 161), though
at least the figure of the devil in the "nether end" of the
building (for which one shilling was paid in 1533) was ap-
parently a wall painting. The other reference, which is to
the painting of St. Christopher at a higher cost (2s. 1d),
could have denoted an image rather than a wall painting.

Angelo Raine quotes the will of Thomas Barton, vicar of

St. Lawrence's Church in York, who in 1523 left "to Sanct Law-
rence vjs. viijd. to paynting of hyme" (p. 294). Surely Bar-
ton's will refers unambiguously to an already existing image,
probably of stone or wood, and not a two-dimensional painting.
Late medieval sculpture is very often more crude in appearance
than we might expect, and the reason is quite clear: these
statues were finished off with gesso and paint, thus necessi-
tating less careful workmanship on the part of the carver.
From the traces of color observable on many extant examples
and from the evidence of exports, mainly alabasters, to the
continent, we learn that England in the Middle Ages did not
admire raw stone or wood; normally medieval statues, like the
walls of the churches themselves, were covered with paint.
However, the paint used on the images was much brighter in
hue, and utilized a good deal of gilding. Sometimes, as we
discover from wills, rich articles of clothing were left to
particular images with the purpose of providing garments for
them. Hence we perhaps ought to suppose that the image of the
Trinity recorded as part of the Doomsday pageant at York in
1526[7] would have been painted and clothed in a more or less
realistic fashion.

Book illumination is, as we have noted, an elite art in
comparison with the humble art of wall painting or even the
art of coloring such items as the statues with which every
church seemingly was outfitted. The distinguished history of
book illumination in England is in its main outlines very
well known, and can be studied by way of introduction by means
of such a book as O. Elfrida Saunders' *English Illumination*.
Saunders' book provides plates which give examples of the
various English schools and the different periods of painting.
To this may be added the excellent account in Margaret Ric-
kert's *Painting in Britain: The Middle Ages*. Unfortunately,
many of the local examples of provincial art which require
listing in the subject lists will be very minor illumina-
tions in manuscripts that often have not been extensively
studied. A common problem is that of establishing the pro-
venance of the book, and often it will be necessary to ac-
cept guesswork when certainty cannot be achieved. It is
necessary to know as much as possible about local styles and
ways of executing details, of course, and it is also vital to
be willing to attempt to discover what can be known about the
ownership of an item that is believed to be associated with a
particular area.

While the danger of encountering an out-and-out fake is
quite rare in book illumination, in the case of sculpture
modern copies and restorations are everywhere present. So
much repair of old stonework has been done during the period

since 1840 that almost any unmutilated statue of a religious
subject must be looked upon with a certain amount of scepti-
cism. In the Chapter House of Salisbury, the restoration of
the sculptures, originally carved c.1270, was very cleverly
done, and even an expert could have difficulty distinguishing
the authentic medieval work from the modern restoration without
the descriptions left by the restorer.[8] The head of Lot in
the scene which shows his wife turned to a pillar of salt and
the entire figure of Noah with the dove in a carving showing
the ark are modern, and other sculpture in the Chapter House
has been even more seriously altered through restoration. At
Lincoln, the mutilated central figures in the thirteenth-
century tympanum on the Judgment porch, which represents
Doomsday, have been repaired, and the repairs include new
heads that therefore are worthless with regard to potential
light which might be thrown on earlier drama. The research-
er simply needs to be wary. Details that can be authenti-
cated can be extremely valuable, especially when found set
forth in the three-dimensional form of sculpture.

With regard to the basic problems of connoisseurship
encountered by the investigator approaching carvings in wood
and stone, he is advised to begin with the elementary handbook
by Arthur Gardner, *English Medieval Sculpture,* 2nd ed. (1951).
Gardner's text and plates provide by far the best introduction
to the subject. Of course, for each individual kind of
sculpture--roof bosses, ivories, tomb sculpture, alabasters,
etc.--this book can only provide limited information, and it
will be necessary at once to find more specialized sources
as soon as the need arises. A number of items in this re-
gard have already been mentioned in Chapter II, above; and
others will appear in the bibliography.

A few other arts are also likely to be encountered by the
researcher, particularly examples which appear in lists and
inventories but are no longer extant. These include church
plate and jewelry, normally made by goldsmiths who, incidental-
ly, also made and repaired certain small images. Hence, for
example, the *Fabric Rolls* of York Minster report that an image
of St. Apollonia was repaired in 1478-79 by John Gorras, who
elsewhere is identified as a goldsmith.[9] Some of the pieces
of jewelry with biblical scenes or figures of saints were
quite diminutive, as in the instance of the morses attached
to ecclesiastical copes or pectoral jewels. One of the latter
at York Minster illustrated the Ascension, according to an in-
ventory of the time of Edward VI.

Vestments, particularly of the kind of elaborately em-
broidered work known as *Opus Anglicanum,* are today exceedingly
rare, but commonly appear in lists and inventories. A good

introduction to this kind of work is the catalogue of the ex-
hibit at the Victoria and Albert Museum in 1963; the catalogue
is entitled *Opus Anglicanum: English Medieval Embroidery*.
Further comment on such matters as style of clerical garb will
be included in the chapter on Costume, below. Sometimes em-
broidery was also intended for such purposes as altar frontals
or hangings in a church or other building; unfortunately, it is
sometimes impossible to discover from extant documents if such
an item is meant or if the reference is to a painted cloth.

VIII.
COSTUME

Since the early producers of the cycle and saints' plays
in England appear from the fragmentary evidence to have fol-
lowed the traditions of contemporary art with regard to mat-
ters such as costume, some attention to clothing will be im-
portant for the compilers of the subject lists. Limitations
of space will prohibit elaborate descriptions of garments in
the lists, but unusual or significant matters should be noted.
The lists thus should provide minimal information about cos-
tume, and scholars utilizing them as a resource therefore will
be enabled to turn easily to the examples themselves for needed
particulars. Needless to say, both compilers and users of the
lists will need to become knowledgeable about styles of
clothing, armor, and ecclesiastical vestments. Ultimately
the various subject lists ought to be particularly useful
with regard to identification of regional variations in
clothing, of changing styles, and of the ways in which
anachronistic patterns were used by artists.

It has often been assumed that the costumes worn by ac-
tors in medieval biblical and hagiographic drama were, like
those of the late Tudor and Jacobean stage, examples out of
the contemporary wardrobe. Everyone knows about Lucius'
statement "their hats are plucked about their ears" in
Shakespeare's *Julius Caesar* II.i.73, or about Cleopatra's
tell-tale "Cut my lace, Charmian, come!" (*Antony and Cleo-
patra* I.iii.71). In late medieval art, contemporary clothing
is regularly encountered, of course; however, *very often it
is not*. There is no reason to believe that the drama of this
time departed from the standard artistic practice.

The Blessed Virgin in late medieval art actually il-
lustrates the retention of conventional aspects of costume de-
sign while at the same time making adjustments to conform with
contemporary style. She often appears in a gown or kirtle and
head covering that have been established for the same or slight-
ly earlier period for aristocratic women, but these derive
their shape in part from tradition. Likewise, the mantle
normally placed over her gown or kirtle can, while it may be
consistent with current fashion, be traced back for centuries.
She never wears, of course, the horned headdress, which was
regarded as a symbol of pride and which hence was considered
more apppropriate for such figures as the Herodias in an ala-

baster in the Victoria and Albert Museum (A.124-1946).

Contemporary garb is to be seen, to be sure, in such figures as the thirteenth-century Cain and Abel on the West Front of Lincoln Cathedral; both men wear tunics which would appear to clash but little with contemporary design for the clothing of farmers and shepherds. Likewise, when Christ appears as the gardener in the Hortulanus scene depicted in alabaster in another carving in the Victoria and Albert Museum (A.67-1946), he wears a gown and hat which would have been characteristic of the contemporary master gardener. This alabaster also displays a curious detail which also deserves notice here: the figure of Mary Magdalene wears a turban headdress and barbette which together may identify the carving as a product of the time of Henry VI. These articles of clothing are repeated from a different angle in yet another alabaster, presumably from the same shop, which shows the figure of Mary Magdalene along with the other two Marys at the tomb after the Resurrection (Victoria and Albert Museum A.30-1950). Here the other two holy women are without gorgets and wear contemporary covrechefs which stand in contrast to the Magdalene's headgear, which apparently involved an attempt to reproduce a style recognized as authentically Oriental.

More exotic, of course, are many figures from the Old Testament, for these are often dressed in curiously imaginative costumes. For example, Noah in Great Malvern glass appears to be wearing a dalmatic-like garment and a rather fantastic hat, which was clearly based on the medieval Jewish cap. The Noah of the *Holkham Bible Picture Book* is dressed a good deal more modestly, but nevertheless retains the Jewish cap in a less modified form than in the Malvern glass.

On the other hand, saints whose lives were lived *after* the time of the apostles were normally presented in ecclesiastical vestments or in entirely modern costume. In the fifteenth-century glass in St. Martin, Coney Street, York, St. Martin of Tours, a fourth-century saint, is shown wearing contemporary ecclesiastical garb, and in one panel he even appears in full plate armor and carries his helmet, also of modern design, as he encounters the enemy army in a famous episode early in his life that was familiar from the *Golden Legend*. And when the Anglo-Saxon Etheldreda is pictured in a well-known series of painted panels of c.1425 in the possession of the Society of Antiquaries, she is presented as a contemporary Benedictine nun, crowned to show her royalty but otherwise clothed in the current manner.

Yet in a great number of instances, contemporary styles are entirely or almost entirely avoided, especially when God or the apostles are depicted. In these cases, the artists tended

to depend on their pattern books and upon tradition more than
upon the designs which they saw in use around them. The
garments are derived ultimately from early Christian art and
hence from Roman fashions of approximately the fourth century
A.D., but the designs are of course somewhat modified since
they have been filtered through Byzantine and barbarian
traditions as well as through the highly abstract art of the
earlier Middle Ages. Hence their development is somewhat
parallel to the evolution of priestly garments out of the
ancient Roman tunic, paenula, etc., as used in the early
liturgy. When we examine closely late representations of, for
example, Christ in Majesty, we often are able to note that the
figure in a gown and mantle is in design directly descended
from the subject as it had appeared in Anglo-Saxon examples,
in the Byzantine tradition, and ultimately in early Christian
art. Medieval English examples such as the mutilated figure
at Lincoln Cathedral and the top figure in the Beatus page
illumination in a thirteenth-century Psalter from Peterborough
(Fitzwilliam Museum, Cambridge, MS. 12) exemplify a development
of the curve of the mantle from the left shoulder down across
the waist--a design deriving from such earlier figures as those
on an Anglo-Saxon ivory in the Victoria and Albert Museum
(A.32-1928) and ultimately in the fourth-century mosaic in the
Mausoleum of S. Constanza, Rome.

In general, the clothing worn in art by Christ and the
apostles followed patterns which developed as they passed down
century after century. Every student of the Middle Ages
knows that originality was not then universally admired (and
in fact was often looked upon as being out of touch with the
realities being depicted). Even the glass painters, so admired
in recent years for their work, were capable of extremely
conventional work based on cartoons, which they sometimes used
over and over again to represent different figures or even
different scenes. Hence students of York glass have noticed
that the cartoon for John the Baptist in Prison in the Martyrdom
Window in the Minster (c.1414) was re-used for St. Peter in
prison in the Bowet Window (c.1423-32). Such cartoons could
also be passed on from one generation of glass painters to
another, so that, as John A. Knowles has noted, the design for
a St. Christopher in All Saints, North Street, York, from
c.1412-35 could be re-used a hundred years later for a design
for St. Michael-le-Belfrey in the same city.[1] On the whole,
the glass painters and other artists of the period attempted to
generate an art which was popular, convincing, and religiously
authentic. Strict realism was not, of course, their object.
They might mix figures dressed in various clothing styles,
including donors in fashionable contemporary dress, with the

traditionally draped Christ and apostles. Hence too torturers
normally appear for their cruel work during the Passion scenes
dressed in tunics, and King Herod is usually exhibited as
resembling a late medieval king in royal mantle and ermine hood
over the shoulders. Only at the very end of the period were
there any serious attempts to return to classical models them-
selves, as in the apparent striving for some classical authen-
ticity in the depiction of Roman soldiers in the windows of
King's College Chapel, Cambridge.

The stability of the iconography of certain scenes may be
useful to note at this point. In the *Holkham Bible Picture
Book*, fol. 19, a representation of the Baptism of Christ appears
in which he is shown nude within a mound of water rising up
around him and John the Baptist pouring water from a jug-like
container over him. Such a design, though without the jug,
had been present in an illumination in the *Benedictional of
St. Ethelwold* (c. 980). But the earlier history of this
iconography goes back much farther to a type that had been
developed very early in the Near East. This form of the
Baptism of Christ was constant in English iconography until
the Reformation.

Nevertheless, as should by now be obvious, all iconographic
elements are hardly static. One of the best examples of change
is perhaps the new form of the Nativity which appeared in the
fifteenth century and which necessitated visualizing the scene
in a radically different way (see Chapter IX). In this case,
the influence of the *Revelations* of St. Bridget of Sweden led
artists to see the episode not as a scene with the Virgin in
bed with the Child in a manger between the ox and the ass,
but as an immediate act of adoration demanded by the new
theology.

Generally, as the example of the new form of the Nativity
ought to imply, the late Middle Ages provided more opportunity
for the appearance of realistic detail and expression than
earlier centuries, while at the same time this historical
period refused to let go of a tradition of iconography which
determined not only symbols associated with particular figures
and scenes but also frequently their costumes. Even when such
costumes have been severely altered to suit more modern taste,
sometimes the colors symbolically associated with individual
characters will have remained surprisingly constant, as in
the case of "Mary's color," which is, of course, blue.

A comprehensive guide to categorizing costume in the
later Middle Ages and early Renaissance periods is impossible
here, to be sure. The following section is offered merely as a
practical introduction to some of the most commonly encountered
forms. For further information about contemporary fashions,

see Herbert Druitt's *Manual of Costume as Illustrated by Monumental Brasses* and especially the extended glossary in Vol. II of F.W. Fairholt's *Costume in England,* a work of valuable nineteenth-century scholarship. Additional information about liturgical garments and their development may be obtained in the introductory *Liturgical Vesture* by Cyril E. Pocknee, in the scholarly *Die Liturgische Gewandung* by Joseph Braun, and in a number of other easily obtained sources. E.C. Clark has written of academic costume in the first volume of the *Archaeological Journal,* and the remarkable illustrations in a manuscript at New College, Oxford, may also be consulted in Thomas F. Kirby's "On Some fifteenth-century Drawings of Winchester College; New College; etc.," in *Archaeologia,* 53 (1892), 212-32.

A. ECCLESIASTICAL

Alb. Normally made from white linen, the alb is a long garment which is fairly close-fitting and which reaches to the feet. A *girdle (zona)* is placed around the waist. The alb is decorated in up to six places by *apparels* or pieces of embroidery placed at each wrist, on the back and front, and at the bottom in front and behind.

Almuce (Aumuce). Hood of fur designed to be worn over other vestments for warmth. See the brass of Thomas Buttler, 1494, at Great Haseley, Oxfordshire, as illustrated in Druitt, facing p. 87.

Amice. Usually made of linen, the amice was of rectangular shape and was used as a neck covering after the eighth century. An *apparel* or piece of embroidery work is placed along the edge of the amice.

Chasuble. Garment worn by Celebrant at Mass over other garments. Sometimes English chasubles were heavily ornamented with embroidery. At York Minster, chasubles were blue, red, purple, green, and black,[3] and were made of various kinds of cloth, including velvet, "tissue," satin, damask, and cloth of gold. Chasubles were decorated with *orphreys,* embroidered work sometimes with jewels which were originally attached over the seams of the vestments. After the custom arose of elevating the Host, chasubles tended to be open at the sides to facilitate arm movement. In English documents, chasubles and other liturgical garb worn at the same time as a set are called *vestments.*

Cope. Long cape which was semi-circular in shape. An ornate collar and a hood were usual. The cope was fastened with a *morse*, which might itself be decorated with a religious scene or image of a saint. After the thirteenth century, the cope became highly ornamented, sometimes with rich embroidery and jewels as in the case of the famous Syon Cope in the Victoria and Albert Museum. Such rich embroidery work on silk was particularly English and was known as *opus anglicanum*. Copes were made in the usual *liturgical colors* (see footnote 3). Less elaborate was the *choral cope*, worn by the singers of the choir. A York inventory lists "Eleaven white copes for queristers."

Crozier. Pastoral staff (*baculus pastoralis*) carried by a bishop or abbot. This is a development out of the shepherd's staff. Another form of staff, the *cross staff* which is carried by an archbishop, terminates in a cross at the top, as on the brass of Thomas Cranley, Archbishop of Dublin, at New College, Oxford, 1417.

Dalmatic. Long-sleeved outer tunic worn by deacon over alb. In the late Middle Ages, this garment was often embroidered elaborately, as in the choir of York Minster in two instances in painted glass. The dalmatic of the deacon was fringed on the left side and sleeve. The episcopal dalmatic, worn by a bishop immediately below the chasuble, had fringes on both sides and on both sleeves. The color of the dalmatic was expected to match the chasuble, and hence was determined according to the season or feast by the local scheme of liturgical colors.

Gloves. Gloves (*cirothecae*), worn by bishops, were often jewelled or contained a *monial*, which is a small tablet either jewelled or enameled, on the back.

Maniple. Of silk with embroidery, the maniple is placed over the left fore-arm of the Celebrant at Mass.

Mitre. After the eleventh century, the headdress of bishops, archbishops, and, normally in its simplest form, of abbots. The horned mitre was common before the twelfth century, which saw the development of the low pointed form. Fourteenth-century mitres are higher, and fifteenth-century examples are higher yet. Mitres might be plain (*simplex*), decorated with gold *orphreys* (*aurifrigiata*), or ornamented with gold plate and jewels (*pretiosa*). Attached to the back of the mitre are two *infula* or ornamented cloth strips. On the mitre, see es-

pecially the article in *Burlington Magazine*, 23 (1913), 221-24, 261-64, by Egerton Beck.

Pallium. A band of narrow cloth worn around shoulders of an archbishop and having pendants about 36 inches long both in front and in back. The pallium was originally attached to the chasuble with pins of precious metal. In late medieval examples, the pendants each would have six embroidered crosses. See Example V in Chapter V, above.

Ring. The ring (*annulus*) was worn by a bishop or abbot. In the York inventories, this kind of ring is identified as a "pontifical," and would have been worn on the right hand, middle finger, where it would have been placed above the second finger-joint over the glove.

Stole. Narrow vestment of embroidered material worn over shoulders by a priest. Since the fifteenth century, it has been the custom for the stole to be worn crossed and made secure by the cord when it is worn as a Mass vestment.

Tunicle. The short outer garment worn by the sub-deacon. It resembles a dalmatic, but is less ornate and has tight sleeves. After the twelfth century, the tunicle was worn by bishops under the dalmatic.

Veil. Worn by nuns as outer head covering.

Wimple (Gorget). A nun's neck covering.

B. ACADEMIC

Cassock. Long coat, sometimes with fur cuffs and possibly sometimes fur-lined.[4] It was worn over a *body garment*, which may be seen extending slightly beyond the cuffs of the cassock at the wrists. After the Reformation, the cassock became the everyday garb of the clergy.

Gown. A long, usually sleeveless garment sometimes reaching to the feet or ground but sometimes shorter, as in the drawing showing New College, Oxford, in 1464 (see Kirby, Pl. XV). The gown when sleeveless had slits at the sides for the arms.

Hood. At first not a sign of having achieved a degree, the hood (*caputium*) was worn by undergraduates as well as graduates. Later it became associated with the graduates' de-

grees.

Tippet. Cape of fur or of cloth edged with fur. It was worn outside the gown.

Pileus. Academic cap, which at first was a skull cap or brimless cap with a point in its center, as in the examples in the drawing of New College, Oxford.

C. MILITARY

Chain Mail. Complete chain mail armor was worn from the time of the Conquest until the fourteenth century, though toward the end of this period especially some pieces of protective plate were added at such places as the knees. Mail was not always interlaced, but sometimes was sewn to a leather garment in bands. The armor was essentially in three parts: (1) the *hawberk* over body and arms with gloves attached, (2) the hood or *coif de mailles* over the head and neck, and (3) the stockings or *chausses* over legs and feet. At the end of this period, pieces of plate armor, such as *jambs* which protected the shins, were added.

Mixed Mail and Plate. During the second quarter of the fourteenth century, more extensive use began to be made of plate armor. The head was now covered by a *bascinet* with a point at the top, under which the *camail* covered the area between the bascinet and shoulders. The outer garment or *surcoat* tended to be short in front but reached to the knees behind. The forearms were covered by pieces of plate called *vambraces*.

Camail. From the middle of the fourteenth century to the reign of Henry IV, armor tended to be an extension of the previous period. The *jupon*, and over-garment, now covered the body, while the *bawdric* or ornamented girdle was worn over this garment. Breast and back plates supplanted the older hawberk by the end of the period, and at the same time the jupon hence became obsolete. A skirt of *taces* made of plate also appeared.

Complete Plate. Armor made completely of plate was first utilized under Henry IV, and in style was distinctly different from that of the earlier armor. The *bascinet* was now only slightly pointed, and was worn with a plate *gorget*. This development in armor is well illustrated by the brass showing Sir John Harpedon in Westminster Abbey, 1457. In the Yorkist period, some changes in style were made, including the very

noticeable *pauldrons* or ridged shoulder plates.

Mail Skirt Period. Armor of the early Tudor period is characterized by the skirt of mail.

Tasset Period. Armor of the age of Elizabeth replaced the taces with *tassets*, plates which overlapped and which were attached to the bottom of the *breastplate.*

D. CIVILIAN (MEN)

Breeches. Worn in Anglo-Saxon times and earlier. During the later Middle Ages, the breeches (*braies*) were often tucked into *hose* (*chausses*). Sixteenth-century breeches were fashionably puffed and made of expensive material.

Buskins. Boots.

Coif. Close-fitting covering for head, especially denoting members of legal profession in late Middle Ages. It is worn by several figures in the *Holkham Bible Picture Book.*

Cote-hardie. A broad term denoting the outer garment worn during the later Middle Ages. One type was long and fairly loose-fitting, with sleeves reaching to elbows and having attached *liripipes* or streamerlike pendants. The other and more common form of the cote-hardie was tighter fitting and shorter, reaching above the knees. Normally it was buttoned down the front.

Doublet. In the sixteenth century, this tight-fitting garment was fashionably made of double thickness of material, with a layer of padding between. It was a development from the earlier *jupon.*

Gridle. Belt.

Hood. Most common headdress, supplanted in stages among various classes of society by hats of different kinds.

Houppeland. Tunic with girdle worn as an outer garment. The houppeland is close-fitting at the top and high-necked, but is loose and full below since it is cut in the shape of a funnel. Sleeves are commonly very full, sometimes hanging down below the knees, and the skirts have slits, usually at the sides. Often the houppeland has a lining of fur and considerable ornamentation.

Mantle. Cloak worn over other garments.

Shirt. Originally an undergarment, normally of linen.

Tabard. Sleeveless surcoat.

Tippet. Cape over shoulders.

Tunic. Man's garment, which took various shapes through the Middle Ages. Essentially it was a short gown, though sometimes its length was extended well below the knee.

E. CIVILIAN (WOMEN)

Caul. Ornamental net or *crespine* for hair in headdress that became popular in the fourteenth century, and led in the next century to the exaggerated *horned headdress* in which the cauls were shaped in two hornlike points. Later, the *butterfly* headdress provided further development during the Yorkist period, and was followed by the *diamondshaped* headdress during the reign of Henry VIII.

Cote-hardie. Sideless woman's gown often worn in the fourteenth century under a *mantle* or cloak.

Covrechef. Veil worn over head. In twelfth through fourteenth centuries (and later in the headdress of widows), the covrechef or *veil* was worn in conjunction with the *gorget* (*wimple*) or, after the thirteenth century, with the *barbette*, which was a chin cloth or strap.

Gown. A dress, which took various shapes and styles, including the bag-shaped design worn with the horned headdress in the early fifteenth century. During the fifteenth century, the *houppeland* gown was popular as a garment worn by women, especially those of higher class.

Kirtle. Garment worn under a surcoat such as a cote-hardie and otherwise as an undergarment. It had long sleeves, sometimes buttoned.

IX.

INTERDISCIPLINARY CRITICISM AND MEDIEVAL DRAMA

The task of criticism has become vastly broadened in re-
cent years, particularly with regard to early literature and
drama. These developments prove that, in spite of the scorn
with which the formerly fashionable "New Criticism" held some
historical scholarship, it is now impossible to ignore matters
which are essentially outside the texts of medieval and re-
naissance plays and poems. This point is, I feel, well made
by two recent books on the lyric: Douglas Gray's *Themes and
Images in the Medieval English Religious Lyric* (1972) and
David L. Jeffrey's *The Early English Lyric and Franciscan
Spirituality* (1975). Professor Flanigan's important papers
on the origins of the early liturgical drama and on the
function of the early *Quem queritis* trope[1] suggest further di-
mensions for interdisciplinary study which insist on an ap-
proach to the dramatic events which sees them as enclosed
within the religious rite. My own insistence on the need for
interdisciplinary criticism as well as scholarship is par-
ticularly focused on the drama, which I feel cannot be pro-
perly understood apart from the element of spectacle. Of
course, spectacle in turn derives always at least in part
from sources outside theatrical traditions. We hence need
to be dealing with larger cultural factors, though surely
when treating such uncharted waters the critic like the
scholar needs to adopt systematic methodologies which will
enable him to provide genuine illumination through his work.

I

Let us begin with a rather obvious example of neces-
sary attention to the visual arts for the study of drama.
If we want to know the appearance of the allegorical fig-
ure of Death in *Everyman*, we can hardly find much help from
internal evidence in the play or even from related literary
texts such as the *Dance of Death* in the adaptation by John
Lydgate. However, the evidence from the visual arts is ex-
tensive, and when we turn to it our question is very quickly
answered. From representations of the Dance of Death and
related subjects (e.g., the Three Living and Three Dead) the
possible variants of Death's form can be studied; the critic
can then focus on those examples contemporary with the play

and/or those most likely to have been available to its author. The limits of criticism should be evident here, but nevertheless what we can know can indeed be set forth within the parameters of possibility. Once this has been established, we find that we are able to explore further the background and the potential for conveying meaning of the iconography, the visual tableaux, and, at least speculatively, the actors' physical expressions in order to see precisely how dramatic experience is related synchronically to human experience.

We will come to realize as we work on such a play as *Everyman*, which admittedly is designed as closet drama, that it could not have been written without a cultural milieu thoroughly preoccupied with death--a topic which also was to inform dramatic works in even more unique ways through the Jacobean period (see Appendix). Following the Black Death of 1348-49, a distinct period in art may be distinguished in which the pessimism and instability that overtook England produced works displaying life's terminus. This phenomenon, as is well known, was a universal one throughout Europe.[2] The spirit of the age has, certainly in great oversimplification, been said to be embodied in the representations of the Dance of Death according to the pattern established at the Cemetery of the Holy Innocents in Paris. The scenes were imitated on the walls of the cloister of St. Paul's in London where, according to Dugdale, "the picture of death" was shown "leading away all estates."[3] At Norwich, glass in St. Andrew's Church shows Death coming for a bishop--part of a Dance of Death originally presented in painted glass (c.1460) which could hardly have been unique.[4] In this example, the grim reaper himself appears as emaciated cadaver draped in grave clothes; his head is reduced to a mere skull. This frightening form takes the bishop, attired in chasuble, dalmatic, alb, and mitre, by the hand. Such a figure, then, also comes to Everyman to bid him go on the same journey which will take him to the inevitable grave.

Everyman's story makes excellent drama out of the existential facts of life as perceived at a particular point in history. Specifically, the subject matter is made dramatic because it is filtered through a ritualized vision of life as seen normally by means of expression in the visual arts. The first scene of the play hinges, as we have seen, on the Dance of Death, which is not exactly a dance in the usual sense. When Death arrives, a person at that point normally is denied freedom of movement in any direction but that determined by Death's "dance." Ultimately Everyman must of necessity encounter the allegorical figure of Confession, whose effect on the protagonist's body and soul cannot be understood apart

from Christ's Passion with its episode of scourging (11. 561-
63). Knowledge, of course, has led him to this condition of
penitence, which is the only preparation for the Eucharist and
extreme unction he will receive off stage. Without the pain-
ful experience of contrition which is imitative of Christ's
anguish during his Passion, Everyman's end can only be despair.
The seal of forgiveness in the sacraments brings the mercy of
the deity to bear on his individual life's ending. Everyman
hence sets forth the pattern of living as a person expecting
to die, "For after dethe amendes may no man make" (1. 912).

In drama as in the liturgy, the experiences of men's
lives and of history are integrated into a vision which tran-
scends everyday happenings. Though non-liturgical drama has
withdrawn from precise and abstract participation in the man-
ner of early medieval art, it nevertheless has this in common
with the ritualized plays of the liturgy: the drama formalizes
experience and makes it applicable to the particular events of
biography and history.

The encouragement of close identification of the individ-
ual with the model of manhood--i.e., Christ's humanity--in the
late Middle Ages meant that dramatic symbolism and action was
capable of revealing on both real and imaginative levels the
mysteries of the category of *becoming*. Jesus, particularly in
his incarnation, suffering, death, and resurrection, hence
brings to every person the *image* of perfectly realized manhood.
When Mercy in the morality play *Mankind* begins to perceive
that the protagonist will perhaps at last leave his unguided
ways, he prays, "O *pirssid Jhesu*, help þou þis synfull synner
to redouce."[5] The term *redouce*, which Eccles glosses (p. 262)
as "lead back to the right way," implies also the possibility
of return to the perfection lost by Adam. Even as called upon
in Mercy's speech, the *image* of the Savior bearing the wounds
of the Passion seems to have some effect.

The affective theology of the later Middle Ages meant, of
course, an altered climate for art and drama,[6] as the illustra-
tions of the Christ of Pity in so many woodcuts and other ex-
amples prove. The Christ of Pity in particular surely under-
lines the emotionalism of religious experience of the type
that is also depicted in such a play as *Mankind*. Gerhart Lad-
ner has called attention to the new psychology especially ex-
pressed in the writings of Hugh of St. Victor and Isaac of
Stella.[7] Here the role of the senses and of the imagination
are especially stressed as "intermediaries" which bring men to
a proper knowledge of the divine realities. Hence images in
art and scenes in drama would function in similar ways to
stimulate men toward experiences which reconcile man and God.

The process described above provides some contrast with

the usual intellectual position in the earlier Middle Ages with regard to images and visual representations. That position owes most perhaps to Pseudo-Dionysius, who argued that religious symbols will lead those who contemplate them upward toward the ultimate model upon which human life rests--i.e., to the deity who is beyond all symbols.[8] The universe itself for Dionysius was an imagistic emanation which accurately reflected the structure of Being. As Ernst Kitzinger notes, "the idea of the relationship between prototype and image as an all-pervading cosmic principle . . . provide[d] a justification for the spreading cult of images."[9] The earlier liturgical drama hence is more directly meditative, providing devotional tableaux for persons to see and contemplate. But the devotional aspect was not, of course, abandoned in the later plays[10] in spite of the new emphasis on sense and imagination.

The most obvious application of the modes of late medieval developments in thought surely involves the plays of the Passion in the late English vernacular cycles. In the image of Christ incarnate and crucified, the artists provided a meditative opening which was believed to provide direct contact with the Savior *and* the work of salvation. Ladner notes: "The image of Christ above all was believed to be in actual contact with Him in his divine-human unified person through the faithful rendering of a hallowed type of His physical appearance."[11] Hence in *Passion Play II* in the N-Town cycle, the Crucifixion culminates in a tableau showing the Savior on the cross along with his mother Mary and the apostle John-- a scene familiar everywhere before the Reformation from the rood normally placed in the rood loft of the English church. In the dramatization, John represents specifically the faith with which the audience is to look upon the emotion-filled event when it is re-enacted in the play, while Mary demonstrates the sorrow considered appropriate for those viewing the scene. Then immediately preceding the burial in this play, she again appears briefly in order to hold the body of Christ in the posture familiar from the visual arts. The stage directions at line 1139 indicate that when Christ's body has been taken from the cross by Nicodemus and Joseph of Arimathea, the latter *"leyth hym in oure ladys lappe."* It was to this scene in sculpture that Margery Kempe, as we have seen, reacted at Norwich with uncontrollable tears. In the drama, the emotional nature of the action is also stressed, for the Virgin gently kisses the "blody face" which is "pale" in death (ll. 1145-46). The tableau is, however, fairly quickly terminated without extending excessively Mary's lament over her "owyn son so dere" (l. 1144). This whole scene has been in the spirit of the Franciscan *Meditations on the*

Life of Christ, which likewise gave a role to Our Lady between
the Deposition and Burial.

The emphasis upon Christ's *humanity* which is implied in
the N-Town cycle furthermore has the function of stressing the
weaknesses and pain of the Savior. The *Meditations* similarly
insist on "true ymagynation and inward [com]passion of the
paynes and the passion of our lord jhesus,"[12] reaffirming the
human nature of Christ to which Anselm had drawn attention in
his *Cur Deus Homo*.[13] And as Walter Hilton insisted, "a man
shall not come to ghostly delight in contemplation of Christ's
Godhead, but he shall come first *in imagination* [italics mine]
by bitterness and by compassion and by steadfast thinking on
his manhood."[14]

II

When we turn from the Passion as represented in the N-
Town cycle to a segment of the York cycle which treats the
early life of Christ, we discover that the scenes seem to be
given substance dramatically by the late medieval fascination
with analyzing every possible aspect of the *humanity* of Christ.
This segment of the York plays will hopefully serve as an ex-
ample of ways in which drama is rooted in religious myth and
practice, which were made available for the theater through
the mediation of the visual arts. The following discussion of
the Infancy plays is not intended as providing methodological
limits for criticism; rather, the purpose instead involves the
tendering of commentary which hopefully will open some fruit-
ful directions for future work. It should be noted that the
analysis here is based on information collected for the subject
list of York art to be published in the Reference Series of
Early Drama, Art, and Music. In addition, considerable work
has also been done with other English as well as continental
art wherever relevant. No attempt has been made to develop the
kind of careful distinctions with regard to date that will be-
come possible at a later time when a substantial amount of
provincial English and some continental art have been subjected
to computer programming.

Plays XII-XX amd Play XLI, the misplaced *Purification of
Mary*, each appear to be constructed as dramatic forms designed
to display a set of speaking images which are devotional in
the sense that the complex representations of fifteenth-cen-
tury religious art are devotional. Hence each play is tightly
controlled by the images which determine its scenes; the
scenes themselves have at their center visual images at-
tached to traditional dialogue taken from such sources as the
liturgy, sermons, the *Meditations on the Life of Christ*, the

Golden Legend, and other writings of a similar nature.

The images are more often than not closely connected with the details noted in the well-known lists compiled in 1415 and c.1422 by Roger Burton, the town clerk of the city of York.[15] Thus Burton's description of the Pewterers' and Founders' pageant in 1415 calls for the following: "Maria, Josep volens dimittere eam, angelus eis loquens vt transeant vsque Bedlem."[16] What is significant here is that this description of the pagenat seems more than anything else like a definition of the essential images in the picturing of Joseph's doubts in the visual arts. The play which appears in the Register, which is of later date, also presents precisely these images, with Mary on one side praying, and Joseph expressing his unhappiness about being "begiled" by a woman mysteriously pregnant (XIII.64). His doubts, of course, will not be set to rest until, as Mary had promised, God sends him a sign. The angel comes to him as it had as early as the sixth-century ivory relief now in the Museo Arcivescoville, Ravenna,[17], where likewise the message of the angel is clearly that Mary's son is truly sent from heaven and that he should take his wife to "Bedlem" where "sall a childe borne be" (XIII.280-81). The bottom portion of the sixth-century ivory shows Joseph lovingly assisting Mary, who is very pregnant and riding on an ass, while the angel is helping to lead the animal. At the end of the York play, however, Joseph and Mary merely set out for Bethlehem, thus eliminating the need for a beast of burden in a play that would have been more conveniently played without such a creature.

As it now stands in the Register, however, *Joseph's Trouble about Mary* appears to contain some hints of alteration from the form it must have taken at the time of Burton's lists. The likelihood is that this play, which has its roots in *Matthew* 1.18-25 and the apocryphal *Protevangelium,* was somewhat en-larged in the early fifteenth century from a shorter version, which may have more closely resembled a speaking tableau. Joseph's complaints appear to be expanded so that Mary does not speak until line 89. Such expansion must surely have provided dramatic effectiveness not previously present, for Joseph's monologue cleverly gives us the impression of insight into a character at once basically fair-minded and somewhat irascible. He lacks the equanimity of mood observed in the young Mary of the Infancy plays, and hence helps to set up a lively contrast between one who feels he has been deceived and a woman whose perfection places her beyond deceit. The elaboration probably does not stop here. Two characters, not mentioned by Burton, are also introduced: two girls who mediate between Joseph and Mary. They are Mary's companions

and serve to speak up more bluntly in her favor than would
be permitted in the Virgin's own speeches. When one of them
insists that Mary has seen "noman" except "an Aungell" who
feeds her once each day (XIII.123-29), Joseph explodes with
the ironic accusation that the "Aungell has made hir with
childe" (XIII.135).

The kind of elaboration observed in this play has direct
affinities with the tendency in both art and architecture in
the fifteenth century to achieve more spectacular effects by
additions to existing designs and structures. Hence, for
example, architects designed intricate patterns for chantry
chapels within older cathedrals and churches. Likewise,
artists often set out during this period to draw, carve, and
paint a richness of detail that stands in contrast to the
style of earlier periods. The result was an unparalleled
lavishness and a multiplication of detail. Also relevant
is the fashion, which can be traced in York art, toward
expansion of the scenes of religious art and the development
of more complicated backgrounds.

In the plays as in the visual arts, rewriting and elab-
oration may have been in part a response to new styles and new
fashions in both iconography and design. Thus a new way of
visualizing the Nativity could attain wide popularity after
about 1420 and hence could begin influencing representations
in painted glass, alabasters, etc. This new iconographic
pattern, established by St. Bridget of Sweden through the
account of a vision of the birth of Christ in her *Revelations*,
informs the revised York Nativity play[18] as it does the painted
glass at Great Malvern (Chapt. V, Ex. J). In 1415 Burton had
listed *"obstetrix"* in addition to Joseph, Mary, the new-born
Child in the manger between the ox and the ass, and the angels
who will announce the birth of the Savior to the shepherds in
the following pageant. Now midwives had made their appearance
in the older form of the Nativity play, as in the Chester
cycle where they certify Mary's virginity and attest to Jesus'
divinity (*Chester* VI.537-76). In art before the early
fifteenth-century, Mary is normally in a bed, while the Child
appears between the ox and the ass. Joseph appears holding
his crutch--the symbol of his advanced age. The participation
of the midwives does not occur in extant York art or in the
records of the lost items from this city. In approximately
1420, the Nativity represented in a York Book of Hours (York
Minster Library MS. Add. 2, fol. 36) continues to utilize the
older iconography. The printed York Missal of 1533 and a
printed York Book of Hours of 1517, which are both books
printed on the continent, illustrate however the new form in
service books commissioned for the diocese. The latter

(fol. 10v) shows Mary and Joseph (with crutch) adoring the Child in a stable which is open but for a picket fence around it. The Child, who is nude and with a cross-nimbus, is lying on the ground, which is covered at that spot by the extraordinarily long gown of the mother.

In contrast to the Nativity play, the *Annunciation,* which is the opening pageant on the life of Christ in the York cycle, seems to appear in a less altered state. Its beginning introduces a Prologue who, if Burton's list is to be believed,[19] wears the costume of a doctor. The speech of the Prologue indeed would have provided quite an adequate introduction to a cycle stripped of its Old Testament plays, for it presents a recapitulation of the entire background for the events hereafter dramatized. Finally, at the end of his speech, the Prologue tells of action that must be pantomimed on stage: God commissions Gabriel to go to the Virgin Mary at Nazareth. These events, as M.D. Anderson has noted, are represented in the fifteenth-century transept bosses of Norwich Cathedral, where (1) God summons Gabriel, who holds "a curiously shaped staff"; (2) Gabriel walks out through the gate of heaven and (3) arrives at the door of Mary's house; and (4) the angel enters the house in order to (5) deliver the message of the Annunciation.[20] In the York play, the visual images dissolve into drama enlivened by speech when Gabriel begins *singing ("tunc cantat angelus")* his well-known message to Mary:

> Hayle! Marie! full of grace and blysse,
> Oure lord god is with þe,
> And has chosen þe for his,
> Of all women blist mot þou be. (XII.145-48)

These are the words which often appear in abbreviated form on a scroll in the visual arts, as in the full page illumination in a York Book of Hours (York Minster Library MS. Add. 2, fol. 35v) and in some examples of painted glass at York.[21] The angelic song shortly continues, bringing the divine "bodword" or message to the Virgin who will chastely bring forth a Son who "sall be God and called God sonne" (XII.153-62).

Presumably, while Gabriel is intoning these words, he kneels before the Virgin--a posture that establishes the central image within this play and communicates its attitude of devotion to the audience. This is the posture that the angel assumes in the miniature cited in the York Hours (cited above), in an important representation of the Annunciation in one of the nave windows of York Minster (Window 32), and in the *Biblia Pauperum.*[22] It is, however, with less certainty that we approach the posture of Mary at the opening of the play. While in the visual arts associated with York Mary is

often standing (at the right) before the angel (who is on the
left), the play might well have presented her at first in
prayer. Painted glass in St. Olave's Church, York, has been
described as follows: "[She] is rising from a chair with her
l[eft] hand still holding the page in the book from which she
was reading before the coming [of] St. Gabriel. The book rests
on a richly covered lectern which at first sight looks like
a part of her dress."[23] Mary at prayer is widely illustrated,
as in the manuscript illumination, which has been connected
with York, removed from the Rennes Psalter and now in the
Beaufort Hours.[24] In *Joseph's Trouble about Mary*, she is
described as sitting "at hir boke full faste prayand" (XIII.81),
a posture that also would have been recognized as thoroughly
traditional.[25] When she is represented with a book in late
medieval art, it is sometimes open at *Isaiah* 7.14,[26] a passage
which has been quoted by the Prologue at line 61 (*"Ecce uirgo
concipiett, et pariet filium &c."*). At Great Malvern, the open
book appears on a prayer desk before which Mary kneels with
raised hands.[27] Whether standing, sitting, or kneeling, how-
ever, at least one of her hands normally is raised in surprise
and expectation, or her hands are placed across her breast.

In the visual arts, Mary's response to the angel's words
was sometimes represented, as in the glass at Great Malvern
and in the *Biblia Pauperum*, through her words "Ecce ancilla
domini fiat michi secundum verbum tuum" on a scroll. The
words are translated in the York play as follows:

> Goddis handmayden, lo! me here,
> To his wille all redy grayd,
> Be done to me of all manere,
> Thurgh thy worde als þou hast saide. (XII.189-92)

It is during or immediately following this speech that the
miraculous conception takes place. The angel already has
promised that "The Holygast in þe sall lighte" (XII.177),
and now, apparently kneeling as in the *Meditations on the
Life of Christ*, she comments on her love for God, speaks the
words quoted above, and is impregnated by the Holy Spirit.
"þus," says John Mirk in a sermon in his influential *Festial*,
"scho conceyued our Lord Ihesu Crist in euerlastyng joy to
all þe world."[28]

There are no stage directions in the York play to indicate
what visual effects are involved. Most likely a dove repre-
senting the Holy Spirit descends, as in some examples in York
glass and in perhaps a majority of late medieval Annunci-
ations. We have evidence from the fourteenth century that the
dove was utilized in liturgical drama on the continent.[29] The
technology for the descent of the dove would be similar to that
utilized for the birds sent out from the ark in Play IX, where

carved or ceramic birds are apparently made to move along a
string between one location and another. In the Annunciation,
the string or strings might appropriately be gilded to repre-
sent divine light. One alternative to the dove might be a
miniature doll, representing the soul of Christ, descending in
a like manner from heaven, as in certain works of art influ-
enced by Franciscan theology.[30] Thus in the Merode Altar-
piece by the Master of Flemalle, a tiny figure representing
Christ's soul carries a miniature cross (to illustrate the
connection between the Incarnation and the Crucifixion) and
descends toward the Virgin. Evidence for this iconography
exists in York art. In the illumination in a York Book of
Hours (York Minster Library MS. Add. 2), the soul of Christ
is shown along with the dove--a not untypical arrangement.
In the Joys of the Virgin Triptych at Danzig--an alabaster
carving probably produced at York--the Child in his descent
from the mouth of the Father holds a cross over his shoulder.[31]
Finally, it is also possible that the descent of the Holy
Spirit may have been represented merely by beams of light (as
indicated, perhaps, by gilded strings or cords, or more
spectacularly by burning tow) which reach from the Trinity in
heaven to Mary. But in the midst of our uncertainty, one
thing is certain: some kind of visual effect is definitely
needed to preserve the integrity of the image which is at
the heart of this scene in the York play. The conception of
Christ is in many ways the most important moment within
history, for it is the moment when the Incarnation takes
place. Medieval audiences would have expected this supremely
significant image not to be excluded from the play. Repre-
sentations of it in drama must have been a solemn reminder
to pious Christians at York that their Savior became man as
an expression of divine love.

 Immediately after the Annunciation, Play XII in the York
cycle shifts to another scene which is again ordered around a
precisely defined devotional image. The topic is the Visit-
ation, in which Mary goes to Elizabeth. This is normally the
scene which follows the Annunciation in the visual arts. In
an early fourteenth-century painting by Pacino di Bonaguida,
both episodes are illustrated within a circle placed on a Tree
of Life: the Annunciation is on the left, with the Child and
the rays of light breaking the circle, and the Visitation is
on the right.[32] The latter event was particularly emphasized
by the Franciscans, among whom it came to be celebrated as a
feast day which thereafter (in 1389) entered the calendar of
the whole Church.[33] But the scene had been long popular in
art, and had appeared in England as early as the seventh
century when it was carved on the Ruthwell Cross.[34] Only two

extant examples of the scene are to be found in York art: a
panel of painted glass dated 1296-1310 in the Northeast Window
of the Chapter House, and a damaged voussoir dated c.1200
formerly in St. Mary's Abbey and now in the Yorkshire Museum.
The image as presented in the York play is designed to elicit
devotion to the Virgin, who appears here as the Mother of God.
Tender emotion is joined with gesture--a touching of hands or
an embrace--and a ritual act of blessing in which Elizabeth
speaks the famous words "Blissid be þou anely/ Of all women in
feere,/ And þe frute of thy body/ Be blissid ferre and nere"
(XII.205-08). At the end of the play, a sixteenth-century
hand has indicated that the *Magnificat* be sung *("tunc cantat")*
presumably in Latin and by Mary.

Music also provides a very natural addition to visually
perceived devotional image in the presentation of the play of
The Angels and the Shepherds. The angels have been made ready
for their song during the previous play, according to Burton's
1415 list.[35] The song is not recorded in the Register, but its
text is clearly the standard biblical item. The words of the
announcement to the shepherds are actually sung by a single
angel, who perhaps even comes down to the three shepherds and
stands before them as in a panel of painted glass in the North-
east window of the Chapter House at York. But the shepherds
too are Musicians, and they attempt not only to imitate the
angelic song at lines 63-64 but also to "make myrthe and melody"
as they seek the Child "with sange" (XV.84-85). In the earlier
Shrewsbury Fragments upon which the York play may be based,
the third shepherd comments: "For solace schal we syng/ To
seke oure Saueour."[36] In iconographic tradition, the shepherds
to whom the announcement is made had been musicians as early
as the sixth century.[37] They play bagpipes in the *Holkham
Bible Picture Book*, fol. 13, and in an embroidered fourteenth-
century band in the Victoria and Albert Museum.[38] The same
instrument is held by one of the shepherds in *Queen Mary's
Psalter*.[39] In a panel of painted glass attributed to "Artist
B" and dated 1330-39 in the nave of York Minster, one of the
shepherds holds bagpipes, but unfortunately this figure in
glass of otherwise good condition was missing in the post-war
restoration.[40] The restored figure is of little or no value
for the purpose of throwing light on the drama. The glass of
Great Malvern also shows the scene, with an angel above and
below shepherds, one of whom holds a pipe.[41] In the Coventry
Pageant of the Shearmen and Taylors (11. 309-11), the first
shepherd makes a gift of his pipe to the Christ Child:

> I haue nothyng to present with thi chylde
>> But my pype; hold, hold, take yt in thy hond;
>> Where-in moche pleysure that I haue fond.[42]

The first shepherd in the York play also must be an instru-
mentalist, for he too offers to give the Child his "horne"
(XV.77)--a promise that he does not, incidentally, carry out,
for his gift will be a brooch with "a belle of tynne" (XV.103).

In the York play, a star has appeared in the sky (XV.15),
where it presumably will remain until the Magi also have made
their way to the Child. In the Coventry Nativity play (1. 588),
a child appeared in the star. The *Shrewsbury Fragments* speak
of "Zone brightnes" which "wil vs bring/ Vnto þat blisful boure"
(A.29-30). The star, according to the *Golden Legend*, was
extremely bright and "was not fixed in the firmament, but hung
in the air near the earth."[43] It is, of course, by following
the star that the shepherds find their way to the Nativity
scene where they will adore the Infant. As a separate scene,
the Adoration of the Shepherds is fairly late in medieval art.
Only one example of this scene is to be found in York art, and
that is in a sixteenth-century Flemish woodcarving now at the
Bar Convent. The scene received impetus from the Franciscan
emphasis on poverty and the friars' observation that Christ's
birth was first announced to the poor.[44] While the shepherds'
gifts of a bob of cherries, a bird, and a ball in the Towneley
Secunda Pastorum specifically reflect Christ's Passion, Resur-
rection, and ultimate sovereignty,[45] the gifts in the York
Angels and the Shepherds seem only to underline the humility
of the participants in the scene of adoration. As in the
Shrewsbury Fragments (A.43), the third shepherd in the York
play gives a horn spoon (XV.124), while the second gives
"Two cobill notis vppon a bande" (XV.112). As has been noted,
the first gives a brooch. The audience at this point is en-
couraged to imagine that it is present at the events being
depicted.

After the shepherds depart "mak[ing] mirth as [they]
gange" (XV.131), the story continues rapidly through the
following pageants, which also follow the pattern which has
been established of organization about central images shared
with the visual arts. These images very likely have their
source in the *tableaux vivants* of the early Corpus Christi
procession. There is, to be sure, some confusion in the
Register about the texts of Plays XVI and XVII, for an
identical section of more than 140 lines is recorded in both
plays. But the scenes which are set forth are nevertheless
again structured about elements familiar to art historians.
Herod, as tyrant, who at the opening of Play XVI makes false
claims to sovereignty, here enters the cycle as the dangerous
antagonist of the Child. The king is the irascible man whose
anger is expressed vividly in the famous roof bosses at
Norwich.[46] His unreasonable expectations underline the false

grandeur of his court, enriched in the play by the presence of
musicians after the Minstrels took over the presentation of
The Coming of the Three Kings to Herod in the sixteenth century.
Herod first appears in his court, perhaps wearing a dark mask[47]
and through his appearance belying his claim to beauty when he
brags about his freshness and fairness "of face" (XVI.17-19).
The soldiers, setting the tone for the Massacre of the Innocents
which is the logical outcome of the tyrant's malice, insist
that they will "with countenaunce full cruell" put down any
rebellious subjects (XVI.43-44). Then the three kings appear
at court in a scene illustrated in a panel of painted glass
in the Northeast Window of the Chapter House at York and in
a miniature in *Queen Mary's Psalter*.[48] The latter repre-
sentation is particularly interesting because it shows Herod's
crown slightly askew on his head.

If it is possible to make judgments on the basis of
Burton's list of 1415, we may assume that the matter of Play
XVII contains the earlier form of the presentation of the
coming of the Magi. Here the meeting of the three kings, who
are independently traveling to Jerusalem, is represented. All
of them are following the star. Unlike the meeting of the
three Magi in the *Tres-Riches Heures* of the Duke of Berry, the
kings in the York play are not on horseback and they do not
have large retinues. However, it seems evident that at some
point this scene was dropped entirely in favor of the more
lively episode at court shown in Play XVI, which then would
provide dramatic background for the meeting of Herod and the
three kings. The news they bring, as we might expect, causes
Herod to explode with anger. "Nay," he insists, "I am kyng
and non but I" (XVI.125). In the next play will be the famous
episode from the Christian story as told in the visual
arts, for the Magi will here kneel one at a time before the
infant and present their gifts. This, along with the Annunci-
ation and the Nativity, is one of the three subjects chosen
from the life of Christ prior to his death for the roof bosses
formerly in York Minster.[49] In the *Biblia Pauperum* and in the
glass at Great Malvern, the eldest king, his crown placed on
the ground beside him, is kneeling in adoration before the
Mother and Child while the other two kings stand by awaiting
their turn.[50] Other similar examples from York include the
earlier glass contained in one of the lights of the East Window
of the North Aisle in All Saints, North Street, York, where
the kneeling king holds his crown as he presents the gift of
a gold cup. In contrast to the impious Herod, whose sovereignty
seems to him to be deeply threatened by the news of the arrival
of the Christ Child, the pagan kings (whose names, according
to the tradition reported by the *Golden Legend,* are Gaspar,

Balthasar, and Melchior) are not afraid to put aside the
symbols of their sovereignty in the face of a greater power.
Like the wise shepherds who in Play XV appear to know the
significance of the Incarnation in advance (XV.1–32), the
kings understand remarkably well the means of salvation which
is being offered to mankind. The audience likewise through
the devotional image is encouraged to understand the events
in the same manner. The medieval interpretation of such visual
displays in art hence becomes the basis for the spectacle of
speaking images in drama.

When the Magi have offered their gifts to the Child,
they set forth again apparently on foot to return to the
envious Herod, who, they have been deceived into thinking,
will "come hym-selffe and make offeryng/ Vn-to þis same"
(XVII.307–08). However, at this point the third king, Bal-
thasar, suggests that they "reste a thrawe" (XVII.309). This
bit of unmotivated action is necessary to set the scene for
the next event to be presented: the angel will come to the
sleeping kings to warn them that Herod "has malise ment" and
that they should go home by "othir waies" to their countries
(XVII.317–21). No examples of this scene have been recorded
in York art, but if representations such as the miniature in
Queen Mary's Psalter are to be taken as a guide, the three
kings, all wearing their crowns, would need to get side by
side into a bed where, once they are asleep, the angel would
appear to them.[51]

Following the Adoration of the Magi is, according to
Burton's list, the rather long (459 lines) play of *The Pur-
ification of Mary*, which was finally entered in the Register
in 1567 but not in its proper place.[52] Instead, the scribe
placed it where there was space between *The Travellers to
Emmaus* and *The Incredulity of Thomas*. The action takes place
forty days after Jesus's birth, when, according to "Moyses
lawes," the mother must undergo the rites of purification
(XLI.191–95). So Mary and her husband are required to take up
"ij dove byrdes" and "a lambe" for their offering (XLI.237)
and go to the Temple. The Christ Child himself is "the lame
of God," they recall (XLI.263), and hence they are able to
eliminate the need for the second and more expensive offering
which they otherwise could not afford. Thus they will arrive
at the Temple with only the two doves, which they carry in a
"panyer" or basket, and their infant. When they have entered
the Temple, they kneel and "offre . . . vp to God meekly/ our
dewe offrand" (XLI.280–81). After the presbyter has prayed to
God that their offering might be accepted, the prophetess Anna
appears—and an angel tells Symeon to go forth to the Temple.
When he arrives, he too praises the Virgin and her Son in a

long speech which culminates in his famous "In peace lorde, nowe leyf thy servand,/ for myne eys haith seyn that is ordand . . . " (XLI.415-16). The scene is designed to bring together all the elements normally present in representations in the visual arts, as three examples from York Minster glass will show. In glass in the nave (Window 32), Mary is holding the Child before the altar, and he is reaching out to Symeon, who stands behind the altar and is dressed in full liturgical vestments with an amice at his neck and an elaborate but oddly obsolete mitre on his head. Joseph holds the basket with three doves.[53] Anna and another figure, apparently wearing a dalmatic, look on. The later (fifteenth-century) glass in the Holy Family Window (Window 17) shows the holy mother and Joseph kneeling at the steps to the altar. Symeon, beside the altar in his vestments, receives her. Because of its date, this example is more important than the nave glass or the glass in the south choir clerestory (Window C6), which is also fourteenth-century. An interesting window at Fairford of later date than any of the York glass presents some similar features but also some significant variations. Here Mary has a servant who with one hand holds a bird cage of wicker which contains two doves, while with the other hand she holds a candle.[54]

The candle in the Fairford window is not unique. One of the women in a representation of the Purification in a window at Great Malvern also holds a candle, as does Anna in the *Biblia Pauperum*.[55] Mary herself and other figures hold candles in an alabaster discussed by W. L. Hildburgh and in the illustration in the *Speculum Humanae Salvationis*.[56] The candles definitely appear in the Chester play in which Joseph speaks: "A signe I offer here alsoe/ of virgine waxe, as other moo,/ in tockeninge shee hase lived oo/ in full devotion" (XI.143-46). Surely candles would also be appropriate in the York play, for Symeon has spoken of God's "light" which has "shynyd this day" (XLI.421). Indeed, the Purification was specifically remembered in the York calendar on February 2, a feast day popularly known as Candlemas.[57] As Mirk notes, "holy chyrch maketh mynde þys day of candels offryng. Ȝe seen, good men, þat hyt ys comyn vse to all crysten men forto come to þe chyrche þys day, and bere a candyll in processyon, as þagh þay ȝedyn bodyly wyth oure lady to chyrch, and aftyr offr wyth hyr yn worschip and high reuerens of hur."[58]

Following the ceremonious occasion celebrated in *The Purification,* the York cycle turns in quick succession to two other scenes extremely well known through representation in the visual arts. *The Flight into Egypt* (Play XVIII) and *The Massacre of the Innocents* (Play XIX) are again organized about specific images normally shown with devotional purpose in the

visual arts. *The Flight into Egypt* hence opens with intro-
ductory matter that prepares the way for Joseph's second dream
in which the angel Gabriel warns him of the danger:

> For Horowde þe kyng gars doo to dede
> All knave childer in ilke a stede,
> þat he may ta
> With ʒeris twa
> þat are of olde. (XVIII.55-59)

After the vision, Joseph prepares Mary for the trip, which will
shortly begin after a little domestic argument such as the
Middle Ages loved to depict in drama, narrative, and the visual
arts. The beginning of the journey may have differed from
extant York illustrations in painted glass and stone since, in
spite of the reference to riding at lines 205-06, it is not
altogether certain that the usual ass was present in the acting
area. Such a limitation could have been imposed on the play
by the conditions of processional production. The lack of an
ass might also explain why further scenes from the journey to
Egypt and the arrival there of the holy family were not recorded
in the drama, but it should also be noted that these additional
scenes associated with the Flight are nowhere evident in York
art.

The *Massacre of the Innocents* is one of the liveliest and
most moving plays in the entire cycle. While the York play
does not achieve the consummate art of the earlier Fleury
drama included by Noah Greenberg and W. L Smoldon in their
edition of *The Play of Herod* (1965), it nevertheless is
extremely spectacular and moving in its own right. Herod
here will open the pageant with a rambling speech in which he
stresses again his sovereignty and his devotion to "Mahounde."
It soon is revealed that he has been "noyed of new" ever since
the three kings passed through on their way to see the Child
Christ. The audience is thus prepared for his explosion into
anger when he hears that the kings have returned to their own
countries without advising him with regard to the infant Jesus.
His anger is indeed so extreme that he will become calm only
after his counsellors have advised the killing of *all* male
children of Jesus' age in the area of Bethlehem.

The events which follow are clearly recorded in painted
glass, manuscript illuminations, etc., from England and the
continent. In a voussoir from St. Mary's Abbey, York, too
early (c.1200) to be of much value for potential light thrown
on the late medieval drama, King Herod is shown sending out
two soldiers to do their terrible work. Elsewhere in examples
from the visual arts, soldiers, who are dressed like contem-
porary knights, move quickly into the platea, where they proceed
to kill young children. The children are normally nude as a

symbol of their innocence, and some of them are accompanied by
mothers who react understandably with anger and hysteria. As
in so many representations of the event in the visual arts,
the soldiers' actions are set off against the king on one
side where he is watching and taking a kind of angry and vi-
carious pleasure in what is going on. In some examples such
as a panel in the East Window of St. Peter Mancroft, Nor-
wich, Herod from his throne actually participates in the but-
chery by brutally hacking an infant to pieces. At Fairford,
he appears alone and is prominently stabbing a child. The
excellent glass in a light in one of the windows in the South
Choir Clerestory at York Minster shows the tyrant likewise en-
couraging the dreadful strokes of the soldiers and even par-
ticipating in the carnage. Here a soldier in plate armor
holds up a sword with a tiny child impaled upon it, while a
mother in grief leans over a richly decorated cradle--per-
haps a cradle holding Herod's own son, who, according to the
Golden Legend, was killed with the rest.[59] More is made of
the conflict between the mothers and soldiers in the glass in
St. Peter Mancroft, where at the top a woman is violently at-
tempting to restrain a soldier who has impaled her infant on
his sword. The woman is reminiscent of the mothers in the
York play who will die if necessary to save their dear sons
(XIX.199-201, 204-06). In the play, the hapless infants are
surely represented by cloth dolls or dummies which are vigor-
ously slashed by the mean-spirited soldiers.[60] When the
atrocities are completed in the York play, the soldiers leave
the platea and return to Herod, to whom they report their
deeds. That he has in fact been looking on from his throne
all through the massacre does not remove the need for the
soldiers' report, which functions as a final speaking tab-
leau which will show Herod's failure to be satisfied con-
cerning Jesus' death. His failure to be satisfied will set
off, of course, a final towering rage. He fears (correctly)
that "þat boy be fledde," and insists that he will not be
able to sleep till he is destroyed (XIX.270-73).

The series of devotional images which are at the core of
the scenes telling the story of the early life of Christ ter-
minate in the illustrations that accompany the episode of the
twelve-year-old Christ among the learned men in the Temple.
This episode is given dramatic representation in the York
play of *Christ with the Doctors in the Temple* (Play XX),
which presents (1) the discovery by Mary and Joseph on the
road from Jerusalem that the Son is missing, (2) Christ's
participation in a disputation in the Temple, and (3) his re-
covery by his parents. Of these, only the first is not found
in the visual arts, though the second and third are normally

brought together within a single illustration. Hence most common is the depiction of the moment when Mary and Joseph (now a very, very old man who, as in *Queen Mary's Psalter*,[61] may use a cane) arrive on the scene. In the Magnificat Window at Great Malvern, the Child, who is sitting on a throne, is encircled by the doctors, who are dressed in academic garb, including gowns with hoods and black caps.[62] A single example at York in the choir of the Minster (Window 13) shows the young Jesus seated in the center, with the professorial Jews in gowns with tippets and hats around him. In this scene, Joseph and Mary have just arrived, and the Child is looking in their direction.

Examination of the York play will show that the scholastic argumentation, which begins with the first Magister's *question*, is not to be taken too seriously.[68] It is the *image* which is at the heart of the scene which is being presented here. In a sense, the audience is intended to receive something of the flavor of a medieval argument in a university without much of the substance. Before Christ has really proven himself to be wise through any statements, the Child is invited to sit in a master's chair! (XX.95). The devotional image at the core of the play involves a Child who has not received education and yet who causes the most learned holders of masters' and doctors' degrees to respect him.

As this analysis of the Infancy pageants in the York cycle has demonstrated, the connection between the medieval understanding and practice of the religious image as presented in art provides the basis for far-ranging criticism focused on the early vernacular drama in England. Detailed examination of the plays which deal with the early life of Christ indicates that the visual elements illuminate their structure and development. Hence the study of the plays against a background of medieval art has a kind of validity that goes beyond the critical intention merely to "supplement" the usual strictly literary approaches. The idea that "men mowen bettere reden the wille of God and his mervelous werkis in the pleying of hem than in the peyntynge" links drama, as we have seen, with art. When applied to the plays of the York cycle, such a concept provides a key not only to a possible historical link between the plays and the images presented as *tableaux vivants* in the earlier Corpus Christi procession, but also to the design of the plays themselves.

<center>III</center>

The critical approach represented above is intended to show what can be accomplished when local and other art have

been systematically studied against the background of other
available information. Such kinds of evidence, when applied
to dramatic records and similar sources of information, can
also greatly illuminate dramatic activity even when the play
books are not extant. The talents of the scholar and the
critic are capable of being joined in the task of recovering
as much as possible of lost plays, which often are of the
greatest significance. Here, of course, careful and systema-
tic work is essential, especially with regard to dating of art
objects and to understanding of the dissemination of icono-
graphic details as well as of stylistic features associated
with various subjects. Certainty may not in every case be ob-
tained, but nevertheless the potential is present for greatly
broadening our understanding of the early drama in England
and on the continent as well.

Even when we examine the extant text of a cycle such as
the Towneley plays, which most scholars (but not all) believe
were performed at Wakefield in West Yorkshire, we cannot ig-
nore the fact that the manuscript is incomplete. One of the
segments which is missing occurs between fols. 121v and 122r,
and involves, as Martin Stevens has demonstrated, a lost set
of twelve leaves that were removed from the manuscript, pre-
sumably to satisfy Protestant reformers in the sixteenth cen-
tury, between the plays of the *Ascension* and the *Last Judg-
ment*.[64] Along with portions of these two plays, Stevens ar-
gues, as many as four plays (including possibly *Pentecost,* a
Death of Mary, an *Appearance of Our Lady to Thomas,* and an
Annunciation and Coronation) may have been excised. Stevens
argues strictly from a comparison to the York plays, and in
conclusion indicates his belief that "it is even possible
that fewer than four plays are missing."[65] Hence we can sur-
mise that, even if the texts of the Towneley plays were widely
different from York, the central images and action of the
most important items--*Pentecost, Assumption, Coronation of
the Virgin*--can be provided with some certainty.

There remains the possibility, of course, that other
plays were also present in the missing leaves, but the fact is
that we can logically now assume at least a minimum content.
The study of art can help to fill in the gaps, and we know
from various medieval sources the incidents which were il-
lustrated and dramatized. Of course, more precise work with
regard to these missing plays should be delayed until the art
and other evidence from West Yorkshire are carefully sur-
veyed.

More elaborate tasks of reconstruction remain elsewhere.
The Coventry plays are nearly lost. The play texts remain for
only two of the plays: one dramatizes the events of the Infan-

cy and the other the Presentation in the Temple. However,
through the dramatic records which fortunately have been re-
corded and through other kinds of evidence, including art, we
should eventually be able to have a much more complete pic-
ture of drama at Coventry.[66] In the case of the York Creed
Play and the apparently widespread Pater Noster plays, we do
not have any play books whatsoever with which to begin the
work of recovery.

The Creed Play at York was very likely the work of Wil-
liam Revetour, a chantry priest who left the play book and
other equipment belonging to the play to the Corpus Christi
Guild in 1446.[67] The play book was identified in 1465 as
containing 88 leaves--a composition of considerable length.[68]
Twelve pageants were apparently included in the play--one for
each of the traditional segments of the Apostles' Creed--and
these were presented processionally, as the presence of ban-
ners would indicate.[69] This play, which was originally de-
signed to be presented "openly and publicly" by the City as a
means of instructing "the ignorant" in the knowledge of the
Creed,[70] was nevertheless considered grand enough to be
staged for King Richard III in September of 1483.[71] Unfortu-
nately, the play book for this drama disappeared after the
final attempt to stage it in 1568.[72] Professor Johnston in
her important recent work on the play reproduces M.D. Ander-
son's list of possible subjects for each of the twelve pa-
geants, which seem related to the examples in painted glass
at Great Malvern and in book illumination in the Arundel
Psalter.[73]

Based on careful examination of the civic records and on
Miss Anderson's scheme, Professor Johnston has arrived at a
conjectural reconstruction of this series of pageants at
York.[74] With some corrections and alterations, much of her
chart showing the pageants' subjects can be retained, as we
shall see below. Some additional evidence does need to be
taken into account, and this includes the painted glass now
in the north clerestory of the Lady Chapel (Windows C1 and
C2) in York Minster. In glass dated c.1390 and perhaps the
work of John de Burgh, C1 presents St. Peter, St. Andrew, St.
James the Greater, St. John, and St. Thomas in the order they
are named in the canon of the Mass, each with his appropri-
ate segment of the Apostles' Creed on a scroll.[75] The placing
of St. Bartholomew and St. Matthew with further segments of
the Creed in Window C2 supports the order of apostles accepted
by Johnston. However, the deliberate appearance of the pro-
phets David, Amos, and Daniel flanking the apostles in C2 fur-
ther suggests that the Creed Play might also have utilized a
typological arrangement of some sort. While the fifteenth

century glass apparently painted at York and formerly at Hampton Court, Herefordshire, underlines York interest in the Creed arrangement of the apostles,[76] no hint is present in it to suggest typological arrangement. Yet, since the Creed Play set out to be educational "ut crede porteratur ad ignorantium,"[77] each pageant could very likely have included the presence of prophets foretelling the events which would follow--events which themselves would then receive immediate representation on the pageant wagons.

Once the scheme of prophets and apostles is tentatively established at York, we can, however, also extend our search to other similar examples of representations of the Creed in the visual arts. These are not hard to find, for, in addition to the example in the Arundel Psalter utilized by Miss Anderson, the so-called Credo tapestries and woodcuts of continental provenance are well known. An excellent description of the entire organization of such designs in art is contained in an article by D.T.B. Wood in the *Burlington Magazine*.[78] From the evidence of the Credo design, a revised scheme for the York Creed Play as set forth in the accompanying chart on page 121 may be advanced. My theory is that both the prophet and the apostle for each play would make an appearance, and that these would essentially stand outside of the action illustrating such topics as the Baptism of Christ or the Harrowing of Hell. In the instance of Isaiah, the prophecy is "Ecce virgo concipiet et pariet filium"--a direct foreshadowing, as we have seen, of "Who was conceived by the Holy Ghost, born of the Virgin Mary." Hence the play would contain representations of both the Annunciation *and* the Nativity, as in the case of the Credo tapestries. The prophecy indicates exactly the content of the pageant. The glass in the Minster shows Amos with an inscription which, though hard to read, apparently is "qui edificat in coelum ascensionem"--a prophecy foreshadowing the Ascension. Likewise the words associated with Daniel seem to be "post ebdomadas sexaginta duas occidetur Christus" ("after threescore and two weeks shall Messiah be cut off," *Dan.* 9.26, AV), which clearly point to the Passion and Crucifixion. David in York glass appears with a text from Psalm 2.7: "en filius meus es tu--ego hodie genui te."[79] While some variations are present in the York and other English examples with regard to the order of the apostles and the prophets as well as their prophecies, the evidence nevertheless supports the understanding of the Creed which underlies the design of the Credo tapestries and very likely the Creed Play of York. Such organization would be in line with examples of the Creed arrangement elsewhere, as at Fairford and at Kenton, Devon.[80]

The Pater Noster Plays, for which records are extant at

THE YORK CREED PLAY

Sentence	Prophet	Apostle	Subject of Pageant
1. I believe in God	Jeremiah	Peter	Creation, Adam and Eve
2. In Jesus Christ	David	Andrew	Baptism of Christ
3. Who was conceived	Isaiah	James Major	Annunciation, Nativity
4. Suffered under Pontius Pilate . . .	Daniel	John	Trial before Pilate, Bearing the Cross, Crucifixion, Burial
5. He descended into hell	Hosea	Thomas	Harrowing, Appearance to BVM
6. He ascended into heaven	Amos	James Minor	Ascension
7. From thence he shall come	Joel	Philip	Doomsday
8. I believe in the Holy Ghost	Haggai	Bartholomew	Pentecost
9. The Holy Catholic Church. . . .	Zephaniah	Matthew	Holy Church
10. The forgiveness of sins	?	Simon	Confession
11. The resurrection of the dead . . .	Ezekiel	Jude	General Resurrection of all who have died
12. The life everlasting	Obadiah	Matthias	Life Everlasting

Beverley, Lincoln, and York, were, according to the evidence
at Beverley, dramatic presentations of the Seven Deadly Sins.
The Beverley play, recorded in 1441 and 1467, included eight
pageants featuring actors representing the seven sins begin-
ning with "Pryde" and ending with "Luxuria" in addition to
"Viciouse,"[81] the latter being apparently an example of the
Vice of English dramatic tradition. In 1467, the pageant of
"Viciouse" was the responsibility of the town elite--gentlemen,
merchants, clerks--assisted by the servants, while the seven
other plays were divided between more than three dozen crafts.
Presentations were given processionally at eight stations.[82]
At York similar subject matter is certain, for an extant docu-
ment from 1388-89 indicates that the play, which had been first
mentioned c.1378, involved the condemnation of sins and vices
and the commendation of virtue.[83] Both Miss Anderson and Pro-
fessor Johnston stress the importance of the homiletic tradi-
tion as a source of information about the manner of attaching
vices and virtues to the petitions of the Lord's Prayer.[84]
Thus it would seem most sensible in the final analysis to re-
turn to the evidence of art and hence to see the Pater Noster
Play as somehow connected with the visualizing of the Seven
Deadly Sins and corresponding virtues. Miss Anderson's ex-
amples are useful but not sufficiently localized with regard
to place and date, yet they provide some allegorical figures
which, sharply visualized, could well have taken part in the
Pater Noster plays at Beverley, York, and Lincoln.[85] As the
Digby *Mary Magdalene* shows, the participation of such sins as
characters is not inconsistent with drama based on the events
of Christian history.

More exact information than is currently available is al-
so possible with regard to the lost York play on the topic of
the Funeral of the Virgin.[86] The York Register contains no
text for a Funeral of the Virgin play, but Burton's list of
1415 describes it as follows:

> Quatuor Apostoli portantes feretrum Marie, et
> Fergus pendens super feretrum, cum ij aliis
> Judeis.[87]

In Burton's other list, the play is identified as belonging to
the masons (in 1415 it had been given to the "Lynweuers") and
is entitled *Portacio corporis Marie.*[88] The other extant drama-
tic records allow us to follow this drama, which apparently
had been discontinued in 1485 though references to the play
appear in the records as late as 1518.[89] Most interesting is
a complaint attributed in 1431 to the masons; it was said by
members of another guild that the play "ubi Fergus flagel-
latus est" was not considered appropriate, since it presented
an apocryphal legend and because it raised laughter and even

blows *rather than devotion* ("magis risum et clamorem causbat quam devocionem, et quandoque lites, contenciones et pugne inde proveniebant in populo").[90] What is clear here is that *Fergus* (the name for the *Portacio corporis Mariae* which is derived from the name of the Jew who attempted to overturn Mary's bier) inspired crowd reaction not to the liking of the craft responsible for the play. The audience's anti-Semitism apparently brought a halt to the playing of the drama, and consequently it was ordered eventually to be "laid apart."

"Fergus" had been present in York art since at least the twelfth century, when the funeral procession of the Virgin was illustrated in the psalter now in the Hunterian Museum of the University of Glasgow (MS. U. 3. 2, quire 5, fol. 2). Continued familiarity with the scene in local art is demonstrated through the presence in York today of two examples in glass in the Chapter House and the Minster, though neither is as late as the fifteenth century. Fortunately, the scene is also represented in an elaborate woodcut in the York Book of Hours printed on the continent in 1517. From these sources the central tableau of the missing York play can be conjecturally reconstructed, though of course careful attention must also be given to everything that can be discovered about the legend from other sources.[91]

Recovering the Lincoln play of the Assumption as produced by the cathedral rather than the city from approximately the middle of the fifteenth century[92] involves considerably more risk, since the records are much more sketchy than in the case of *Fergus* at York. The Lincoln Assumption was probably (but not necessarily) in Latin, and we do not know if the dialogue was spoken or sung. That it continued until the middle of the sixteenth century does not prove very much, since liturgical drama did survive until the Reformation. We know from the records, however, that the drama included both the scenes of the Assumption and of the Coronation of the Virgin. For these scenes we can, of course, visualize with reasonable certainty the iconography and even some of the staging that might have been utilized. Earlier examples in art in the cathedral at Lincoln as well as later illustrations of these scenes elsewhere in English and continental art show which elements are constant and which are flexible in the representations for the period.

The Coronation of the Virgin is shown in a late thirteenth century roof boss in the choir at Lincoln Cathedral and on a mutilated misericord from the next century. While these are considerably earlier than the lost play, they nevertheless show details that are worth noting. Christ in each of the examples appears alone on the right with his right hand raised in the

direction of the Virgin's head. In the boss, she is already
crowned, and his right hand indicates his blessing while his
left holds a book. Unfortunately, both the head of the Virgin
and his right hand are missing in the misericord, which, how-
ever, has Christ holding an orb in his left hand and wearing a
mantle joined over his breast with a large brooch. In both
examples, Mary has her hands joined in prayer. No evidence is
present in art at Lincoln to suggest that the Trinity might
have been present as three separate persons, as in the fif-
teenth-century examples at Holy Trinity, Goodramgate, York,
or Doddiscombsleigh, Devon. Miss Anderson notes that at the
latter location "the Three Persons are shown with golden
faces, a bizarre and unsuccessful attempt to express in yel-
low stain the radiance of the Divine Presence."[93] Far from
being bizarre, however, such practice must have been fairly
common, and it is only the ravages of Puritanism and time
that have made such examples rare. There is evidence in York
Minster of gold stain for God's features, in glass formerly
in St. Martin, Coney Street, and in a Corpus Christi subject
now in Window 12 in the choir. At Coventry, the dramatic re-
cords indicate that Jesus' "cheverel" (wig) and "cote" (pre-
sumably the item mentioned elsewhere as being of white leath-
er) were treated with gilt.[94] Apparently God's face was also
gilt. In 1433 in the York Doomsday play, God specifically
wore a gold mask ("a veserne gilted").[95] And at York in
1449-51, an account roll of the Corpus Christi Guild listed
"one gilded mask with wigs" among the properties for the
Creed Play.[96] Very likely the practice was extremely wide-
spread, and may be taken to suggest the possibility also for
the Coronation play in the cathedral at Lincoln. Such the-
orizing, however, would need further study, and indeed the
whole question of this drama at Lincoln demands that we sus-
pend final judgments until all the evidence from local art
has been systematically studied.

The above comments are admittedly often tentative, for
their purpose has been merely to suggest some ways in which
we are able to expand our knowledge of the history of drama,
particularly during the late medieval period. Criticism of
the sort encouraged here may seem at times "unscientific,"
but in spite of its insistence on something more than posi-
tivist criticism, it hardly flaunts the scholarly facts as we
have them. The hope is that we will build on what we know,
and that the next two decades will bring us much closer to
the writing of a thorough critical history of drama in England
to the reign of Queen Elizabeth and beyond--i.e., up to 1642.

To be sure, careful study of continental drama during
the coming years will also provide benefits for the student of

English drama, and we are reminded that we all must become less provincial in our approach to the theater of our native language. Conversely, of course, work on English drama through its application of new methodologies will likewise help to illuminate the history of theater in Europe. *Early Drama, Art, and Music* will attempt to draw together scholarship and criticism focusing on the continental plays and theatrical practices together with the work of those whose efforts are directed toward the plays and productions of the early British dramatists and actors.

APPENDIX.
ART AND RENAISSANCE DRAMA:
THE EXAMPLE OF SHAKESPEARE

In spite of Glynne Wickham's astute observation that the public theaters of Shakespeare's day were "emblematic"--i.e., a theater that "aimed at achieving dramatic illusion by figurative representation" rather than by "seeking to stimulate actuality" through the assistance of perspective scenery[1]-- modern scholars and critics still largely, for example, tend to see Shakespeare's tragedies, which were designed for the theater, as essentially verbal. While Wickham's understanding of the renaissance stage would seem to demand a criticism that joins "the action to the word, the word to the action,"[2] the assumption behind many twentieth-century studies seems yet to be that Shakespeare's plays were recited, almost like sermons perhaps, from a rather crude stage and under conditions of repertory production that precluded sophisticated presentation. Even imagery studies, which have proliferated since the publication of Caroline Spurgeon's *Shakespeare's Imagery and What It Tells Us* (1935), have often as a matter of fact deflected our attention from the larger visual effects which must have been presented in the theater, though these effects are sometimes given emphasis by the imagery contained in Shakespeare's text.

If Shakespeare's drama is truly "emblematic," then iconographic study should reveal not only something of his understanding of *tragedy*--a topic which will be taken up later in this Appendix--but also the presence of certain *tableaux* charged with meaning and located at crucial points in each scene. Thus at Act III, Scene iii, line 485 of *Othello*, the hero and the villain strike a pose which must have been remarkably like that illustrated in an emblem in Geoffrey Whitney's *A Choice of Emblemes*. Turning against Desdemona who is, he thinks, unfaithful, Othello now joins himself in friendship with the treacherous Iago. "Now thou art my lieutenant," Othello exclaims, presumably grasping Iago's hand to seal the agreement. In Whitney's emblem, the good man has generously turned to grasp the hand of the wicked one, who emblematically wears the coat of a fox. Though Othello cannot see him as he is, the audience of Shakespeare's play must have seen Iago as foxlike--good at tactics but poor at strategy. And Whitney's text contrasts the harm which we may receive from "open foes"

with the more serious danger from the smiling rascal whose
malice is "secret."[3] Of course, no one would suggest that
either Shakespeare or the members of his company might have
been borrowing from the emblem book at this point; yet the
dramatist when he wrote this scene must have been very much
aware of the emblematic significance of the tableau which the
players precisely at this point would be presenting to the
audience in the theater.

Another example should demonstrate the validity of this
approach to Shakespeare's dramaturgy. In *King Lear* I.i.135-39,
the king who is stepping down from power gives up his "sway,/
Revenue, [and] execution" of kingship to his "sons" Albany and
Cornwall; to confirm his act he gives them "This coronet [to]
part between [them]." Lear's speech as united here with ap-
propriate action functions very much like an emblem, though
there is no precise parallel to it in the emblem books of the
age. Yet, understood in the manner of an emblem, the visual
effect at this point achieves a richness not hitherto recog-
nized. First, a crown or coronet is normally emblematic of
the glory of nobility, not of its power.[4] To give away the
power--the "sway,/ Revenue," etc.--is to give away some
glory too: the old ruler is deceiving himself when he thinks
to keep for himself the "name and *all* th' addition to a king"
(italics mine). Second, the gift of a coronet to be parted
"between" the two "sons" involves a kind of absurdity. When
parted, the coronet in its divided state will be less than the
whole. A type of violence has been wrought upon this impor-
tant symbol of nobility--a violence presaging the trouble
which will engulf the kingdom after it has also suffered the
outrage of division.

These examples, which can be multiplied *ad infinitum,*
suggest that it might be possible to see a Shakespearian drama
as a series of iconographically and visually defined scenes
which point beyond the mere spectacle toward intellectual and
existential possibilities that were apprehended by renaissance
audiences accustomed to a less positivistic approach to plays
than might be the case today. Thus, going beyond the literary
studies of imagery, an examination of the tragedies as drama
from the standpoint of iconography and visual effects seems im-
perative. The spectacle of the plays, regarded both as color-
ful emblematic configuration on the stage and as the image de-
scribed by the language spoken by the actors, deserves to be
studied for the iconographic evidence which is essential for
our interpretation of these works. Drama has meaning beyond
any mere words spoken on stage, for it is apprehended by the
eye as well as the ear.

Naturally, part of the neglect of much iconographic evi-

dence derives from the obvious fact that the plays as original-
ly staged are not now available to us. We have only the print-
ed text from which to work, and even the best modern perfor-
mances fail to penetrate certain basic aspects of Shakespeare's
design. Furthermore, there is a tacit assumption among many
critics that the plays, since they were allegedly performed on
a fairly "neutral" stage, corroborate our understanding of
the renaissance as a period which stressed the ear at the ex-
pense of the eye. Protestantism indeed did elevate the ear
above the sense of sight.[5] ("Faith is by hearing," St. Paul
had said, and Protestantism tended to take him very serious-
ly.) That extreme Protestantism which we call Puritanism was
particularly certain that the eye is even a dangerous organ--
a source of temptation and wickedness. Radical Protestants
hence saw the plays as representing a perverse institution;
like the Roman Catholic Church, which valued the eye above the
ear, the plays allegedly seduced men from true religion and
proper moral behavior.

That Shakespeare and the other members of his company saw
their drama in a very different light is a fact which deserves
attention. For them, the stage was a place where art and life
merged in a theater designed to mirror forth images of the
totality of human existence under the heavens. Their stage
itself was emblematic, representing the world and sheltered by
a canopy labeled "the heavens" which contained the figures of
the zodiac. And, if we are to believe Frances Yates, the de-
sign of the entire theater may have been based on Vitruvius in
such a manner that it *mathematically* reflected the correspon-
dence between the macrocosm and the microcosm.[6] She cites
with interest the statement by Hester Thrale, who in the
eighteenth century saw the foundations of the second Globe,
"which though hexagonal in form without was round within."[7] A
round theater named the *Globe!* Can anyone doubt the icono-
graphic significance of the shape of this building? When the
first Globe, which had previously stood on these same founda-
tions, burned in 1613, Ben Jonson wrote: "See the world's
ruins."[8]

In addition, there is the evidence of the *device* which
identified the Globe: "the figure of Hercules supporting the
Globe, under which was written, *Totus mundus agit histri-
onem.*"[9] On one level, this device illustrates sensitivity to
the carefully designed *imprese* of the renaissance; on the
other, its meaning penetrates to an understanding of drama
which links it with the iconographic art of the period, with
the emblem, and with the renewed interest in hieroglyphics
during the centuries immediately following the discovery of
Horapollo in the fifteenth century.[10] Also--and this point is

perhaps the most significant for our purposes--men informed by
such modes of thought still believed that the emblematic dis-
play contained a quality which more thoroughly captured the
mind of the viewer than words alone could ever hope to do.
Hence Shakespeare in his plays not only developed powerful
patterns of imagery which more often than not are related to
traditional iconographic motifs and modes, but also apparent-
ly arranged his scenes in order that the events on stage would
depict visual configurations which would be meaningful from
the standpoint of iconography. As we have seen, there is every
reason to believe that special emphasis would have been placed
by the actors upon such iconographically potent tableaux as
Lear's gift of the coronet to his "sons" and Othello's de-
cision to promote Iago to lieutenant.

In the plays, what the audience therefore is expected to
perceive as visual is linked both consciously and unconsciously
to those concerns which are most basic to our existence. In
the tragedies, of course, the single concern from which there
seems to be no escape is the final act of existence: *death*.
Shakespeare's iconography is not merely a verbal and visual
game, but is designed to arouse the emotions as well as the
intellect. And the theater in which the action takes place is
calculated to give the broadest possible significance to the
spectacle.

Since death is indeed the *sine qua non* of tragedy, the
most regularly recurring iconographic elements in these plays
ought to be related to human mortality. Hence at the end of
Julius Caesar, the audience witnesses the suicide of Brutus
who runs upon his sword--a scene illustrated in the emblem
book of Andria Alciati (under the heading "Fortuna uirtutem
superans") and repeated in Whitney's *Choice of Emblemes*.11
Like the moralizing texts of the emblem books, Shakespeare's
play also presents us here with a Brutus whose "valiant"
heart is overcome by chance, by the fortune of war. The man
who "was the noblest Roman of them all" receives more "glory"
by his death than do the others through their military vic-
tory (V.v.36-37, 68). Brutus' sword, like other fatal in-
struments, like poison, like disease, is typical of the icono-
graphic elements which appear both in imagery and action in
the tragedies of Shakespeare.

Most explicit as an emblem of tragedy in the plays is the
knife or dagger. Such is the instrument that Shylock pre-
pares in order to take the pound of flesh from Antonio--a
pound that would have transformed this play utterly if the
villain had succeeded in obtaining his wish. In *The Merchant
of Venice*, the knife or dagger cannot be bloodied without con-
verting comedy to tragedy.

The *bloody* dagger is indeed the emblem chosen by Cesare
Ripa to illustrate tragedy in his influential *Iconologia*.
Tragedy, according to Ripa, contains "nothing but the Ruin of
Princes, by *violent Death*, which is demonstrated by the bloody
dagger."[12] Now Shakespeare also uses the dagger in precisely
the same way in his play of *Macbeth*. Such was the instrument
seen by Macbeth in his imagination before the tragic murder of
Duncan:

> Is this a dagger, which I see before me,
> The handle toward my hand? Come, let me clutch thee:
> I have thee not, and yet I see thee still.
> Art thou not, fatal vision, sensible
> To feeling, as to sight? or art thou but
> A dagger of the mind, a false creation,
> Proceeding from the heat-oppressed brain?
> I see thee yet, in form as palpable
> As this which now I draw.
> Thou marshall'st me the way that I was going;
> And such an instrument I was to use.
> Mine eyes are made the fools o' th' other senses,
> Or else worth all the rest: I see thee still;
> And on thy blade, and dudgeon, gouts of blood,
> Which was not so before. (II.i.33-47)

Despite the fact that this iconographic detail, the dagger
with "gouts of blood" upon its hilt and blade, is only brought
before the eyes of the audience by the incantation of the
actor's speech--an incantation reinforced when Macbeth removes
his own dagger from its sheath at line 41--its effects on those
who are viewing the happenings on stage cannot fail to be pro-
found. Because it is rooted in renaissance iconography, the
dagger is more convincing far than the real dagger which Mac-
beth shows in the course of his speech.
 Tragedy exploits deep psychic forces in an emotional dis-
play that has its end in the marvelous and sorrowful. Its
sensationalism--i.e., its appeal to the senses of sight and
hearing--contributes to its presentation of the marvelous,
which, in Castelvetro's words, "generates terror and com-
passion."[13] And in moments of such disaster as we see in
Macbeth, the sorrow which must overcome the audience is
derived from the spectacle to be seen and described on stage
when we observe the triumph of persons and powers we regard
with antipathy. Both elements, the marvelous and the sorrow-
ful--these are renaissance transformations of Aristotle's
"fear" and "pity"[14] --are expressed in the words of Macduff
after his discovery that King Duncan has been stabbed with
daggers: "O horror! horror! horror!/ Tongue nor heart cannot

conceive nor name thee" (*Macbeth* II.iii.64-65).

It is with a dagger that Othello too presumably kills himself at the sorrowful conclusion of that play. The Moor's final speech in which he adumbrates his despair (he is "Like the base Judean [Judas?]" who has thrown "a pearl away,/ Richer than all his tribe" [V.ii.348-49]) concludes with an action and words that speak with emblematic clarity:

> . . . in Aleppo once,
> Where a malignant and a turban'd Turk
> Beat a Venetian, and traduc'd the state,
> I took by the throat the circumcised dog,
> And smote him thus. (V.ii.353-57)

In the end he identifies himself with the Turk--an infidel opposed to the way of Christian grace and forgiveness. At the beginning of the play his own Moslem background had appeared to stand in sharp contrast with his acceptance of the Christian cause; here in his despair he recognizes in himself an enemy of all goodness[15]--and lifts his own hand against his own infidel breast. The dagger represents most marvelous vengeance; it is an instrument of tragic justice directed at oneself. We are reminded of emblems which illustrate divine vengeance in the form of a dagger held by a hand reaching out of the clouds and threatening the guilty.[16] Othello tragically pronounces doom against himself.

At the conclusion of *Hamlet*, the figure of Death is said to be making his "feast" upon the noble bodies scattered around the stage. Fortinbras enters and demands to know "Where is this *sight?*" Horatio answers with a rhetorical question ("What is it you would *see?*") and, presumably turning to indicate the scene of carnage, adds: "If aught of woe or wonder cease your search" (V.ii.360-61; italics mine). *Woe* and *wonder:* these then are the essential terms chosen by Shakespeare to describe the affects of tragic spectacle.[17] These then are the terms which indicate the sorrowful and marvelous--concepts which, in turn, may be identified with "the affects of admiration and commiseration" that Sir Philip Sidney found inherent in tragedy.[18] Surely such breathtakingly marvelous sorrow as we have at the conclusion of *Hamlet, Othello,* or *King Lear* is what gives this dramatic form its immense power. When the daggers of men's malice have done their bloody work, tears should drown the stage.

It is thus essential to see that one central point around which the iconographic details in each tragedy are arranged is the fact of life's terminus. Every tragedy must end in mortal disaster for the principal character or characters. Death

must come, for, as J.V. Cunningham has noted, it is "not inci-
dental to Shakespearean tragedy; it is rather the defining
characteristic."[19] The hero must perish, deaths must occur if
the tragic form is to be preserved. When near the end of his
career Shakespeare turned away from tragedy to romance, he
created, in a play such as the *Tempest,* a work which contains
considerable ambiguity and also elements associated with tragic
action, but the woe is averted and transformed into reconcili-
ation. Valuable as this play is for the light which it sheds
on Shakespearian tragedy, it belongs to another genre: it
"wants deaths, which is enough to make it no tragedy."[20]

Of course, Shakespeare's presentation of death in the
tragedies varies a great deal from one play to another. In
Titus Andronicus and *Hamlet,* for example, the scenes which are
offered to us for viewing as well as the imagery in the
speeches are more tightly linked with the theme of mortality,
while *Romeo and Juliet,* a play which partly shares the spirit
and tone of the romantic comedies he was writing in the 1590's,
participates in a broader range of human experience. However,
in the final analysis these plays all assert iconographically
the central place of death in life and in tragedy. Perhaps
Shakespeare is here reflecting also the Stoic doctrine, still
pervasive in the renaissance, that all men ought to live as
expecting to die. Certainly this idea had never really dropped
out of sight since ancient times. In the twelfth century, the
man who was to be named Pope Innocent III wrote the treatise
De *miseria humanae conditionis,* which in the sixteenth century
was translated by George Gascoigne and included in his *The
Droomme of Doomes Day* (1576). Innocent comments: "we should
so live, as though we were ever ready to dye. For it is writ-
ten, Be myndeful and remember, that death will not long tarry
from thee, time passeth away, and death approcheth."[21] "In
the myddest of lyfe, we be in death," the Book of Common Prayer
tells us.[22] The same position is argued in a different way by
an emblem in Sambucus' *Emblemata* under the motto "In morte
vita": here a skull appears prominently and above it an hour-
glass, while below is a curved brass trumpet.[23]

As Hamlet and Horatio in the graveyard scene examine the
skulls thrown up by the gravedigger, they recognize that here
is the fate of all men, great and small. The skull is perhaps
the most conventional of all images--the *memento mori* popular-
ized in West European art in the wake of the Black Death. It
is to this that mortality eventually brings us. As in the em-
blem associated with the motto *Sic transit gloria mundi* in
George Wither's *A Collection of Emblemes,* all signs of earthly
predominance are ultimately reduced to ashes.[24]

Such a focus on life's terminus in drama here, as in the

case of *Everyman*, opens the way to the most profound treatment
of the human condition. When Shakespeare's audience is con-
fronted consciously with images displaying the fact of mortali-
ty, the result is potentially a dramatic experience of greater
depth than perhaps any other in the history of English-speak-
ing man. Thus it is true that on the whole the aesthetic re-
sponse elicited by the tragedies is far more complex than the
mere personal fear of death. The woe and wonder with which
the plays affect an audience are indicative of a vision which,
while triggered by the theme of death, embraces the most sig-
nificant aspects of life, both positive and negative: friend-
ship, anger, ambition, hatred, love, loyalty, jealousy,
treachery, wisdom, foolishness.

 Shakespearian tragedy may thus be described as like an
iconographically rich tapestry in which we see the most im-
portant character and others in the play *fall* into the ac-
tuality of mortality. The pattern is not essentially dif-
ferent from Lydgate's *Fall of Princes* or from *The Mirror for
Magistrates*, which was intended as a continuation of Lydgate's
popular work. Fortune frowns, deservedly or otherwise: the
man, whether he be the quintessential emblem of power in the
world, Alexander the Great, or a humble person attempting to
place himself into an undeservedly high position in society
(e.g., Jack Cade), will tumble down from the wheel with most
disastrously final results. Tragedy hence partly provides a
renaissance commentary on the text of human greatness--or on
pretentions to greatness--for there in the margin of life's
page it is written that all living beings must die. And, from
the theologians of the age, iconography learned the lesson
that Death came irrevocably into human experience through
Adam's sin. Because of an act of disobedience at the beginning
of time, every man is doomed to come to his predetermined
earthly end. As Gertrude says in *Hamlet*, "all that lives must
die,/ Passing through nature to eternity" (I.ii.72-73).
Tragedy makes of this, however, a spectacular and moving event.

 It has often been noted that the victim of the tragic
action in Shakespeare is nearly always a chief magistrate or
another individual of tremendous importance in the state. As
in the renaissance iconography of Fortune's wheel or in the
popular representations in verse and woodcuts of the Dance of
Death, the moment will come when greatness may fall and when
Time itself must have a stop. Curiously, Tottel's edition of
The Fall of Princes (1554) contains an appendix which also
prints Lydgate's *The Daunce of Machabree*. This work is, of
course, the text of a Dance of Death in which, as in Holbein's
famous woodcut series (1538), a personification of Death ap-
pears to representatives from every level of society, includ-

ing the most high--proud pope, emperor, king, cardinal--as well
as the low--child, clerk, humble hermit. The prologue reminds
us that "Death spareth nought low ne high degre," for no one,
Lydgate notes, is safe forever from the turning of Fortune's
wheel.[25]

Early in the nineteenth century, Douce introduced the
idea that one of Holbein's woodcuts, the Emperor (No. 7), in-
fluenced Shakespeare in his writing of the remarkable speech
spoken by the king in *Richard II* (III.ii.155-70). A modern
scholar's comment that Holbein's design "does not approach very
closely to Shakespeare's lines (except for 'kill with looks')"
seems accurate in regard to specific details;[26] nevertheless,
the woodcut, with its demonic figure of Death seizing the crown
from the Emperor's head, strikes a pose that most certainly
prepares the way for the mood expressed in *Richard II,* a his-
torical play which has much in common with the tragedies:

> . . . for within the hollow crown
> That rounds the mortal temples of a king
> Keeps Death his court, and there the antic sits,
> Scoffing his state and grinning at his pomp,
> Allowing him a breath, a little scene,
> To monarchize, be fear'd, and kill with looks;
> Infusing him with self and vain conceit,
> As if this flesh which walls about our life
> Were brass impregnable, and with a little pin
> Bores thorough his castle wall, and farewell king!

In neither Holbein nor Lydgate do we see Death actually holding
his court "within" the ruler's crown, nor do we see the grim
reaper holding any "little pin" with which to release the em-
peror's soul from his body. But in Lydgate, Death does mock
the Emperor with ironic references to his sovereignty, his
riches, his pride, while the King, who is similarly treated,
says:

> Death all fordoeth, this is his usage,
> Great and smal that in this world sojourne:
> Who is most meke, I hold hym most sage;
> For we shall all to dede ashes tourne.[27]

This awareness of the inevitability of death, which will come
to all those living, informs all of Shakespeare's tragedies on
the level of iconography, scenic display, and spectacle. In
these dramas, we actually see the greatest men reduced to lit-
tle, little graves. "Ex maximo minimum" is the motto of an
emblem in Whitney's *Choice of Emblemes;*[28] the greatest will be
reduced to the least. Death, who is first seen in the world

alongside the fallen Adam in late medieval iconography,[29] will
have his day in every man's life. Thus "men have died from
time to time, and worms have eaten them," Rosalind quips in
As You Like It (IV.i.98-99), while Hamlet, looking upon the
jester's skull in Act V, Scene i, asks a question: "Dost thou
think Alexander look'd o' this fashion i' th' earth?" "E'en
so," Horatio replies.

Shakespeare hence is always aware of the iconographic
tradition, and the bloody dagger which Ripa identifies as an
emblem of tragedy is sometimes actually present--literally or
imaginatively--in the plays. Other potent emblems of mortali-
ty likewise illustrate the theme of death without which no
tragedy can exist. But more important is the way in which em-
blematic scenes in each play dissolve into life. Performed in
a theater which itself was an emblem of the world, such plays
as *Hamlet, Macbeth, Othello,* and *King Lear* were designed to
combine language and iconographic display in a manner which
would "suit the action to the word, the word to the action."
The reaction of renaissance audiences to such a dramatic feast
must at the conclusion of each play have included a surfeit of
woe and wonder. At the end of *Hamlet,* Fortinbras orders:
"Take up the bodies--such a *sight* as this/ Becomes the field,
but here *shows* much amiss" (V.ii.399-400; italics mine). And
as Lodovico gazes sadly on the bodies of Othello and Desdemona,
he invites Iago--*and the entire audience*--to "Look on the
tragic loading of this bed" (V.ii.364; italics mine). These
are clearly plays not only to be heard but also to be seen--
and to be seen in all their iconographic richness.

Shakespeare's attentiveness to the visual--especially the
visual as closely associated with meaning--is not, of course,
something apart from the techniques or practices of the other
dramatists of his time. For proof of this statement, we have
only to think of the conjuring scene or the appearance of the
Seven Deadly Sins in *Doctor Faustus,* or of Ben Jonson's icono-
graphically rich court masques. The difference between the
late medieval drama, especially as it was centered in such
cities as Coventry and York, and the professional theater of
renaissance England is not the concern with visual matters
which they share. Yet, since the nature of the spectacle has
changed, a different kind of approach to the visual in renais-
sance plays must be pursued. But both late medieval and re-
naissance plays are capable of being studied systematically,
and through such studies we can expect as a result some genu-
ine advancement of our knowledge concerning the spectacle and
visual display of drama to 1642.

NOTES

CHAPTER I

[1]F.P. Pickering, *Literature and Art in the Middle Ages* (Coral Gables, Florida: Univ. of Miami Press, 1970), *passim*.

[2]Play XXXV.253-58; quotations are from the *York Plays,* ed. Lucy Toulmin Smith (1885; rpt. New York: Russell and Russell, 1963).

[3]See Clifford Davidson, "The Realism of the York Realist and the York Passion," *Speculum,* 50 (1975), 274-77.

[4]For the earlier view, see Katharine Lee Bates, *The English Religious Drama* (New York, 1893), p. 169. The persistence of the idea of evolutionary development--i.e., from less complex to more complex forms--earlier in this century led to the assumption that the liturgical plays were less complicated than the more inventive vernacular plays. These, in turn, were more often than not regarded as crude precursors of Elizabethan drama. Such views have been largely overturned in recent years.

[5]Glynne Wickham, *Early English Stages, 1300 to 1660*, II, Pt. 1 (London: Routledge and Kegan Paul, 1963), 206-45 and *passim*.

[6]See Catherine B. C. Thomas, "The Miracle Play at Dunstable," *Modern Language Notes*, 32 (1917), 337-44.

[7]Carleton Brown, "An Early Mention of a St. Nicholas Play in England," *Studies in Philology*, 28 (1931), 594-601; Alfred B. Harbage, *Annals of the English Drama*, 2nd ed., revised S. Schoenbaum (Philadelphia, 1964), pp. 4-21.

[8]Ibid., pp. 20-21. On the saint play, see also D. Jeffrey, "English Saints' Plays," *Medieval Drama*, Stratford-upon-Avon Studies, 16 (London: Edward Arnold, 1973), pp. 69-89, and Mary del Villar, "Some Approaches to the Medieval English Saint's Play, *Research Opportunities in Renaissance Drama*, 15-16 (1972-73), 83-91.

[9]See Robert T. Meyer, "The Middle Cornish Play *Beunans Meriasek*," *Comparative Drama*, 3 (1969), 54-64.

[10]See Eric George Millar, *The Luttrell Psalter* (London: British Museum, 1932).

[11]Margaret Rickert, *Painting in Britain: The Middle Ages*, 2nd ed. (Baltimore: Penguin, 1965), p. 134.

[12]D.C. Baker and J.L. Murphy, "The Late Medieval Plays of MS. Digby 133: Scribes, Dates, and Early History," *Research Opportunities in Renaissance Drama*, 10 (1967), 162-63.

[13]W. L. Hildburgh, "Iconographic Peculiarities in English Medieval Alabaster Carvings," *Folk-Lore*, 44 (1933), 32-56, 123-50.

[14]Clifford Davidson, "The Digby *Mary Magdalene* and the Magdalene Cult of the Middle Ages," *Annuale Mediaevale*, 13 (1972), 77-79, 84-86. For further attention to images of Mary Magdalene in art, see Marjorie M. Malvern, *Venus in Sackcloth* (Carbondale and Edwardsville: Southern Illinois Univ. Press, 1975), *passim*.

[15]*Non-Cycle Plays and Fragments*, ed. Norman Davis, EETS, s.s. 1 (London, 1970), pp. 16-17.

[16]Merle Fifield, "The Arena Theatres in Vienna Codices 2535 and 2536," *Comparative Drama*, 2 (1968-69), 259-82.

[17]See the detailed article by Natalie Crohn Schmitt, "Was There a Medieval Theater in the Round? A Re-examination of the Evidence," *Theatre Notebook*, 23 (1968-69), 130-42, and 24 (1969-70), 18-25; rpt. in *Medieval English Drama*, ed. Jerome Taylor and Alan H. Nelson (Chicago: Univ. of Chicago Press, 1972), 292-315. See also Roberta D. Cornelius, *The Figurative Castle* (Bryn Mawr, Pa., 1930), *passim*.

[18]W. L. Hildburgh, "English Alabaster Carvings as Records of Medieval English Drama," *Archaeologia*, 93 (1955), 51-101.

[19]Jacobus de Voragine, *The Golden Legend*, trans. Granger Ryan and Helmut Ripperger (1941: rpt. New York: Arno Press, 1969), p. 164.

[20]Karl Young, *The Drama of the Medieval Church*, I (Oxford: Clarendon Press, 1933), 249-50, 254-55. It has been argued that another text, the *Harrowing* in Cambridge University Library MS. Ll. 1. 10, fols. 98v-99v, may represent an earlier liturgical play than the Winchester Easter play; see David N. Dumville, "Liturgical Drama and Panegyric Responsory from the Eighth Century? A Re-Examination of the Origin and Contents of the Ninth-Century Section of the Book of Cerne," *Journal of Theological Studies*, 23 (1972), 374-406. The argument in favor of seeing this text as dramatic raises, of course, the perennial question of "What is rite?" and "What is drama?" While attempting to preserve distinctions, the student of drama ought, I feel, to be broadly interested in rites and ceremonies.

[21]Dunbar H. Ogden, "The Use of Architectural Space in Medieval Music-Drama," *Studies in Medieval Drama in Honor of William L. Smoldon*, ed. Clifford Davidson (Kalamazoo, 1974), pp. 63-67, 73-74. For an exemplary study of the relationship between continental liturgical drama and specific examples of art, see Robert Edwards, "Iconography and the Montecassino Passion," *Comparative Drama*, 6 (1972-73), 274-93.

[22]*Records of Plays and Players in Lincolnshire*, ed. Stanley J. Kahrl, Malone Soc., *Collections VIII* (Oxford, 1974), pp. xii-

xiii, 24-27.

[23]See Young, *Drama of the Medieval Church*, I, 112-48.

[24]*Testamenta Eboracensia*, (Durham, 1836-1902), III, 190n. Sepulchre candles were, of course, not limited to York. See, for example, Roger Martin's description (c. 1578) of the Easter Sepulchre before the reign of Elizabeth in Long Melford Church, Sussex. Martin described the Easter Sepulchre there as of timber frame, with places for candles before the structure. See Roger Martin, "The State of Melford Church and our Ladie's Chappel at the East end, as I did know it," *Gentleman's Magazine*, 146 (1830), 206.

[25]Church Accounts, as quoted by Angelo Raine, *Mediaeval York* (London: John Murray, 1955), p. 161. See also Henry J. Feasey, *Ancient English Holy Week Ceremonial* (London: Baker, 1897), pp. 173-75.

[26]See *Liber cantus* (Uppsala, 1620), sigs. Q3-Q4v.

[27]O. B. Hardison, Jr., *Christian Rite and Christian Drama in the Middle Ages* (Baltimore: Johns Hopkins Press, 1965), pp. 1-34.

[28]C. Clifford Flanigan, "The Roman Rite and the Origins of the Liturgical Drama, " *University of Toronto Quarterly*, 43 (1974), 263-84.

[29]Ibid., pp. 281-82.

[30]Mary Marshall, "Aesthetic Values of the Liturgical Drama," rpt. in Taylor and Nelson, p. 36.

[31]William Durandus, *The Symbolism of Churches and Church Ornaments* [*Rationale Divinorum Officiorum,* Book 1], trans. John Mason Neale and Benjamin Webb (Leeds, 1843), p. 53.

[32]Ibid., p. 54.

[33]Sixten Ringbom, *Icon to Narrative*, Acta Academiae Aboensis, ser. A, 31, No. 2 (Åbo, 1965), pp. 11-12.

[34]Text of *Sponsus* in Young, *Drama of the Medieval Church*, II, 361-64; see also the practical edition prepared by W.L. Smoldon for Oxford Univ. Press. See Lynette R. Muir, *Liturgy and Drama in the Anglo-Norman* Adam (Oxford: Blackwell, 1973).

[35]E.K. Chambers, *The Mediaeval Stage* (Oxford: Oxford Univ. Press, 1903), II, 338-39; see also comment in Richard Axton, *European Drama in the Early Middle Ages* (London: Hutchinson, 1974), pp. 162-63.

[36]Chambers, *Mediaeval Stage*, I, 91.

[37]*York Memorandum Book A/Y*, fols. 187v-188; translation from text forthcoming in *York Dramatic Records*, ed. Alexandra F. Johnston and Margaret Dorrell Rogerson, Records of Early English Drama.

[38]See Clifford Davidson, "Northern Spirituality and the Late Medieval Drama of York," *The Spirituality of Western Christendom*, ed. E. Rozanne Elder (Kalamazoo: Cistercian Publications,

1976), pp. 125-51; Theresa Coletti, "Devotional Iconography in the N-Town Marian Plays," *Comparative Drama*, 11 (1977), forth-coming.

[39]Chambers, *Mediaeval Stage*, II, 68-105.

[40]On the relationship between the *Shrewsbury Fragments* and the York plays, see Davis, ed., *Non-Cycle Plays and Fragments*, pp. xvii-xix.

[41]*York Memorandum Book A/Y*, fol. 9v, as quoted by Smith, ed., *York Plays*, pp. xxxi-xxxii.

[42]Martin Stevens, "The York Cycle: From Procession to Play," *Leeds Studies in English*, n.s. 6 (1972), 44. The theory that the plays developed out of the Corpus Christi procession was first advanced by Charles Davidson in his *Studies in the English Mystery Plays* (1892). See also Merle Pierson, "The Relationship of the Corpus Christi Procession to the Corpus Christi Play in England," *Transactions of the Wisconsin Academy of Sciences, Arts, and Letters*, 18 (1916), 110-60.

[43]Quoted in translation in Cuthbert Butler, *Western Mysticism* (1922; rpt. New York: Harper and Row, 1966), p. 116.

[44]*The Book of Margery Kempe*, ed. Sanford B. Meech, EETS, o.s. 212 (London, 1940), p. 148. It is perhaps important to note that Walter Hilton explicitly called meditation on the Passion "an opening of the ghostly eye into Christ's man-hood" (*Scale* 1.35, as quoted by Joy M. Russell-Smith, "Walter Hilton and a Tract in Defence of the Veneration of Images," *Dominican Studies*, 7 (1954), 194.

[45]Davidson, "Realism of the York Realist," pp. 270-73.

[46]Stanley J. Kahrl, *Traditions of Medieval English Drama* (London: Hutchinson, 1974), pp. 72-98.

[47]Alexandra F. Johnston, "The Guild of Corpus Christi and the Procession of Corpus Christi in York," *Mediaeval Studies*, 38 (1976), 372-84.

[48]*Altenglischen Sprachproben*, ed. Eduard Mätzner (Berlin, 1869), I, Pt. 2, 229.

[49]For comment on the conservative nature of drama, see Clifford Davidson and Nona Mason, "Staging the York *Creation, and Fall of Lucifer*," *Theatre Survey*, 17 (1976), 175-76.

[50]Thomas Sharp, *A Dissertation on the Pageants or Dramatic Mysteries anciently performed at Coventry* (Coventry, 1825), pp. 31, 35.

[51]Ibid., p. 28.

[52]Ibid., p. 31.

[53]*Plays and Players in Lincolnshire*, p. 54.

[54]Alexandra F. Johnston and Margaret Dorrell, "The Doomsday Pageant of the York Mercers, 1433," *Leeds Studies in English*, n.s. 5 (1971), 30.

[55]Alexandra F. Johnston and Margaret Dorrell, "The York

Mercers and Their Pageant of Doomsday, 1433-1526," *Leeds Studies in English*, n.s. 6 (1972), 25-26.

[56]Ibid., p. 26.

[57]Ibid., p. 28.

[58]Ibid., pp. 29-30.

[59]Ibid., p. 30.

[60]Ibid., pp. 30-31.

CHAPTER II

[1]*Drama and Imagery in English Medieval Churches* (Cambridge: Cambridge Univ. Press, 1963), p. 149.

[2]Ibid., p. 149.

[3]*Gentleman's Magazine*, 146 (1830), 207. On the treatment of objects of religious art during the Reformation, see especially John Phillips, *The Reformation of Images* (Berkeley and Los Angeles: Univ. of California Press, 1973), *passim*. Some other relevant implications of the anti-arts movement among radical Protestants in England are detailed by Russell Fraser, *The War against Poetry* (Princeton: Princeton Univ. Press, 1970).

[4]*Tudor English Documents of the Diocese of York*, ed. J. S. Purvis (Cambridge: Cambridge Univ. Press, 1948), p. 4.

[5]*Tudor Royal Proclamations, II: The Later Tudors*, ed. Paul L. Hughes and James F. Laskin (New Haven: Yale Univ. Press, 1969), p. 147.

[6]Albert Hollaender, "The Doom-Painting of St. Thomas of Canterbury, Salisbury," *Wiltshire Archaeological and Natural History Magazine*, 50 (1942), 356-57.

[7]See, for example, Margaret Rickert, "The So-Called Beaufort Hours and York Psalter," *Burlington Magazine*, 104 (1962), 238-45.

[8]See W. O. Hassall, *The Holkham Bible Picture Book* (London: Dropmore Press, 1954), pp. 23-27.

CHAPTER III

[1]When funding, staff, and space are available, the main office of *Early Drama, Art, and Music* will begin collecting slides, black and white photographs and xerox prints for the use of scholars. Plans call for a collection catalogued for easy reference and covering England as well as selected continental areas. The cooperation of individual researchers will be sought, and whenever possible copies of their slides and photographs will be made for the collection.

[2]High Speed Ektachrome may also be used at the ASA 400 setting on the camera *only if this fact is specified at*

the time the film is developed.
[3]*Testamenta Eboracensia*, IV, 116.

CHAPTER IV

[1]See Patrick J. Collins, "Narrative Bible Cycles in Medieval Art and Drama," *Comparative Drama*, 9 (1975), 125–46.
[2]Typological interpretations of medieval art and drama are criticized by Arnold Williams in his article "Typology and the Cycle Plays: Some Criteria," *Speculum*, 43 (1968), 677–84. His attack is particularly aimed at the approach described by John Dennis Hurrell, "The Figural Approach to Medieval Drama," *College English*, 26 (1965), 598–604. But see also the reasoned article on typology and English drama by Patrick J. Collins, "Typology, Criticism, and Medieval Drama: Some Observations on Method," *Comparative Drama*, 10 (1976–77), 298–313.

CHAPTER VII

[1]Hugh Arnold and Lawrence B. Saint, *Stained Glass of the Middle Ages in England and France* (1913; rpt. London: A. and C. Black, 1925), p. 34.
[2]*On Divers Arts: The Treatise of Theophilus*, trans. John G. Hawthorne and Cyril Stanley Smith (Chicago: Univ. of Chicago Press, 1963), pp. 45–74.
[3]Noël Heaton, "The Origin and Use of Silver Stain," *Journal of the British Society of Master Glass-Painters*, 10 (1947–48), 9–16.
[4]See Alexandra F. Johnston and Margaret Dorrell, "The York Mercers and Their Pageant of Doomsday, 1433–1526," p. 30.
[5]See E. A. Gee, "The Painted Glass of All Saints' Church, North Street, York," *Archaeologia*, 102 (1969), 170, 193, Pl. XXXII.
[6]G. McN. Rushforth, *Medieval Christian Imagery* (Oxford: Clarendon Press, 1936), pp. 7–20.
[7]Johnston and Dorrell, "The York Mercers and Their Pageant of Doomsday," p. 31.
[8]See Arthur Gardner, *English Medieval Sculpture*, revised ed. (Cambridge: Cambridge Univ. Press, 1951), pp. 108–09.
[9]*Register of the Freemen of the City of York*, Surtees Soc., 96 (Durham, 1897), I, 185.

CHAPTER VIII

[1]John A. Knowles, *Essays in the History of the York School of Glass-Painting* (London: SPCK, 1936), p. 38.

142

²See Hendrik Cornell, *The Iconography of the Nativity of Christ*, Uppsala Universitets Årsskrift (Uppsala, 1924), pp. 12-13 and *passim*. On the influence of this iconography on the drama, see J. W. Robinson, "A Commentary on the York Play of the Birth of Jesus," *JEGP*, 70 (1971), 241-54, and Clifford Davidson, "Northern Spirituality and the Late Medieval Drama of York," in *The Spirituality of Western Christendom*, pp. 148-51.

³Modern usage with regard to liturgical colors is not necessarily reliable for medieval English practice. The diversity of English usage is the subject of William St. John Hope and E. G. Cuthbert F. Atchley, *English Liturgical Colors* (London: SPCK, 1918); this book should be consulted whenever questions concerning liturgical colors are encountered.

⁴The presence of fur on an academic costume did not necessarily signify the holder of an advanced degree, since even undergraduates were allowed to use this material, though it was necessarily of a less expensive variety than that which was utilized by Master, Doctor, or Professor.

CHAPTER IX

¹"The Roman Rite and the Origins of the Liturgical Drama," *passim*, and "The Liturgical Context of the Quem Queritis Trope," *Studies in Medieval Drama in Honor of William L. Smoldon*, pp. 45-62.

²See T. S. R. Boase, *Death in the Middle Ages* (London: Thames and Hudson, 1972). The effect of the plague on people's attitudes is also treated in Millard Meiss, *Painting in Florence and Siena after the Black Death* (Princeton: Princeton Univ. Press, 1951), pp. 59-93.

³William Dugdale, *The History of St. Pauls Cathedral in London* (London, 1658), p. 131.

⁴See George A. King, "The Pre-Reformation Painted Glass in St. Andrew's Church, Norwich," *Norfolk Archaeology*, 18 (1913), 291-93.

⁵Line 825 (italics mine); *The Macro Plays*, ed. Mark Eccles, EETS, o.s. 262 (1969), p. 181.

⁶In addition to the work of Sandro Sticca ("Drama and Spirituality in the Middle Ages," *Medievalia et Humanistica*, n.s. 4 [1973], 69-87, see also Robert D. Marshall, "The Development of Medieval Drama: A New Theology," *Studies in Medieval Culture*, 4 (1974), 407-17.

⁷Gerhart Ladner, *Ad Imaginem Dei: The Image of Man in Mediaeval Art* (Latrobe, Pennsylvania: Archabbey Press, 1965), pp. 55-56. See also Chapter I, above, and, for related information on Franciscan psychology, David L. Jeffrey, *The Early*

English Lyric and Franciscan Spirituality (Lincoln: Univ. of Nebraska Press, 1975), p. 101.

[8]Ernst Kitzinger, "The Cult of Images in the Age before Iconoclasm," *Dumbarton Oaks Papers*, 8 (1954), 137-38, 144. See also Guntram G. Bischoff, "Dionysius the Pseudo-Areopagite: The Gnostic Myth," *The Spirituality of Western Christendom*, pp. 16, 22-30.

[9]Kitzinger, p. 144.

[10]This point is dealt with at length by Theresa Coletti in her recent dissertation entitled "Spirituality and Devotional Images: The Staging of the Hegge Cycle" (Univ. of Rochester, 1974).

[11]Ladner, *Ad Imaginem Dei*, pp. 15-16.

[12]*Mirrour of the Blessed Lyf of Jesu Christ*, trans. Nicholas Love (London: Caxton, 1486), sig. N3r.

[13]See Sticca, *The Latin Passion Play* (Albany: State Univ. of New York Press, 1970), p. 43.

[14]Hilton, *Scale* 1.35, as quoted in Russell-Smith, p. 194.

[15]*York Plays*, pp. xx-xxii; transcription of the second list by Angelo Raine printed in Mendal G. Frampton, "The Date of the 'Wakefield Master'," *PMLA*, 53 (1938), 101-03n.

[16]*York Plays*, p. xx.

[17]Gertrud Schiller, *Iconography of Christian Art*, trans. Janet Seligman (Greenwich, Conn.: New York Graphic Soc., 1971), I, fig. 139.

[18]See Chapter VIII, fn. 2, above.

[19]*York Plays*, p. xx.

[20]Anderson, *Drama and Imagery in English Medieval Churches*, pp. 91-92, Pl. 10.

[21]See, for example, Chapter V, Ex. H.

[22]Facsimile in H. Th. Musper, *Die Urausgaben der holländischen Apokalypse und Biblia pauperum* (Munich: Prestel-Verlag, 1961), Vol. II, Pl. 1.

[23]*St. Olave's Church, York* (Gloucester: British Publishing Co., 1950), p. 15.

[24]Fol. 23v; see Rickert, "The So-Called Beaufort Hours and York Psalter," p. 238, fig. 8.

[25]See Theresa Coletti, "Devotional Iconography in the N-Town Marian Plays," *Comparative Drama*, 11 (1977), forthcoming.

[26]Schiller, I, 42. See, for example, the representations of the Annunciation in the Estouchville Triptych (Courtauld Institute) and in the Beaufort Hours.

[27]Rushforth, *Medieval Christian Imagery*, p. 276.

[28]John Mirk, *Festial*, ed. T. Erbe, EETS, e.s. 96 (1905), p. 107.

[29]Young, *The Drama of the Medieval Church*, II, 249.

[30]See Schiller, I, 45. Sometimes the soul of Christ was not so small, as in an alabaster in the Victoria and Albert Museum (A-58-1925) which shows it in an aureole extending almost all the way from the Father to the Virgin below!

[31]Philip Nelson, "The Virgin Triptych at Danzig," *Archaeological Journal*, 76 (1919), 140, Pls. I, II.

[32]Schiller, Vol. I, fig. 99. In *Queen Mary's Psalter*, the Annunciation is illustrated above, and the Visitation below (Pl. 147).

[33]M. E. McIver, "Visitation of Mary," *New Catholic Encyclopedia* (New York: McGraw-Hill, 1967), XIV, 721.

[34]F. Saxl, "The Ruthwell Cross," *Journal of the Warburg and Courtauld Institutes*, 6 (1943), Pl. Id.

[35]*York Plays*, p. xxi.

[36]*Non-Cycle Plays and Fragments*, p. 2.

[37]M. D. Anderson, *The Imagery of British Churches* (London: John Murray, 1955), p. 107.

[38]Acquisition No. 8128-1863; *Gospel Stories in English Embroidery* (London: Her Majesty's Stationery Office, 1963), p. 16.

[39]*Queen Mary's Psalter*, Pl. 162.

[40]Eric Milner-White's comments on the restoration of this panel are contained in "The Resurrection of a Fourteenth-Century Window," *Burlington Magazine*, 94(1952), 111. Milner-White's identification of the panel as the Annunciation to Joachim, the father of the Virgin, is superseded by T.W. French, "Observations on Some Medieval Glass in York Minster," *Antiquaries Journal*, 51 (1971), 90.

[41]Rushforth, *Medieval Christian Imagery*, p. 380.

[42]*Two Coventry Corpus Christi Plays*, ed. Hardin Craig, EETS, e.s. 87 (1957), p. 11.

[43]*Golden Legend*, p. 87.

[44]See Schiller, I, 87.

[45]Lawrence J. Ross, "Symbol and Structure in the *Secunda Pastorum*," *Comparative Drama*, 1 (1967), 22-23.

[46]Anderson, *Drama and Imagery*, Pl. 11; Alan H. Nelson, "On Recovering the Lost Norwich Corpus Christi Cycle," *Comparative Drama*, 4 (1970-71), figs. 1-2.

[47]See Anderson, *Drama and Imagery*, p. 165; Rosemary Woolf, *The English Mystery Plays* (Berkeley and Los Angeles: Univ. of California Press, 1972), pp. 391-92.

[48]*Queen Mary's Psalter*, p. 173.

[49]John Browne, *The History of the Metropolitan Church of St. Peter, York* (London, 1847), I, 140-42; Vol. II, Pls. XCVI, CI, CVI.

[50]*Biblia Pauperum*, Pl. 3; Rushforth, *Medieval Christian*

Imagery, pp. 284–86.

[51]*Queen Mary's Psalter*, Pl. 174. See also Schiller, Vol. I, fig. 272, and Émile Mâle, *The Gothic Image*, trans. Dora Nussy (1913; rpt. New York: Harper and Row, 1958), figs. 111–12.

[52]Smith, *York Plays*, p. xxi.

[53]A similar basket and three doves appear also in *Queen Mary's Psalter*, Pl. 185.

[54]See Oscar G. Farmer, *Fairford Church and Its Stained Glass Windows*, 8th ed. (1968), p. 10.

[55]Rushforth, *Medieval Christian Imagery*, pp. 106–07; *Biblia Pauperum*, Pl. 4.

[56]Hildburgh, "English Alabaster Carvings as Records of the Medieval Religious Drama," pp. 70-71, Pl. XIIIc: *Speculum Humanae Salvationis*, ed. J. Lutz and P. Perdrizet (Leipzig, 1909), Pl. 19.

[57]Calendar, p. 4, in *Breviarium ad usum insignis ecclesie Eboracensis*, I, Surtees Soc., 71 (1880).

[58]Mirk, *Festial*, p. 59.

[59]*Golden Legend*, p. 137; see also Anderson, *Drama and Imagery*, p. 137.

[60]See ibid., pp. 136-37.

[61]Pl. 188.

[62]Rushforth, *Medieval Christian Imagery*, p. 382.

[63]The question-answer form is, of course, suggested in the apocryphal *Gospel of Thomas*, which asserts that "after the third day [his parents] found him in the temple sitting in the midst of the doctors and hearing and asking them questions," and in the biblical account in *Luke* 2.46. See the *Apocryphal New Testament*, trans. M. R. James (Oxford: Clarendon Press, 1924), p. 54.

[64]Martin Stevens, "The Missing Parts of the Towneley Cycle," *Speculum*, 45 (1970), 258-59.

[65]Ibid., p. 259.

[66]The dramatic records for Coventry are being edited for Records of Early English Drama by R. Ingram. I am currently undertaking a survey of relevant art in Coventry as well as a larger study of drama in that city.

[67]*Testamenta Eboracensia*, II, 117; Alexandra F. Johnston, "The Plays of the Religious Guilds of York: The Creed Play and the Pater Noster Play," *Speculum*, 50 (1975), 57.

[68]Ibid., p. 57.

[69]Ibid., p. 83.

[70]Ibid., pp. 57, 82.

[71]Ibid., pp. 61, 83.

[72]Ibid., pp. 65-66

[73]Ibid., pp. 66-67; Anderson, *Drama and Imagery*, p. 40;

cf. Woolf, p. 60

[74]See Johnston, "The Plays of the Religious Guilds of York," pp. 68-69.

[75]I am indebted to Jeremy Haselock for examining this glass and providing his opinion in matters of dating, condition, etc. The attribution to John de Burgh is Mr. Haselock's conjecture.

[76]Madeline Caviness, "Fifteenth Century Stained Glass from the Chapel of Hampton Court, Herefordshire: The Apostles' Creed and Other Subjects," *Walpole Society*, 42 (1968-70), 35-60.

[77]Johnston, "The Plays of the Religious Guilds of York," p. 82.

[78]"'Credo' Tapestries," *Burlington Magazine*, 24 (1914), 247-54, 309-16. See also William H. Forsyth, "A 'Credo' Tapestry: A Pictorial Interpretation of the Apostles' Creed," *Metropolitan Museum of Art Bulletin*, n.s. 21 (1963), 240-51.

[79]Mr. Haselock kindly provided the transcription of the three inscriptions quoted here. Five further prophets appear as part of the Creed arrangement in C8, though one of these cannot be identified.

[80]F. T. S. Houghton, "Astley Church and Its Stall Paintings," *Birmingham Archaeological Society Transactions*, 51 (1925-26), 23-24, 27; Farmer, *Fairford Church*, pp. 33-35.

[81]Alan H. Nelson, *The English Medieval Stage* (Chicago: Univ. of Chicago Press, 1974), pp. 97-98; Chambers, *Medieval Stage*, II, 154; Arthur F. Leach, "Some English Plays and Players, 1220-1548," *An English Miscellany Presented to Dr. Fu Furnivall* (Oxford: Clarendon Press, 1901), p. 221.

[82]Ibid., p. 221. Professor Nelson believes that the play at Beverley "was more declamatory than properly dramatic" (*English Medieval Stage*, p. 97).

[83]Johnston, "The Plays of the Religious Guilds of York," pp. 86-87.

[84]Anderson, *Drama and Imagery*, pp. 62-63; Johnston, "The Plays of the Religious Guilds of York," pp. 77-78.

[85]Anderson, *Drama and Imagery*, pp. 66-70.

[86]My student, Mr. Mark Sullivan, is currently working on a paper on the York play of the Funeral of the Virgin.

[87]*York Plays*, p. xxvii.

[88]Ibid., p. xxvii.

[89]Anna J. Mill, "The York Plays of the Dying, Assumption, and Coronation of our Lady," *PMLA*, 65 (1950), 866-70.

[90]*York Memorandum Book A/Y*, II, 123ff, as quoted by Mill, p. 868.

[91]See, for example, the discussion by M. R. James in "The Paintings in Eton College Chapel and in the Lady Chapel

of Winchester Cathedral," *Walpole Society*, 17 (1928-29), 19-20.

[92]*Records of Plays and Players in Lincolnshire*, p. 33.

[93]Anderson, *Imagery of British Churches*, p. 82.

[94]Sharp, *Dissertation on the Pageants*, pp. 14, 26.

[95]Johnston and Dorrell, "The Doomsday Pageant of the York Mercers," p. 29.

[96]Johnston, "The Plays of the Religious Guilds of York," p. 81 (trans.).

APPENDIX

[1]Wickham, *Early English Stages*, II. pt. 1, 155.

[2]*Hamlet* III.ii. 17-18. Quotations from *Hamlet* in this Appendix are from the New Shakespeare edition, edited by John Dover Wilson; other plays are quoted from the New Arden editions, though I have not in all instances followed the Arden readings (e.g., I have preferred "Judean" to "Indian" in *Othello* V.II.348).

The approach to action and word here posits an interest in visual-verbal effects that goes beyond the mere cataloguing of images or the listing of comparisons with emblem literature. Shakespeare's plays were first examined in light of emblem literature by Henry Green, *Shakespeare and the Emblem Writers* (1869). A selection of more recent work is contained in the Select Bibliography, below.

[3]Geoffrey Whitney, *A Choice of Emblemes* (Leyden, 1586), p. 124.

[4]See Thomas Bilson, *A Sermon Preached before the King and Queenes Majesties at their Coronation* (London, 1603), sig. A7.

[5]See William G. Madsen, *From Shadowy Types to Truth* (New Haven: Yale Univ. Press, 1968), pp. 155-66.

[6]Frances A. Yates, *Theatre of the World* (Chicago: Univ. of Chicago Press, 1969), pp. 112-35.

[7]E.K. Chambers, *The Elizabethan Stage* (Oxford: Clarendon Press, 1923), II, 428; quoted by Yates, p. 130.

[8]Chambers, II, 422.

[9]Shakespeare, *Works*, Variorum edition, ed. Edmond Malone (London, 1821), III, 66-67, as quoted by Yates, p. 131n.

[10]Mario Praz, *Studies in Seventeenth-Century Imagery*, 2nd ed. (Rome, 1964), p. 23. On distinctions between hieroglyph, emblem, device, etc., see Praz, Chapt. I, pp. 11-54, and Henri Estienne, *The Art of Making Devices*, trans. Thomas Blount (London, 1648), pp. 1ff.

[11]Andrea Alciati, *Emblematum Libellus* (Paris, 1542; facsimile rpt. Darmstadt: Wissenschaftliche Buchgesellschaft,

1967), p. 96; Whitney, p. 70.

[12]Cesare Ripa, *Iconologia*, English translation (London, 1709), p. 75; see also the Rome, 1603 edition (p. 490) as well as the Padua, 1630 edition (pt. 3, p. 129, sig. I1r).

[13]Lodovico Castelvetro, *The Poetics of Aristotle Translated and Annotated*, in *Literary Criticism: Plato to Dryden*, ed. Allan H. Gilbert (1940; rpt. Detroit: Wayne State Univ. Press, 1962), p. 328.

[14]Aristotle, *The Poetics*, in *Literary Criticism*, pp. 75–76.

[15]Though modern critics (myself included) might like to think otherwise, it is not impossible that Shakespeare meant Othello to regard himself in terms of the emblem under the motto "Impossible" in Alciati, p. 188, and "Aethiopem lauare" in Whitney, p. 57.

[16]See Arnold Whittick, *Symbols, Signs and Their Meaning* (Newton, Mass.: Charles T. Branford, 1960), p. 91; cf. *ibid.*, p. 274.

[17]See J. V. Cunningham, *Woe or Wonder* (Denver: Univ. of Denver Press, 1951), *passim*.

[18]Sir Philip Sidney, *The Defense of Poesie*, in *Literary Criticism*, p. 432.

[19]Cunningham, p. 13.

[20]John Fletcher, Preface to *The Faithful Sheperdess*, in *The Works of Francis Beaumont and John Fletcher*, Variorum ed. (London, 1908), III, 18.

[21]George Gascoigne, *The Droomme of Doomes Day* (London, 1576), sig. B5v.

[22]*The First and Second Prayerbooks of King Edward the Sixth* (London: Dent, 1910), p. 269.

[23]Joannes Sambucus, *Emblemata* (Antwerp, 1558), p. 110.

[24]George Wither, *A Collection of Emblemes* (London, 1635), p. 98; the plates utilized by Wither originally appeared in Gabriel Rollenhagio, *Nucleus Emblematum Selectissimorum* (Cologne, 1611). The illustration of *Sic transit gloria mundi* is No. 86 in Rollenhagio, and is conveniently reprinted in Russell Fraser, *Shakespeare's Poetics in Relation to King Lear* (London: Routledge and Kegan Paul, 1962), Pl. XLIV.

[25]John Lydgate, *The Fall of Princes*, ed. Henry Bergen (Washington: Carnegie Institution, 1923), p. 1025.

[26]Peter Ure in the New Arden edition of *Richard II*, 5th ed. (1961), p. 102.

[27]*Fall of Princes*, p. 1029.

[28]Whitney, p. 229; see also Arthur Henkel and Albrecht Schöne, *Emblemata: Handbuch zur Sinnbildkunst des XVI. und XVII. Jahrhunderts* (Stuttgart: Metzler, 1967), col. 997.

[29]One of the five preliminary woodcuts in Holbein's

Dance of Death series shows Death beside the fallen Adam who is digging in the earth. See also the woodcut of the Expulsion of Adam and Eve from Eden in St. Augustine, *La Cité de Dieu*, trans. Raoul de Presles (c. 1486), p. 7; reproduction in Arthur M. Hind, *An Introduction to a History of Woodcut* (1935; rpt. New York: Dover, 1963), II, 623.

SELECT BIBLIOGRAPHY

For journal title abbreviations, see pages 40–41, above.

I. *Books and articles on English art before the Reformation.*

Anderson, M. D. *The Medieval Carver.* Cambridge: Cambridge
 Univ. Press, 1935.
_____. *Animal Carvings in British Churches.* Cambridge:
 Cambridge Univ. Press, 1938.
_____. *Design for a Journey.* Cambridge: Cambridge
 Univ. Press, 1940.
_____. *Looking for History in British Churches.* London:
 John Murray, 1951.
Baker, John. *English Stained Glass.* London: Thames and Hudson,
 [1960].
Beckwith, John. *Ivory Carvings in Early Medieval England.*
 London: Miller and Medcalf, 1972.
_____. *Early Medieval Art.* London: Thames and Hudson,
 1964.
Biver, Paul. "Some Examples of English Alabaster Tables in
 France," *ArchJ,* 67 (1910), 66–87.
Boase, T. S. R. *English Art, 1100-1216.* Oxford: Clarendon
 Press, 1953.
Bond, Francis. *Fonts and Font Covers.* London: Oxford Univ.
 Press, 1908.
_____. *Screens and Galleries in English Churches.*
 London: Oxford Univ. Press, 1908.
_____. *Wood Carvings in English Churches.* 2 vols.
 London: Oxford Univ. Press, 1910.
_____. *Dedications of English Churches.* Oxford:
 Humphrey Milford, 1914.
_____ and Dom Bede Camm. *Roodscreens and Roodlofts.*
 London: Pitman, 1909. 2 vols.
Borenius, Tancred, and E. W. Tristram. *English Medieval
 Painting.* Paris: Pegasus Press, 1927.
Brieger, Peter H. *English Art, 1216-1307.* Oxford: Clarendon
 Press, 1957.
Caiger-Smith, A. *English Medieval Mural Paintings.* Oxford:
 Clarendon Press, 1963.
Cave, C. J. P. *Roof Bosses in Medieval Churches.* Cambridge:
 Cambridge Univ. Press, 1948.
Chamot, Mary. *English Medieval Enamels.* London: Ernest
 Benn, 1930.

Clayton, Muriel. *Catalogue of Rubbings of Brasses and Incised Slabs*, 2nd ed. Victoria and Albert Museum. London: His Majesty's Stationery Office, 1929.

Collins, Arthur H. *Symbolism of Animals and Birds Represented in English Church Architecture*. New York: McBride, Nast, 1913.

Cox, J. Charles. *Bench-Ends in English Churches.* London: Oxford Univ. Press, 1916.

_____ and Alfred Harvey. *English Church Furniture*, 2nd ed. London: Methuen, 1908.

Crossley, Fred H. *English Church Craftsmanship*. London: Batsford, 1941.

Dodgson, Campbell. "English Devotional Woodcuts of the Late Fifteenth Century, with Special Reference to those in the Bodleian Library," *Walpole Society*, 17 (1929), 95-108.

Druce, G. C. "Animals in English Wood Carvings," *Walpole Society*, 3 (1914), 57-73.

Dugdale, William. *Monasticon Anglicanum*, trans. J. Stevens. London, 1718. New ed., with additions by John Caley, Henry Ellis, Bulkley Bandinel. 6 vols. London, 1819.

English Alabasters from the Hildburgh Collection. London: Her Majesty's Stationery Office, 1956.

Evans, Joan. *English Art, 1307-1461.* Oxford: Clarendon Press, 1949.

Gardner, Arthur. *English Medieval Sculpture*, 2nd ed. Cambridge: Cambridge Univ. Press, 1951.

_____. *Minor English Wood Sculpture, 1400-1550*. London: Alec Tiranti, 1958.

Harvey, John. *Gothic England*, 2nd ed. London: Batsford, 1948.

_____. *The English Cathedrals*, 2nd ed. London: Batsford, 1956.

_____. *Mediaeval Craftsmen*. London: Batsford, 1975.

_____ et al. *English Medieval Architects: A Biographical Dictionary Down to 1550*. London: Batsford, 1954.

Heales, Alfred. "Easter Sepulchres; Their Object, Nature, and History," *Arch*, 42 (1869), 263-308.

Haseloff, Günther. *Die Psalterillustration im 13. Jahrundert.* Kiel, 1936.

Herbert, J. A., G. F. Warner, and E. G. Millar. *Reproductions from Illuminated Manuscripts.* Ser. 1-4. London: British Museum, 1923-28. Ser. 5. London: British Museum, 1965.

Hildburgh, W. L. "Folk-Life Recorded in Medieval English Alabaster Carvings," *Folk-Lore*, 60 (1949), 249-64.

Hodnett, Edward. *English Woodcuts, 1480-1535*, revised ed. Oxford: Oxford Univ. Press, 1973.

152

Hope, W. H. St. John. "On the Early Working of Alabaster in
 England," *ArchJ*, 61 (1904), 221-40.
_____. "Quire Screens in English Churches," *Arch*, 68
 (1917), 43-110.
_____ and T. M. Fallow. "English Medieval Chalices and
 Patens," *ArchJ*, 43 (1886), 137-61, 364-402.
*Illustrated Catalogue of the Exhibition of English Medieval
 Alabaster Work, 1910*. London: Society of Antiquaries,
 1913.
Kendon, Frank. *Mural Painting in English Churches during the
 Middle Ages*. London: John Lane, 1923.
Kendrick, A. F. *English Embroidery*. London: George Newnes,
 1904.
Keyser, C. E. *List of Buildings having Mural Decorations*.
 London, 1883.
Kuhn, Charles L. "Herman Scheerre and English Illumination
 of the Early Fifteenth Century," *AB*, 22 (1940), 138-56.
Lafond, Jean. Review of Christopher Woodforde, *English Stained
 and Painted Glass*. *ArchJ*, 111 (1954), 239-41.
LeCouteur, J. D. *English Medieval Painted Glass*. London:
 SPCK, 1926.
Millar, Eric G. *English Illuminated Manuscripts of the XIVth
 and XVth Centuries*. Paris and Brussels: G. van Oest,
 1928.
Nelson, Philip. *Ancient Painted Glass in England, 1170-1500*.
 London, 1913.
_____. "Some Unusual English Alabaster Panels,"
 TrHSLaCs, 69 (1918), 80-96.
_____. "Some Further Examples of English Medieval
 Alabaster Tables," *ArchJ*, 74 (1917), 106-21.
_____. "English Alabasters of the Embattled Type,"
 ArchJ, 75 (1918), 310-34.
_____. "Some Additional Specimens of English Alabaster
 Carvings," *ArchJ*, 84 (1927), 114-24.
Oman, C. *English Church Plate, 597-1830*. London: Oxford
 Univ. Press, 1957.
Opus Anglicanum: English Medieval Embroidery. Victoria and
 Albert Museum Exhibit Catalogue. London: Arts Council,
 1963.
Pächt, Otto, and J. J. G. Alexander. *Illuminated Manuscripts
 in the Bodleian Library, Oxford*. Vol. III: British,
 Irish and Icelandic Schools. Oxford: Clarendon Press,
 1973.
Peacock, Edward. *English Church Furniture, Ornaments and
 Decorations, at the Period of the Reformation*. London,
 1866.
Phillips, John. *The Reformation of Images: Destruction of*

Art in England, 1535-1660. Berkeley and Los Angeles: Univ. of California Press, 1973.

Prior, Edward S., and Arthur Gardner. *An Account of Medieval Figure-Sculpture in England.* Cambridge: Cambridge Univ. Press, 1912.

Rackham, Bernard. *A Guide to the Collections of Stained Glass.* Victoria and Albert Museum. London, 1936.

Read, Herbert. *English Stained Glass.* London, 1926.

Remnant, G. L. *A Catalogue of Misericords in Great Britain.* Oxford: Clarendon Press, 1969.

Rickert, Margaret. *Painting in Britain in the Middle Ages.* Baltimore: Penguin, 1954.

Rouse, E. Clive. *Discovering Wall Paintings*, revised ed. Tring, Herts.: Shire, 1971.

Saint, Lawrence B., and Hugh Arnold. *Stained Glass of the Middle Ages in England and France.* London: A. and C. Black, 1913.

Saunders, O. Elfrida. *A History of English Art in the Middle Ages.* Oxford: Clarendon Press, 1932.

_____. *English Illumination.* 1932; rpt. New York: Hacker, 1969.

Spencer, B. W. "Medieval Pilgrim's Badges," *Rotterdam Papers*, ed. J. G. N. Renaud. Rotterdam, 1968. Pp. 137-47.

Stone, Lawrence. *Sculpture in Britain: The Middle Ages.* Baltimore: Penguin, 1955.

Thomson, W. M. G. *A History of Tapestry*, 2nd ed. London: Hodder and Stoughton, 1930.

Tristram, E. W. *English Medieval Wall Painting: The Twelfth Century.* London: Oxford Univ. Press, 1944.

_____. *English Medieval Wall Painting: The Thirteenth Century.* 2 vols. London: Oxford Univ. Press, 1950.

_____. *English Wall Painting in the Fourteenth Century.* London: Routledge and Kegan Paul, 1955.

Wall, James Charles. *Mediaeval Wall Paintings*, 2nd ed. London: Talbot, n.d.

Westlake, N. H. J. *A History of Design in Painted Glass.* 4 vols. London, 1881-94.

Willement, Thomas, *et al. Illustrations of Glass.* 5 vols. 1815-64. British Library MSS. Add. 34866-69, 34873.

Woodforde, Christopher. *English Stained and Painted Glass.* Oxford: Clarendon Press, 1954.

II. *Some examples of books and articles on local art and individual manuscripts containing illuminations.*

Anderson, M. D. *The Choir Stalls of Lincoln Minster.* Lincoln: Friends of Lincoln Cathedral, 1967.

Benson, George. *The Ancient Painted Glass Windows in the Minster and Churches of the the City of York.* York: Yorkshire Philosophical Society, 1915.

Boase, T. S. R. *The York Psalter in the Library of the Hunterian Museum, Glasgow.* London: Faber and Faber, 1962.

Browne, John. *The History of the Metropolitan Church of St. Peter, York.* 2 vols. London, 1847.

Cave, C. J. P. "The Bosses on the Vault of the Quire of Winchester Cathedral," *Arch,* 76 (1927), 165ff.

Chatwin, Philip B. "The Decoration of the Beauchamp Chapel, Warwick, with Special Reference to the Sculptures," *Arch,* 77 (1927), 313-34.

Cockerell, Sydney C. *The Gorleston Psalter.* London: Chiswick Press, 1907.

Farmer, Oscar G. *Fairford Church and Its Stained Glass Windows,* 8th ed. [Fairford,] 1968.

French, T. W. "Observations on Some Medieval Glass in York Minster," *AntJ,* 51 (1971), 86-93.

Gee, E. A. "The Painted Glass of All Saints' Church, North Street, York," *Arch,* 102 (1969), 151-202.

Gibson, Peter. "The Stained and Painted Glass of York," *The Noble City of York,* ed. Alberic Stacpoole *et al.* York: Cerialis Press, 1972. Pp. 67-223.

Hamand, L. A. *The Ancient Windows of Gt. Malvern Priory Church.* St. Albans: Campfield Press, 1947.

Harrison, F. *The Painted Glass of York.* London: Dropmore Press, 1954.

Inventory of the Historical Monuments in the City of York. Vol. III: South-West of the Ouse. Vol. IV: Outside the City Walls, East of the Puse. Royal Commission on Historical Monuments, 1972-75.

James, M. R. *A Descriptive Catalogue of the Manuscripts in the Fitzwilliam Museum.* Cambridge: Cambridge Univ. Press, 1895.

_____. *Suffolk and Norfolk.* London: Dent, 1930.

_____. *A Descriptive Catalogue of the Manuscripts in the Library of Lambeth Palace.* Cambridge: Cambridge Univ. Press, 1932.

King, George A. "The Pre-Reformation Painted Glass in St. Andrew's Church, Norwich," *NoArch,* 18 (1913), 283-94.

Knowles, John A. *Essays in the History of the York School of Glass Painting.* London: SPCK, 1936.

_____. "John Thornton of Coventry and the East Window of Great Malvern Priory," *AntJ,* 39 (1959), 274-82.

Lightfoot, G. H. "Mural Paintings in St. Peter's Church, Pickering," *YsAJ,* 13 (1895), 353-70.

Martin, Roger. "The State of Melford Church and our Ladie's
 Chappel at the East End, as I did know it," *Gentleman's
 Magazine*, 146 (1830), 206-07.
Millar, Eric George. *The Luttrell Psalter*. London: British
 Museum, 1932.
Milner-White, Eric. *Friends of York Minster*. *Annual Reports*,
 17-35. York, 1945-63.
_____. "The Resurrection of a Fourteenth Century
 Window," *BurlM*, 94 (1952), 108-12.
Morrell, J. B. *Woodwork in York*. York, 1949.
Nelson, Philip. "The Virgin Triptych at Danzig," *ArchJ*,
 76 (1919), 139-42.
Page, William. *The Inventories of Church Goods for the
 Counties of York, Durham, and Northumberland*, Surtees
 Soc., 97. Durham, 1897.
Parker, J. H., and John Browne. "Architectural Notes of the
 Churches and Other Buildings in the City and Neighbour-
 hood of York, with Notices of the Painted Glass,"
 *Memoirs Illustrative of the History and Antiquities of
 the County and City of York*. Proceedings of the
 Archaeological Institute, 1846. London, 1848. Part
 VIII, pp. 1-48.
Purey-Cust, Arthur P. *The Heraldry of York Minster*. 2 vols.
 Leeds: Richard Johnson, 1890-96.
Purvis, J. S. *The Condition of Yorkshire Church Fabrics,
 1300-1800*, St. Anthony's Hall Publications, 14. York,
 1958.
_____. "The Use of Continental Woodcuts and Prints by
 the 'Ripon School' of Woodcarvers in the Early Six-
 teenth Century," *Arch*, 85 (1935), 107-27.
Rackham, Bernard. Review of John A. Knowles, *Essays in the
 York School of Glass-Painting*. *BurlM*, 70 (1937), 149.
_____. *The Ancient Glass of Canterbury*. London:
 Humphries, 1949.
Radford, U. M. "The Wax Images Found in Exeter Cathedral,"
 AntJ, 29 (1949), 164-68.
Raine, Angelo. *Mediaeval York*. London: John Murray, 1955.
Raine, James, ed. *The Fabric Rolls of York Minster*, Surtees
 Soc., 35. Durham, 1859.
Rickert, Margaret. "The So-Called Beaufort Hours and York
 Psalter," *BurlM*, 104 (1962), 238-45.
Rouse, E. Clive. "Wall Paintings in the Church of St. John
 the Evangelist, Corby, Lincolnshire," *ArchJ*, 100 (1943),
 150-76.
_____. "Wall Paintings in St. Andrew's Church, Pickworth,
 Lincolnshire," *JBAA*, 13 (1950), 24-33.
Rushforth, Gordon McNeil. "The Glass in the Quire Clerestory

of Tewkesbury Abbey," *BlGsArch*, 46 (1924), 289-324.

_____. "The Windows of the Church of St. Neot, Corn-
wall," *Exeter Diocesan Architectural and Archaeological
Society*, 15 (1937), 150-90.

Shaw, P. J., *et al*. *An Old York Church, All Hallows in North
Street*. York, 1908.

Torre, James. *The Antiquities of York-Minster*. MS., York
Minster Library.

Tristram, E. W., and M. R. James. "Wall Paintings in
Croughton Church, Northamptonshire," *Arch*, 76 (1927),
179-204.

Warner, George. *Queen Mary's Psalter*. London: British
Museum, 1912.

Wayment, Hilary. *The Windows of King's College Chapel,
Cambridge*. Corpus vitrearum medii aevi. London: Oxford
Univ. Press, 1950.

Woodforde, Christopher. *The Norwich School of Glass-
Painting in the Fifteenth Century*. London: Oxford
Univ. Press, 1950.

Wordsworth, Christopher. "Inventories of Plate, Vestments,
&c., belonging to the Cathedral Church of the Blessed
Mary at Lincoln," *Arch*, 53 (1892), 1-82.

Zarnecki, George. *Romanesque Sculpture at Lincoln Cathedral*,
Lincoln Minster Pamphlets, 2nd ser., 2. Lincoln: Friends of
Lincoln Cathedral, 1970.

III. *On subjects in art and iconography*.

Anderson, M.D. *The Imagery of British Churches*. London:
John Murray, 1955.

_____. *History and Imagery in British Churches*. London:
John Murray, 1971.

André, J. Lewis. "Saint John the Baptist in Art, Legend, and
Ritual," *ArchJ*, 50 (1893), 1-19.

_____. "Saint George the Martyr, in Legend, Ceremonial,
Art, Etc.," *ArchJ*, 57 (1900), 204-23.

Axton, William E. A. "The Symbolism of the 'Five Wounds of
Christ'," *Transactions of the Lancashire and Cheshire
Antiquarian Society*, 10 (1892), 67-77.

Bilson, John. "On a Sculptured Representation of Hell
Cauldron, Recently Found at York," *YsAJ*, 19 (1906-07),
435-45.

Blunt, Anthony. "Blake's 'Ancient of Days': The Symbolism of
the Compasses," *Journal of the Warburg and Courtauld
Institutes*, 2 (1938-39), 53-63.

Boase, T. S. R. *Death in the Middle Ages*. London: Thames and
Hudson, 1972.

Borenius, Tancred. *St. Thomas Becket in Art*. London, 1932.

Brooks, Neil C. *The Sepulchre of Christ in Art and Liturgy*, Univ. of Illinois Studies in Language and Literature, 7, No. 2. Urbana, 1921.

Brown, Howard Mayer, and Joan Lascelle. *Musical Iconography: A Manual for Cataloguing Musical Subjects in Western Art before 1800*. Cambridge: Harvard Univ. Press, 1972.

Callisen, S. A. "The Iconography of the Cock on the Column," *AB*, 21 (1939), 160-78.

Caviness, Madeline. "Fifteenth Century Stained Glass from the Chapel of Hampton Court, Herefordshire: The Apostles' Creed and Other Subjects," *Walpole Society*, 42 (1968-70), 35-60.

Christie, Mrs. A. H. "An Unknown English Chasuble," *BurlM*, 51 (1927), 285-92.

Clark, James M. *The Dance of Death in the Middle Ages and the Renaissance*. Glasgow: Jackson, 1950.

Clement, Clara Erskine. *A Handbook of Legendary and Mythological Art*, enlarged ed. 1881; rpt. Detroit: Gale Research, 1969.

Cohn, Norman. "The Horns of Moses," *Commentary* (1958), pp. 220-26.

Cornelius, Roberta D. *The Figurative Castle*. Bryn Mawr, Pa., 1930.

Cornell, Henrik. *The Iconography of the Nativity of Christ*. Uppsala Universitets Årsskrift. Uppsala, 1924.

Curtius, Ernst. *European Literature and the Latin Middle Ages*, trans. Willard Trask, Bollingen ser., 36. New York: Pantheon, 1953.

DeWald, E. T. "The Iconography of the Ascension," *American Journal of Archaeology*, 2nd ser., 19 (1915), 277-319.

Didron, Adolphe Napoleon (and Margaret Stokes). *Christian Iconography*. 2 vols. 1851; rpt. New York: Ungar, 1965.

Drake, Maurice, and Wilfred Drake. *Saints and Their Emblems*. 1916; rpt. New York: Burt Franklin, 1971.

Durandus, William. *The Symbolism of Churches and Church Ornaments*, trans. John Mason Neale and Benjamin Webb. Leeds, 1843.

Emerson, O. F. "Legends of Cain, Especially in Old and Middle English Literature," *PMLA*, 21 (1906), 831-77.

Fabre, Abel. "L'Iconographie de la Pentecôte," *GdesBA*, 65, pt. 2 (1923), 33-42.

Ferguson, George. *Signs and Symbols in Christian Art*. 1954; rpt. New York: Oxford Univ. Press, 1961.

Fleming, Percy. "Notes on St. Anthony the Great," *ArchJ*, 89 (1932), 79-86.

Forsyth, William H. "A 'Credo' Tapestry: A Pictorial Inter-

pretation of the Apostles' Creed," *Metropolitan Museum of Art Bulletin*, n.s. 21 (1963), 240-51.

Fowler, James. "On Mediaeval Representations of the Months and Seasons," *Arch*, 44 (1873), 137-224.

Frank, Grace. "Popular Iconography of the Passion," *PMLA*, 46 (1931), 333-40.

Galpin, Francis W. *Old English Instruments of Music*, 3rd ed. London: Methuen, 1965.

Gordon, James D. "The Articles of the Creed and the Apostles," *Speculum*, 40 (1965), 634-40.

Gray, Douglas. "The Five Wounds of Our Lord," *N&Q*, 208 (1963), 50-51, 82-89, 127-34, 163-68.

Gurewich, Vladimir. "Observations on the Iconography of the Wound in Christ's Side, with Special Reference to Its Position," *Journal of the Warburg and Courtauld Institutes*, 20 (1957), 358-62.

Heather, P. J. "Colour Symbolism," *Folk-Lore*, 60 (1949), 165-83, 209-16, 266-76, 316-31.

Henderson, George. "Cain's Jaw Bone," *Journal of the Warburg and Courtauld Institutes*, 24 (1961), 108-14.

Hildburgh, W. L. "An Alabaster Table of the Annunciation with the Crucifix: A Study in English Iconography," *Arch*, 74 (1923-24), 203-34.

_____. "Notes on Some English Alabaster Carvings," *AntJ*, 4 (1924), 374-81.

_____. "Miscellaneous Notes concerning English Alabaster Carvings," *ArchJ*, 88 (1931), 228-46.

_____. "Some Further Notes on the Crucifix on the Lily," *AntJ*, 12 (1932), 24-26.

_____. "Iconographic Peculiarities in English Alabaster Carvings," *Folk-Lore*, 44 (1933), 32-56, 123-50.

_____. "Note on Medieval Representations of the Resurrection of Our Lord," *Folk-Lore*, 48 (1937), 95-98.

_____. "Medieval Alabaster Figures of the Virgin and Child," *BurlM*, 88 (1946), 30-35, 37, 62-66.

_____. "An English Alabaster Carving of *St. Michael Weighing a Soul*," *BurlM*, 89 (1947), 128-31.

_____. "Representations of the Saints in Medieval English Alabaster Carvings," *Folk-Lore*, 61 (1950), 68-87.

Hill, G. F. "The Thirty Pieces of Silver," *Arch*, 59 (1905), 235-54.

Hollaender, Albert. "The Doom-Painting of St. Thomas of Canterbury, Salisbury," *WlArch*, 50 (1942), 351-70.

Hope, W. H. St. John. "On Sculptured Alabaster Tablets Called St. John's Heads," *Arch*, 52 (1890), 669-708.

_____ and E. G. Cuthbert F. Atchley. *English Liturgical*

Colours. London: SPCK, 1918.

Horne, Ethelbert. "The Crown of Thorns in Art," _Downside Review_, 53 (1935), 48-51.

Houghton, F. T. S. "Astley Church and Its Stall Paintings," _TrBAS_, 51 (1925-26), 19-28.

Hulme, F. Edward. _The History, Principles, and Practice of Symbolism in Christian Art_. London, 1899.

James, M. R. _Illustrations of the Book of Genesis_. Oxford: Roxburghe Club, 1921.

_____. _The Apocalypse in Art_. London, 1931.

_____. "On Fine Art as Applied to the Illustration of the Bible in the Ninth and Following Centuries," _Cambridge Antiquarian Society Communications_, 7 (1888-91), 31-69.

_____ and E. W. Tristram. "The Wall Paintings in Eton College Chapel and in the Lady Chapel of Winchester Cathedral," _Walpole Society_, 17 (1928-29), 1-44.

Jameson, Mrs. [Anna B.] _Sacred and Legendary Art_, 8th ed. 2 vols. London: Longmans, Green, 1879.

_____. _Legends of the Madonna_, new ed. London: Longmans, Green, 1890.

_____ and Lady Eastlake. _The History of Our Lord as Exemplified in Works of Art_. 2 vols. London: Longmans, Green, 1864.

Katzenellenbogen, Adolf. _Allegories of the Virtues and Vices in Mediaeval Art_, trans. Alan J. P. Crick. 1939; rpt. New York: Norton, 1964.

Keyser, Charles E. "On the Sculptured Tympanum of a Former Doorway in the Church of South Ferriby, Lincolnshire," _Arch_, 47 (1883), 161-78.

_____. "On a Panel Painting of the Doom Discovered in 1892, in Wenhaston Church, Suffolk," _Arch_, 54 (1894), 119-30.

_____. "Notes on a Sculptured Tympanum at Kingswinford Church, Staffordshire, and Other Early Representations in England of St. Michael the Archangel," _ArchJ_, 62 (1905), 137-46.

Kirschbaum, Engelbert, _et al_. _Lexikon der Christlichen Ikonographie_. 8 vols. Freiburg: Herder, 1968-76.

Knowles, John A. "Dance of Salome," _N&Q_, 12th ser., 9 (1921), 197.

Ladner, Gerhart B. "_Homo Viator_: Mediaeval Ideas on Alienation and Order," _Speculum_, 42 (1967), 233-59.

Laurence, Marion. "Maria Regina," _AB_, 7 (1924-25), 150-61.

Levi d'Ancona, Mirella. _The Iconography of the Immaculate Conception in the Middle Ages and Early Renaissance_, Monographs on Archaeology and Fine Arts, 7. Chicago:

College Art Association, 1957.

Loomis, Grant. "The Growth of the Saint Edmund Legend," *Harvard Studies and Notes*, 14 (1932), 83-113.

Mâle, Émile. *The Gothic Image*, trans. Dora Nussey. 1913; rpt. New York: Harper and Row, 1958.

_____. *L'Art religieux de la fin du moyen age en France.* Paris: Librairie Armand Colin, 1908.

_____. *Religious Art from the Twelfth to the Eighteenth Century.* 1949; rpt. New York: Noonday, 1958.

Malvern, Marjorie M. *Venus in Sackcloth.* Carbondale and Edwardsville: Southern Illinois Univ. Press, 1975.

Martin, Henry. "Les enseignements des miniatures," *GdesBA*, 4th ser., 9 (1913), 173-88.

Mead, William E. *The English Medieval Feast.* Boston: Houghton Mifflin, 1931.

Meiss, Millard. *Painting in Florence and Siena after the Black Death.* Princeton: Princeton Univ. Press, 1951.

Mellinkoff, Ruth. *The Horned Moses in Medieval Art.* Berkeley and Los Angeles: Univ. of California Press, 1970.

Milburn, R. L. P. *Saints and Their Emblems in English Churches.* Oxford: Blackwell, 1957.

Morley, C. R. "A Group of Gothic Ivories in the Walters Art Gallery," *AB*, 18 (1936), 199-212.

Musper, H. T. *Die Urausgaben der holländischen Apokalypse und Biblia Pauperum.* Munich: Prestel, 1961.

Nelson, Philip. "A Doom Reredos," *TrHSLaCs*, 70 (1919), 67-71.

_____. "An English Fifteenth Century Alabaster Reredos of St. Edmund," *TrHSLaCs*, 75 (1924), 208-12.

Panofsky, Erwin. *Early Netherlandish Painting.* 2 vols. Cambridge: Harvard Univ. Press, 1953.

Peebles, Rose Jeffries. *The Legend of Longinus in Ecclesiastical Tradition and in English Literature.* Baltimore: Furst, 1911.

Perry, Mary Phillips. "On the Psychostasis in Christian Art," *BurlM*, 22 (1912-13), 94-105, 208-18.

Pickering, F. P. *Literature and Art in the Middle Ages.* Coral Gables, Florida: Univ. of Miami Press, 1970.

Prideaux, Edith K. "The Carvings of Mediaeval Musical Instruments in Exeter Cathedral Church," *ArchJ*, 72 (1915), 1-36.

Ratkowska, Paulina. "The Iconography of the Deposition without St. John," *Journal of the Warburg and Courtauld Institutes*, 27 (1964), 312-17.

Read, Charles Hercules. "On a Panel of Tapestry of about the Year 1400 and Probably of English Origin," *Arch*, 68 (1917), 35-42.

Réau, Louis. *Iconographie de l'art Chrétien.* 3 vols. Paris: Presses Universitaires de France, 1955-59.

"Relic of the Pilgrimage of Grace," *YsAJ*, 21 (1910-11), 108-09.

Ringbom, Sixten. *"Maria in Sole* and the Virgin of the Rosary," *Journal of the Warburg and Courtauld Institutes*, 25 (1962), 326-30.

_____. *Icon to Narrative*, Acta Academiae Aboensis, ser. A, 31, pt. 2 Åbo, 1965.

_____. "Devotional Images and Imaginative Devotions," *GdesBA*, 111 (1969), 159-70.

Robb, David M. "The Iconography of the Annunciation in the Fourteenth and Fifteenth Centuries," *AB*, 18 (1936), 480-526.

Robbins, Rossell Hope. "The 'Arma Christi' Rolls," *Modern Language Review*, 34 (1939), 415-21.

Rouse, E. Clive, and Audrey Baker. "Wall Paintings in Stoke Orchard Church, Gloucestershire, with Particular Reference to the Cycle of the Life of St. James the Great," *ArchJ*, 123 (1966), 79-119.

Rushforth, Gordon McNeil. "The Baptism of St. Christopher," *AntJ*, 6 (1926), 152-58.

_____. "The Kirkham Monument in Paignton Church," *Transactions of the Exeter Diocesan Architectural and Archaeological Society*, 15 (1927), 1-37.

_____. "Seven Sacraments Compositions in English Medieval Art," *AntJ*, 9 (1929), 83-100.

_____. *Medieval Christian Imagery*. Oxford: Clarendon Press, 1936.

Salmon, John. "St. Christopher in English Medieval Art and Life," *JBAA*, 61 (1936), 76-115.

Schapiro, Meyer. "Cain's Jaw-Bone That Did the First Murder," *AB*, 24 (1942), 205-12.

_____. "The Image of the Disappearing Christ: The Ascension in English Art around the Year 1000," *GdesBA*, 6th ser., 23 (1943), 135-58.

_____. *Words and Pictures: On the Literary and the Symbolic in the Illustration of a Text*. The Hague: Mouton, 1973.

Scharf, George. "Observations on a Picture in Gloucester Cathedral and Some Other Representations of the Last Judgment," *Arch*, 36 (1855), 370-91, 457-60.

_____. "On a Votive Painting of St. George and the Dragon, with Kneeling Figures of Henry VII, his Queen and Children," *Arch*, 49 (1886), 243-95.

Schiller, Gertrud. *Iconography of Christian Art*, trans. Janet Seligman. 2 vols. Greenwich, Conn, 1971.

Schlauch, Margaret. "The Allegory of Church and Synagogue," *Speculum*, 14 (1939), 448-64.

Schorr, Dorothy. "The Iconographic Development of the Presentation in the Temple," *AB*, 28 (1946), 17-32.

_____. *The Christ Child in Devotional Images in Italy during the XIV Century.* New York: George Wittenborn, 1954.

Simpson, W. Sparrow. "On the Measure of the Wound in the Side of the Redeemer," *JBAA*, 30 (1874), 357-74.

Smith, Alison M. "The Iconography of the Sacrifice of Isaac in Early Christian Art," *American Journal of Archaeology*, 26 (1922), 159-73.

Sparrow, W. Shaw, ed. *The Apostles in Art.* London: Hodder and Stoughton, 1906.

Storck, Willy F. "Aspects of Death in English Art and Poetry," *BurlM*, 21 (1912), 249-56, 314-19.

Varty, Kenneth. *Reynard the Fox: A Study of the Fox in Medieval English Art.* New York: Humanities Press, 1967.

Westlake, N. *The Dance: Historic Illustrations of Dancing from 3300 B.C. to 1911 A.D.* London, 1911.

Wood, D. T. B. "'Credo' Tapestries," *BurlM*, 24 (1914), 247-54, 309-16.

Woolf, Rosemary. "The Theme of Christ the Lover-Knight in Medieval English Literature," *Review of English Studies*, 13 (1962), 1-16.

Zarnecki, George. "The Coronation of the Virgin on a Capital from Reading Abbey," *Journal of the Warburg and Courtauld Institutes*, 13 (1950), 1-12.

IV. Drama and Art to the Reformation

Anderson, M. D. *Drama and Imagery in English Medieval Churches.* Cambridge: Cambridge Univ. Press, 1963.

Blanch, Robert J. "The Gifts of the Shepherds in *Prima Pastorum*: A Symbolic Interpretation," *Cithara*, 13 (1974), 69-75.

Bonnell, J. K. "The Source in Art of the So-Called Prophets' Play of the Hegge Collection," *PMLA*, 29 (1914), 327-40.

_____. "The Serpent with a Human Head in Art and in Mystery Play," *American Journal of Archaeology*, 2nd ser., 21 (1917), 255-91.

Bradbrook, M. C. "An 'Ecce Homo' of the Sixteenth Century and the Pageants and Street Theatres of the Low Countries," *Shakespeare Quarterly*, 9 (1958), 424-26.

Cohen, Gustave. "The Influence of the Mysteries on Art in the Middle Ages," *GdesBA*, 24 (1943), 327-42.

Coletti, Theresa. "Spirituality and Devotional Images: The Staging of the Hegge Cycle," Univ. of Rochester diss., 1975.

_____. "Devotional Iconography in the N-Town Marian
 Plays," *CompD*, 11 (1977), 22-44.
Collins, Patrick J. "Narrative Bible Cycles in Medieval Art
 and Drama," *CompD*, 9 (1975), 125-46.
_____. "Typology, Criticism, and Medieval Drama: Some
 Observations on Method," *CompD*, 10 (1976-77), 298-313.
Cutts, John P. "The Shepherds' Gifts in *The Second Shepherds'
 Play* and Bosch's 'Adoration of the Magi'," *CompD*, 4
 (1970), 120-24.
Davidson, Clifford. "An Interpretation of the Wakefield
 Judicium," *Annuale Mediaevale*, 10 (1969), 104-19.
_____. "The End of the World in Medieval Art and Drama,"
 Michigan Academician, 5 (1972), 257-63.
_____. "The Digby *Mary Magdalene* and the Magdalene Cult
 of the Middle Ages," *Annuale Mediaevale*, 13 (1972), 70-
 87.
_____. "Civic Concern and Iconography in the York
 Passion," *Annuale Mediaevale*, 15 (1974), 125-49.
_____. "The Realism of the York Realist and the York
 Passion," *Speculum*, 50 (1975), 270-83.
_____. "After the Fall: Design in the Old Testament Plays
 in the York Cycle," *Mediaevalia*, 1 (1975), 1-24.
_____. "Northern Spirituality and Late Medieval Drama,"
 The Spirituality of Western Christendom, ed. E. Rozanne
 Elder. Kalamazoo: Cistercian Publications, 1976.
 Pp. 125-51, 205-08.
_____. "From *Tristia* to *Gaudium*: Iconography and the
 York-Towneley *Harrowing of Hell*," *American Benedictine
 Review*, forthcoming.
_____ and Nona Mason. "Staging the York *Creation, and
 Fall of Lucifer*," *Theatre Survey*, 17 (1976), 162-78.
Edwards, Robert R. "Iconography and the Montecassino Passion,"
 CompD, 6 (1972-73), 274-93.
Fischel, Oskar. "Art and the Theater," *BurlM*, 66 (1935),
 4-14, 54-67.
Gauvin, Claude. *Un cycle du théâtre religieux anglais du
 moyen âge*. Paris: Centre National de la Recherche
 Scientifique, 1973.
Green, Rosalie. Review of M. D. Anderson, *Drama and Imagery*.
 Speculum, 41 (1966), 725-26.
Harvey, John H. Review of M. D. Anderson, *Drama and Imagery*.
 ArchJ, 120 (1963), 316-17.
Hassall, W. O. Review of M. D. Anderson, *Drama and Imagery*.
 Medium Aevum, 33 (1964), 241-42.
Hildburgh, W. L. "English Alabaster Carvings as Records of
 the Medieval English Drama," *Arch*, 93 (1955), 51-101.
Johnston, Alexandra F. "The Plays of the Religious Guilds

of York: The Creed Play and the Pater Noster Play,"
Speculum, 50 (1975), 55-90.

_____ and Margaret Dorrell. "The Doomsday Pageant of
the York Mercers, 1433," *Leeds Studies in English*, n.s.
5 (1971), 29-34.

_____ and Margaret Dorrell. "The York Mercers and Their
Pageant of Doomsday, 1433-1526," *Leeds Studies in English*,
n.s. 6 (1972), 10-35.

Kahrl, Stanley J. *Traditions of Medieval English Drama*.
London: Hutchinson, 1974.

Kernodle, George R. "The Medieval Pageant Wagons of Louvain,"
Theatre Annual (1943), pp. 58-62.

Larson, Orville, K. "Tscension Images in Art and Theatre,"
GdesBA, 101 (1959), 161-76.

Mâle, Émile. "Le renouvellement de l'art par les 'mystères'
a la fin du moyen age," *GdesBa*, 46, pt. 1 (1904),
283-301.

Mill, Anna J. "The York Plays of the Dying, Assumption, and
Coronation of Our Lady," *PMLA*, 65 (1950), 866-76.

Muir, Lynette R. *Liturgy and Drama in the Anglo-Norman* Adam,
Medium Aevum Monographs, n.s., 3. Oxford, 1973.

_____. "The Trinity in Medieval Drama," *CompD*, 10
(1976), 116-29.

_____. "The Fall of Man in the Drama of Medieval Europe,"
Studies in Medieval Culture, 10 (1977), forthcoming.

Nelson, Alan H. "Some Configurations of Staging in Medieval
English Drama," *Medieval English Drama*, ed. Jerome
Taylor and Alan H. Nelson. Chicago: Univ. of Chicago
Press, 1972. Pp. 116-47.

_____. *The Medieval English Stage*. Chicago: Univ. of
Chicago Press, 1974.

_____. "'Of the seuen ages': An Unknown Analogue of
The Castle of Perseverance," *Studies in Medieval Drama
in Honor of William L. Smoldon*, ed. Clifford Davidson.
Kalamazoo: Comparative Drama, 1974. Pp. 125-38.

Nicoll, Allardyce. *Masks, Mimes, and Miracles*. London:
Harrap, 1931.

Pächt, Otto. *The Rise of Pictorial Narrative in Twelfth-
Century England*. Oxford: Clarendon Press, 1962.

Paull, Michael. "The Figure of Mahomet in the Towneley
Cycle," *CompD*, 6 (1972), 187-205.

Reiss, Edmund. "The Story of Lamech and Its Place in
Medieval Drama," *Journal of Medieval and Renaissance
Studies*, 2 (1972), 35-48.

Robinson, J. W. "The Art of the York Realist," *MP*, 60
(1962-63), 241-51.

_____. "The Late Medieval Cult of Jesus and the

Mystery Plays," *PMLA*, 80 (1965), 508-14.

_____. "A Commentary on the York Play of the Birth of
Jesus," *Journal of English and Germanic Philology,* 70
(1971), 241-54.

Ross, Lawrence J. "Art and the Study of Early English Drama,"
Renaissance Drama, 6 (1963), 35-46.

_____. "Symbol and Structure in the *Secunda Pastorum*."
CompD, 1 (1967), 122-43.

Smith, M. Q. "The Roof Bosses of Norwich Cathedral and Their
Relation to the Medieval Drama of the City," *NoArch*, 32
(1958), 12-26.

Staines, David. "To Out-Herod Herod: The Development of a
Dramatic Character," *CompD*, 10 (1976), 29-53.

Stuart, D. C. "The Stage Setting of Hell and the Iconography
of the Middle Ages," *Romanic Review*, 4 (1913), 330-42.

Wickham, Glynne. *Early English Stages, 1300 to 1660*. Vol. I.
London: Routledge and Kegan Paul, 1959.

Woolf, Rosemary. *The English Mystery Plays*. Berkeley and Los
Angeles: Univ. of California Press, 1972.

Young, Karl. *The Drama of the Medieval Church*. 2 vols.
Oxford: Clarendon Press, 1933.

V. *Research Tools*

No attempt will be made to duplicate the Research Guide pre-
pared for Records of Early English Drama by Ian Lancashire
(*REED Newsletter*, 1 [1976], 10-23). Serious students should
consult Professor Lancashire's work.

Archaeological Bibliography for Great Britain and Ireland.
London: Council for British Archaeology, 1954- .

British Humanities Index. 1962- .

Cheney, Christopher R., ed. *Handbook of Dates for Students
of Local History*, revised ed. Royal Historical Soc.,
1970.

Gomme, George L. *Index of Archaeological Papers, 1665-1890*.
London, 1907. Supplements issued annually until 1910.

Harcup, Sara E. *Historical, Archaeological and Kindred
Societies in the British Isles*, 2nd ed. London, 1968.

Ker, N. R., ed. *Medieval Libraries of Great Britain*, 2nd
ed. London: Royal Historical Soc., 1964.

_____. *Medieval Manuscripts in British Libraries*.
Vol. I: London. Oxford, 1969. Vols. II-III: Aberdeen-
Liverpool, Maidstone-York, forthcoming.

Latham, R. E. *Revised Medieval Latin Word-List from British
and Irish Sources*. London, Oxford Univ. Press, 1965.

Medieval Latin Dictionary. In progress.

Mullins, Edward L. C. *A Guide to the Historical and Archaeological Publications of Societies in England and Wales, 1901-1933.* London: Univ. of London, 1968.

Pollard, A. W., and G. R. Redgrave. *A Short-Title Catalogue of Books Printed in England, Scotland, and Ireland, and of English Books Printed Abroad, 1475-1640.* London: Bibliographical Soc., 1926.

Poole's Index to Periodical Literature, 1802-1881, revised ed. 2 vols. Boston, 1891. Supplementary vols. extend coverage to Jan. 1907.

Subject Index to Periodicals. London: Library Association, 1919- . Coverage from 1915-16 to 1961; for 1962- , see *British Humanities Index.*

VI. *Some studies in iconography, mythology, visual effects, and art relevant to the drama of the post-Reformation period to 1642.*

Allen, Don Cameron. "Symbolic Color in the Literature of the Renaissance," *Philological Quarterly*, 15 (1936), 81-92.

_____. "Ben Jonson and the Hieroglyphics," *Philological Quarterly*, 18 (1939), 290-300.

_____. *Mysteriously Meant: The Rediscovery of Pagan Symbolism and Allegorical Interpretation in the Renaissance.* Baltimore: John Hopkins Press, 1970.

Aptekar, Jane. *Icons of Justice.* New York: Columbia Univ. Press, 1969.

Bernen, Satia and Robert. *Myth and Religion in European Painting, 1270-1700.* New York: Braziller, 1973.

Boas, George, trans. *The Hieroglyphics of Horapollo*, Bollingen ser., 23. New York: Pantheon, 1950.

Bush, Douglas. *Mythology and the Renaissance Tradition in English Poetry*, revised ed. New York: Norton, 1963.

Cary, Cecile. "'Go Breake This Lute'; Music in Heywood's *A Woman Killed with Kindness*," *Huntington Library Quarterly*, 37 (1973-74), 111-22.

Chew, Samuel C. *The Pilgrimage of Life.* New Haven: Yale Univ. Press, 1962.

Cody, Richard. *The Landscape of the Mind.* Oxford: Clarendon Press, 1969.

Cutts, John P. *Rich and Strange.* Pullman: Washington State Univ. Press, 1968.

_____. *"When were the Senses in such order plac'd?"* *CompD*, 4 (1970), 52-62.

_____. "Seventeenth-Century Illustrations of Three Masques by Jonson," *CompD*, 6 (1972), 125-34.

Davidson, Clifford. "*Coriolanus*: A Study in Political Dis-
 location," *Shakespeare Studies*, 4 (1968), 263-74.
_____. *The Primrose Way: A Study of Shakespeare's*
 Macbeth. Conesville, Iowa: Westburg, 1970.
_____. "The Triumph of Time," *Dalhousie Review*, 50
 (1970), 170-81.
Dieckmann, Liselotte. "Renaissance Hieroglyphics," *Com-
 parative Literature*, 9 (1957), 308-21.
Doebler, John. *Shakespeare's Speaking Pictures*. Albuquerque:
 Univ. of New Mexico Press, 1974.
Elton, William R. King Lear *and the Gods*. San Marino,
 Calif.: Huntington Library, 1966.
Ewbank, Inga-Stina. "'More pregnantly than words': Some Uses
 and Limitations of Visual Symbolism," *Shakespeare
 Survey*, 24 (1971), 13-18.
Fleischer, Martha Hester. *The Iconography of the English
 History Play*. Salzburg: Institut für Englische Sprache
 und Literatur, 1974.
Fraser, Russell. *Shakespeare's Poetics in Relation to* King
 Lear. London: Routledge and Kegan Paul, 1962.
Freeman, Rosemary. *English Emblem Books*. 1948; rpt. New
 York: Octagon, 1966.
Gellert, Bridget. "The Iconography of Melancholy in the
 Graveyard Scene of *Hamlet*," *Studies in Philology*,
 67 (1970), 57-66.
Gombrich, Ernst H. "*Icones Symbolicae*: The Visual Image
 in Neo-Platonic Thought," *Journal of the Warburg and
 Courtauld Institutes*, 11 (1948), 163-92.
Haaker, Ann. "*Non sin causa*: The Use of Emblematic Method
 and Iconology in the Thematic Structure of *Titus
 Andronicus*," *Research Opportunities in Renaissance
 Drama*, 13-14 (1970-71), 143-68.
Heckscher, William S. "Shakespeare in His Relationship to the
 Visual Arts: A Study in Paradox," *Research Opportunities
 in Renaissance Drama*, 13-14 (1970-71), 5-71.
Henkel, Arthur, and Albrecht Schöne. *Emblemata: Handbuch zur
 Sinnbildkunst des XVI. und XVII. Jahrhunderts*. Stutt-
 gart: J. B. Metzler, 1967.
Hollander, John. *The Untuning of the Sky: Ideas of Music in
 English Poetry, 1500-1700*. Princeton; Princeton Univ.
 Press, 1961.
Joseph, B. L. *Elizabethan Acting*. Oxford Univ. Press, 1964.
Kernodle, George R. *From Art to Theatre*. Chicago: Univ.
 of Chicago Press, 1944.
Kirschbaum, Leo. "Shakespeare's Stage Blood and Its Critical
 Significance," *PMLA*, 64 (1949), 517-29.
Lenz, Carolyn Ruth Swift. "The Allegory of Wisdom in Lyly's

Endimion," *CompD*, 10 (1976), 235-57.

Madsen, William G. *From Shadowy Types to Truth*. New Haven: Yale Univ. Press. 1968.

McDowell, John H. "Conventions of Medieval Art in Shakespearian Staging," *Journal of English and Germanic Philology*, 47 (1948), 215-29.

Mehl, Dieter. "Emblems in English Renaissance Drama," *Renaissance Drama*, n.s. 2 (1969), 39-57.

Meyer-Baer, Käthi. *Music of the Spheres and the Dance of Death*. Princeton: Princeton Univ. Press, 1970.

Orgel, Stephen. *The Jonsonian Masque*. Cambridge: Harvard Univ. Press, 1965.

Panofsky, Erwin. *Studies in Iconology*. New York: Oxford Univ. Press, 1939.

Pentzell, Raymond J. "*The Changeling*: Notes on Mannerism in a Dramatic Form," *CompD*, 9 (1975), 3-28.

Praz, Mario. *Studies in Seventeenth-Century Imagery*, 2nd ed. Rome: Edizioni di Storia e Letteratura, 1964.

Ripa, Cèsare. *Baroque and Rococo Imagery. The 1758-60 Hertel Edition of Ripa's 'Iconologia,'* ed. Edward A. Maser. New York: Dover, 1971.

Ross, Lawrence J. "The Meaning of Strawberries in Shakespeare," *Studies in the Renaissance*, 7 (1960), 225-40.

Shearman, John. *Mannerism*. Baltimore: Penguin, 1967.

Southern, Richard, and C. W. Hodges. "Color in the Elizabethan Theatre," *Theatre Notebook*, 6 (1952), 57-58.

Saccio, Peter. *The Court Comedies of John Lyly*. Princeton: Princeton Univ. Press, 1969.

Schuman, Samuel. "Emblems and the English Renaissance Drama: A Checklist," *Research Opportunities in Renaissance Drama*, 12 (1969), 43-56.

Seznec, Jean. *The Survival of the Pagan Gods*, trans. Barbara F. Sessions, Bollingen ser., 38. New York: Pantheon, 1953; rpt. New York: Harper and Row, 1961.

Snyder, Susan. "The Left Hand of God: Despair in Medieval and Renaissance Tradition," *Studies in the Renaissance*, 12 (1965), 18-59.

Spivack, Bernard. *Shakespeare and the Allegory of Evil*. New York: Columbia Univ. Press, 1958.

Starnes, DeWitt, and Talbert, Ernest William. *Classical Myth and Legend in Renaissance Dictionaries*. Chapel Hill: Univ. of North Carolina Press, 1955.

Steadman, John M. "Iconography and Renaissance Drama: Ethical and Mythological Themes," *Research Opportunities in Renaissance Drama*, 13-14 (1970-71), 73-122.

Tayler, Edward William. *Nature and Art in Renaissance Literature*. New York: Columbia Univ. Press, 1964.

Tuve, Rosamund. *Allegorical Imagery: Some Medieval Books and Their Posterity*. Princeton: Princeton Univ. Press, 1966.

Velz, John W. "Two Emblems in Brutus' Orchard," *Renaissance Quarterly*, 25 (1972), 307-15.

Wickham, Glynne. *Early English Stages, 1300 to 1660*. Vol. II, Pt. 1 London: Routledge and Kegan Paul, 1963.

Wind, Edgar. *Pagan Mysteries in the Renaissance*, revised ed. New York: Norton, 1968.

Yates, Frances. *Giordano Bruno and the Hermetic Tradition*. Chicago: Univ. of Chicago Press, 1964.

_____. *Theatre of the World*. Chicago: Univ. of Chicago Press, 1969.